STREET STYLE, VINTAGE, OBSESSION

AMY LEVERTON

Denim

STREET STYLE, VINTAGE, OBSESSION

RIZZOLI
NEW YORK

New York · Paris · London · Milan

CONTENTS

I HAVE OFTEN SAID THAT

I WISH I HAD INVENTED BLUE JEANS:

THE MOST SPECTACULAR, THE MOST PRACTICAL, THE MOST RELAXED, AND NONCHALANT. THEY HAVE EXPRESSION, MODESTY, SEX APPEAL, SIMPLICITY— ALL I HOPE FOR IN MY CLOTHES.

YVES SAINT LAURENT

INTRODUCTION

If denim were a company, its shares would be worth more than Apple's, if it were a restaurant, the queues would stretch round the block, if it were a song, it would be permanently at number one. Why? Because denim encapsulates exactly what Saint Laurent spoke of: it's something to everyone, it's tomboy, it's hot, it's understated, it's outrageous.

And who said the denim industry was a man's world? Yeah OK, maybe they had a point in the late 1800s and early 1900s. Men wore denim to build America: they were the workers, the railroaders, and the cowboys. Denim was a male fabric, associated with strength, durability, and a rugged attitude.

But in the 1930s and '40s came the land girls, the suffragettes, and the factory femmes who claimed workwear as their equal right. And following them came Marilyn Monroe. When I think of women in denim many iconic images come to mind, but for me they all start with Monroe sitting in a director's chair in *that* Lee Rider jacket circa 1961. Since that moment denim and sex have not been separated.

Through the years there have been many women who shaped the future of denim style: Blondie's Debbie Harry made the Levi's 505 jean a New York staple in 1976, Daisy Duke looked so hot in her cut-off shorts that the name stuck, Farrah Fawcett in *that* skateboard shot summed up an entire era of flares, and, of course, nobody got between Brooke Shields and her Calvins.

What is it about women in denim that's just so irresistible? Like Saint Laurent said, denim is classic, it's rock and roll, it's timeless, it's sexy, it's effortless. This book celebrates some of today's most iconic denim dressers, designers, stylists, and makers. These are the women who create trends, start empires, and take this once functional fabric into the realm of the runway.

AMERICA

WITHIN AMERICA LIES THE VERY FOUNDATION OF DENIM.

The word "de Nimes" might have originated in France but denim's attitude was born in the U.S.A. Charting the humble jean's progression from a durable and practical workwear staple during the West Coast gold rush all the way to the New York City runways of today traces a journey through '50s rebellion, '60s rock and roll, '70s hippies, '80s ostentation, and '90s grunge. Today's market has changed considerably and we wouldn't be where we are without the early noughties premium denim boom in Los Angeles or the queens of the New York catwalks.

Today's heroines of denim include New York's Rachel Comey and Los Angeles's Emily Current and Meritt Elliott, women who have led denim trends around the globe. And of course you can't forget the big-box brands out of California who dominate the global market and are a mainstay for celebrities, off-duty models, and girls who are serious about denim style.

But it's not all about trend. Purist artisans and one-woman brands reside in the hills of San Francisco and are scattered among the factories of Vernon in Los Angeles. Indigo dyers are turning their hands blue in Brooklyn and biker babes are donning durable denim and living for the ultimate fades in the desert. American denim is very much alive and kicking.

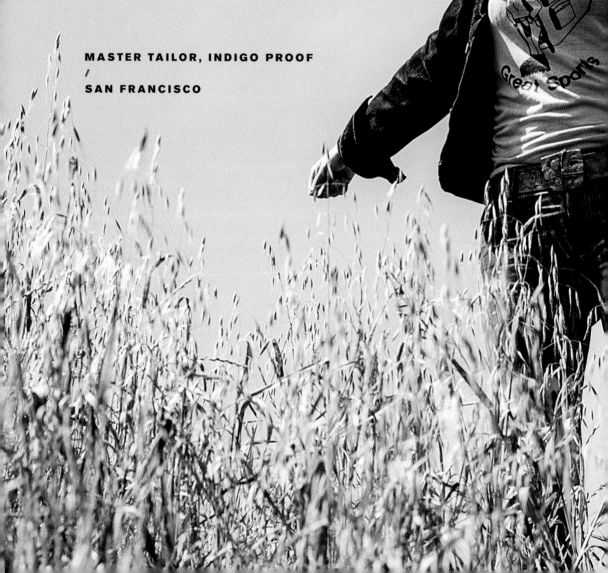

RAIN DELISLE,
CUSTOM CASUAL

My jacket is a men's Iron Heart/Self Edge collaboration in black overdyed 18-oz denim, and the rocker I had custom chainstitched for me by Jerry Lee of Hoosier Chainstitch. It's a portrait of my better half: the Singer 47W70, which is the machine I do all my repair work on. Indigo Proof is my repairing alter ego, the name I work and blog under. I feel like I'm in a one-woman gang in this jacket, and I pretty much live in it!

I made these jeans the week of this shoot—I was actually indigo dyeing them the night before! They are natural white pima cotton 3sixteen's that I dyed in a four-process rainbow and then bound and overdyed indigo. I love how the indigo reacts with the chemical dyes, eating away at the color leaving these cool yellowish tones streaked throughout.

Both pieces are pretty much as customized as they can be, which is something I feel pretty strongly about. In this industry, people can take themselves so seriously they forget that fashion is about self-expression and, most of all, fun!

MASTER TAILOR, INDIGO PROOF
/
SAN FRANCISCO

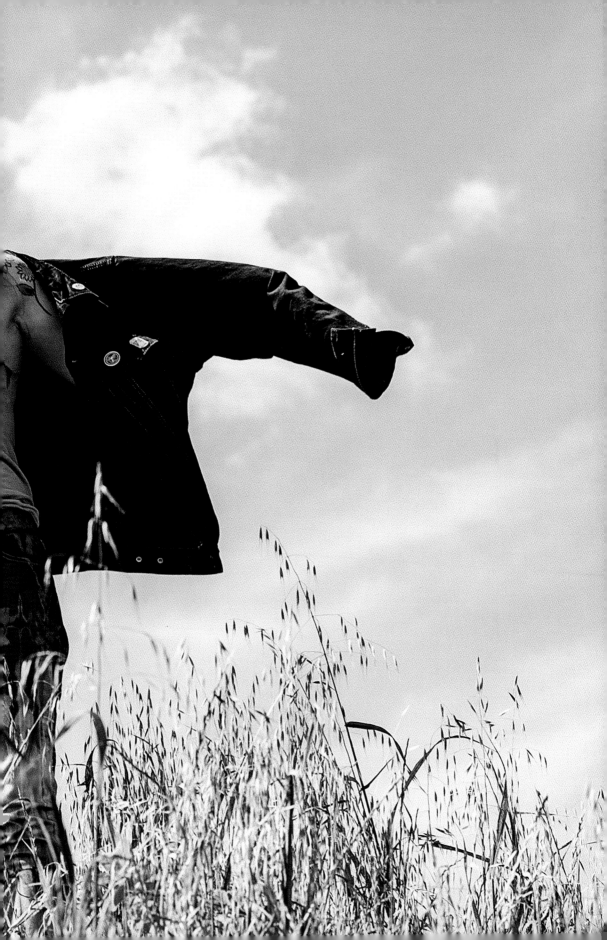

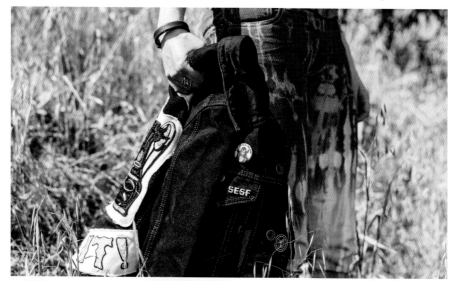

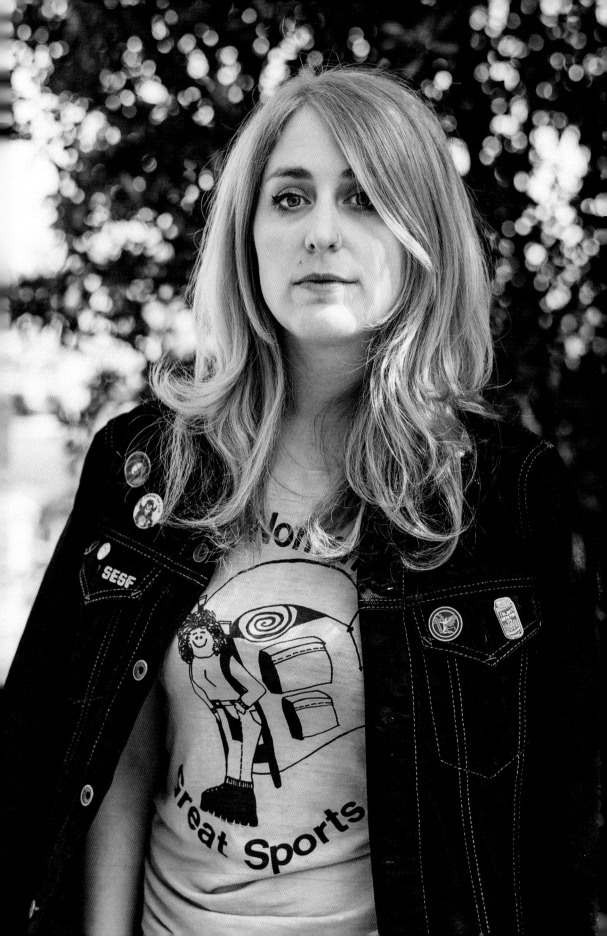

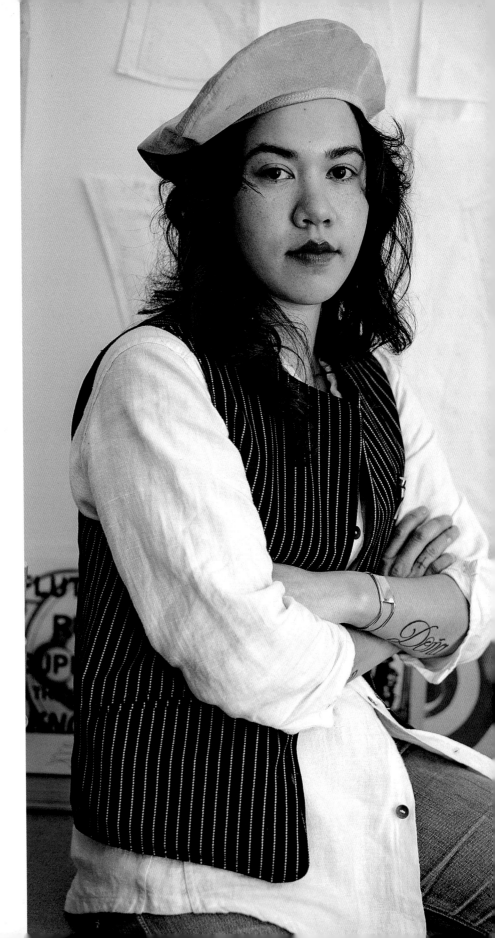

MELISSA VU,
ATELIER EXTRAORDINAIRE

Everything I am wearing from head to toe garment-wise I designed and sewed myself in my atelier. I see garments as an art practice and flirt with ideas of interesting details that also serve a purpose, making the garment a piece of history of what is going on in my mind from that time. The vest I am wearing is a reversible vest made of Japanese indigo wabash stripe cotton twill. The shirt is single needle, hand tailored in a white linen with custom hardware buttons I designed. The jeans are my first custom pair I made for myself years ago while co-starting a denim menswear company previously known as Jackknife Outfitters. And to top it all off, a beret made of vintage suede leather from my current creative atelier, MME.VU— I call them Basquiat hats.

APPAREL DESIGNER AND
CREATIVE DIRECTOR, MME. VU
/
SAN FRANCISCO

JESSICA GEESEY,
CUSTOM CLASSIC

For as long as I can remember, I've had a love for the unique; the one of a kind, the things in my life that I know there's not a single person out there with this exact piece. Enter my love affair with vintage; denim especially. Denim is the perfect opportunity to make something uniquely your own. It's a journey and every turn is a thing of beauty. Add an incredible story to the mix? Even better. Heart melted.

These jeans are near and dear to my heart because of the life they've led. They're a '60s-era big "E" 717 that have been loved, reworked, loved some more, passed down, reworked again, and become my favorite pair. Funny enough, the previous owner is a Denim Dude himself. These originally belonged to Bart Sights, whom I am lucky enough to work closely with every day at Eureka. Somewhere along the way he picked these up at the Rose Bowl down near Los Angeles. They had been taken in along the inseam to slim the bootcut into a straight. When these found their way to me, they had been let back out to a bootcut, leaving a beautiful, dark "gusset" of the original shade. That's when I slimmed them back down to what you see here, this time from the outseam to keep the incredible wear pattern the first taper had created. I only recently learned that these had belonged to Bart. It's a rare thing to know the previous life of a vintage jean. Funny the way things work out sometimes.

The bandanna was found on a road trip at a quirky little antique mall just outside of Reno, Nevada. It's full of holes and beautifully faded. Wouldn't have it any other way. Sweater and shoes are modern pieces I fell in love with: sweater by Isabel Marant and shoes by Maryam Nassir Zadeh. I like to mix old and new, high and low. It keeps things interesting and never too "one note."

Denim is always a part of my everyday. Pretty rare to catch me in anything other than a love-worn pair of Levi's.

DESIGN, LEVI'S VINTAGE CLOTHING
/
SAN FRANCISCO

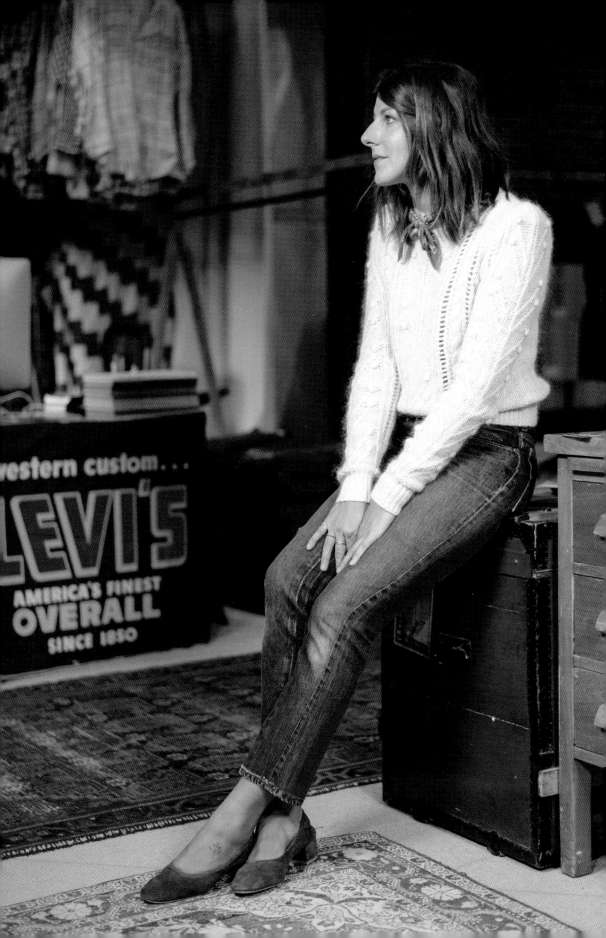

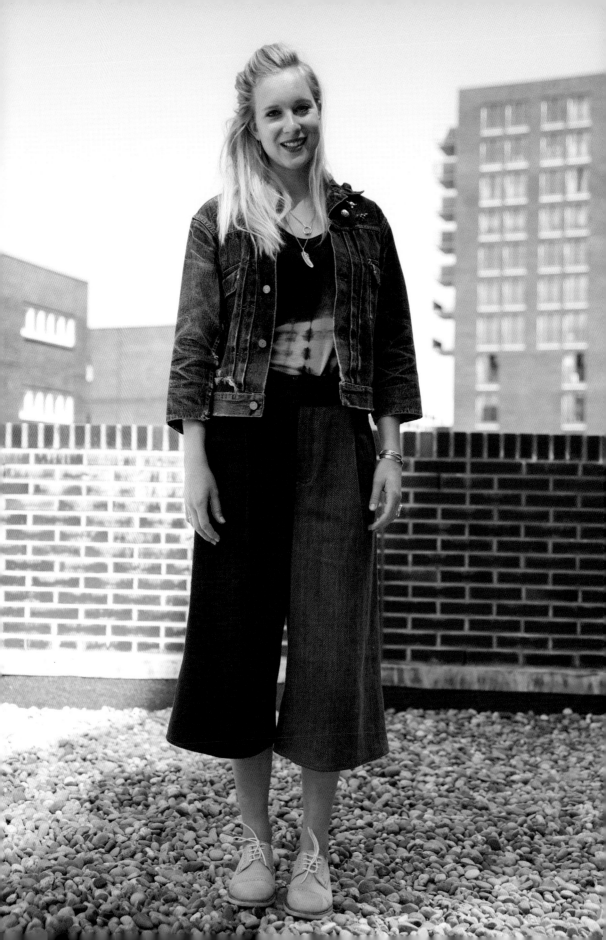

LIZZIE KROEZE,
INDIGO GIRL

I love indigo, that's basically what it comes down to. It was thought to have been used first for textile dyeing and printing in India thousands of years ago, and nearly all cultures have some sort of indigo tradition. Whether it comes from homegrown indigo tinctoria or woad or is imported, the color blue connects people from all over. The way that indigo-dyed textiles age and come to tell a story about their wearers and users captures an essence of what makes us human, and I love that. The jacket I'm wearing, for instance, a 1950s Levi's Type II trucker, has some amazing honeycombs and other creases, telling the story of its previous owner. He or she customized it by removing the cuffs and short-ening the sleeves. When I got it, it was badly damaged so I added my own chapter to the story by hand repairing it using a piece of the reproduction fabric Levi's Vintage Clothing used for their 1954 501Z jean.

The culottes I'm wearing I sewed myself using an indigo kendo fabric, washed in two different shades. They were the first pair of pants I made from scratch; not perfect, but I really like them! The shibori T-shirt was dyed by my good friend and amazing in-digo artist Celia Geraedts.

FACING WEST
/
SAN FRANCISCO

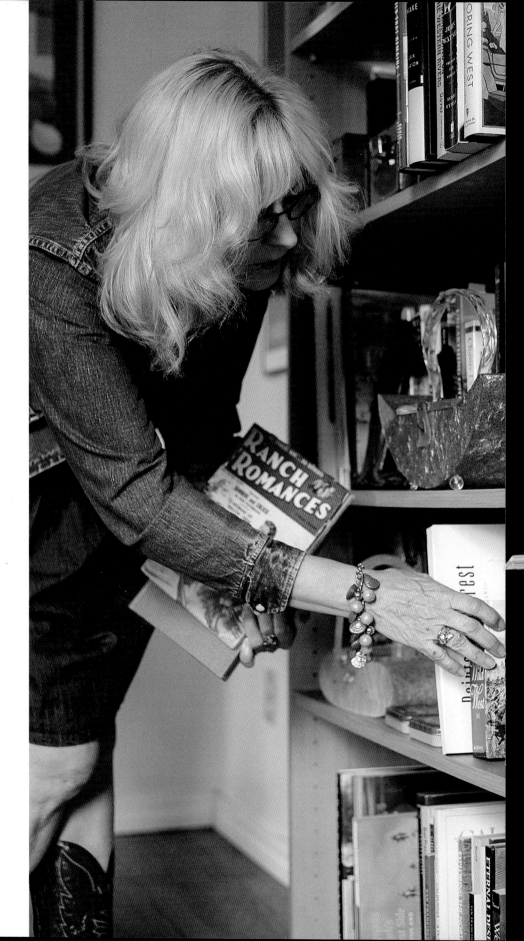

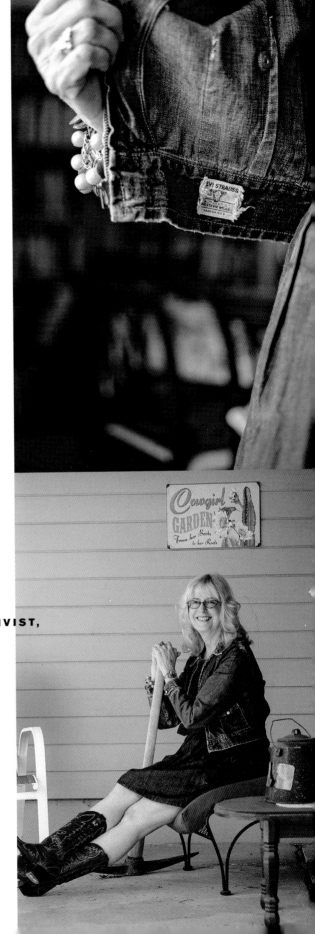

LYNN DOWNEY,
QUEEN OF THE ARCHIVES

I can't remember a time when I didn't wear denim. Which makes sense since my family has lived in the West for over one hundred years and we've worn denim the whole time, most of it made by Levi Strauss & Co.

I love vintage clothing of all kinds, and I especially like to mix vintage and modern together, like this ensemble. The denim dress, made by Levi's, is cut like a 1950s cinch-waisted, full-skirted dress, one of my favorite styles from the time. The jacket is a Levi's Western Wear item from the 1940s. I am obsessed with the clothes they made for the dude ranch crowd, because I stay at and write about dude ranches myself. And of course everything looks good with cowboy boots, especially if they're red. I also wear a lot of vintage jewelry when I put together an outfit like this. Most of it is from the 1950s and belonged to my grandmother.

If clothes are about self-expression, then this outfit says I have one boot in the present, and one boot in the past. Which is just right.

HISTORIAN EMERITUS FOR LEVI STRAUSS & CO., CONSULTING ARCHIVIST, AUTHOR, AND HISTORIAN
/
SONOMA

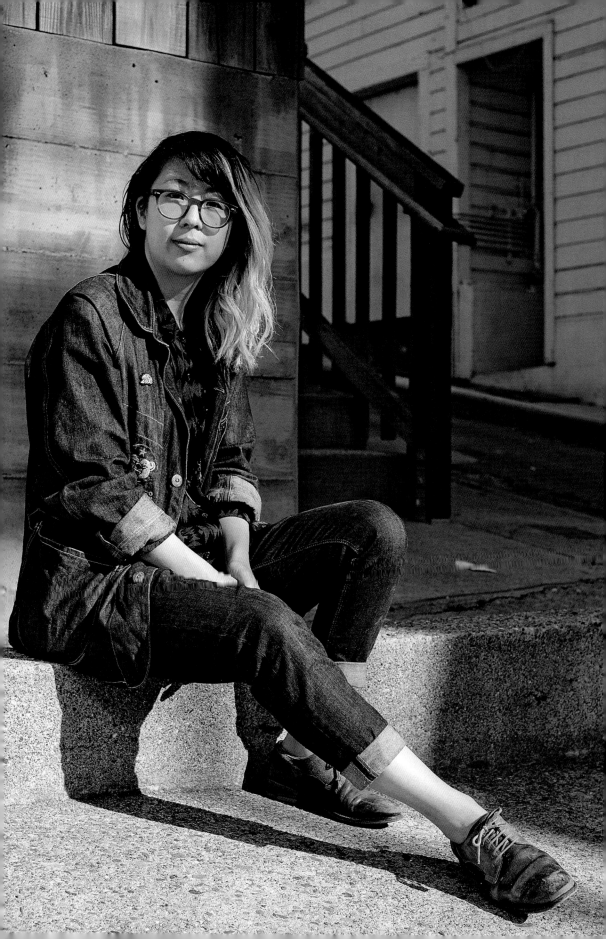

SAMANTHA LEE,
FIT FANATIC

In old terms, I'm a tradesman in denim and clothing. We support small, good-quality craftsmen and we admire both a nod to heritage and a nod to contemporary. As far as my loyalty to these brands, I am always wearing something we have stocked. In these photos, I'm wearing items that broke my seal to understanding good clothing. The Engineer jacket from Rising Sun that I know will grow dusty with me has already shown my use in the pockets. Once I was mugged in San Francisco and so I banned myself from using purses and started wearing only what I needed and could carry and this jacket was the cure.

The shoes are NDC. I've never owned a good pair of shoes until these. I would tread through the city and would end up tossing shoes in six months. It wasn't until my boss, Howard, introduced me to quality shoes that I knew what it was to have something to mold to your foot and something that you could re-cobble. Scars and all these NDCs have seen all of my days.

The jeans I'm wearing are by an Italian brand called Novemb3r. They are amazing because they are a dropped crotch, tapered leg, yet styled with a heritage nod with the cinch back and notched waistband with small pleats in the front. It is a beautiful blend of old and new ideas. Their motto is random imperfections are symptoms of life. Ultimately, good clothes will only get better with age and I would like to make my mark wearing them.

SHOP MANAGER, AB FITS
/
SAN FRANCISCO

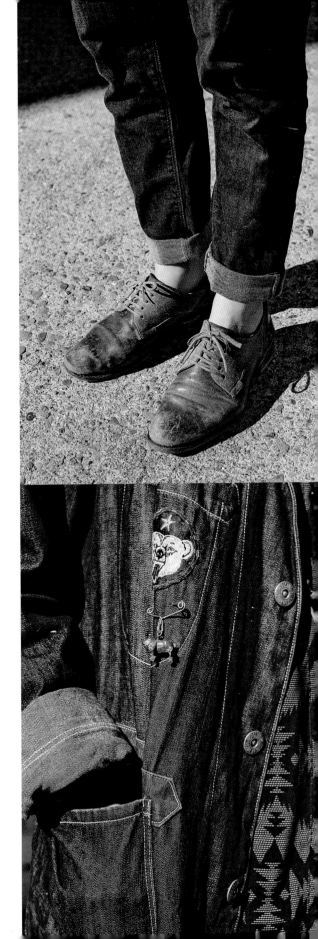

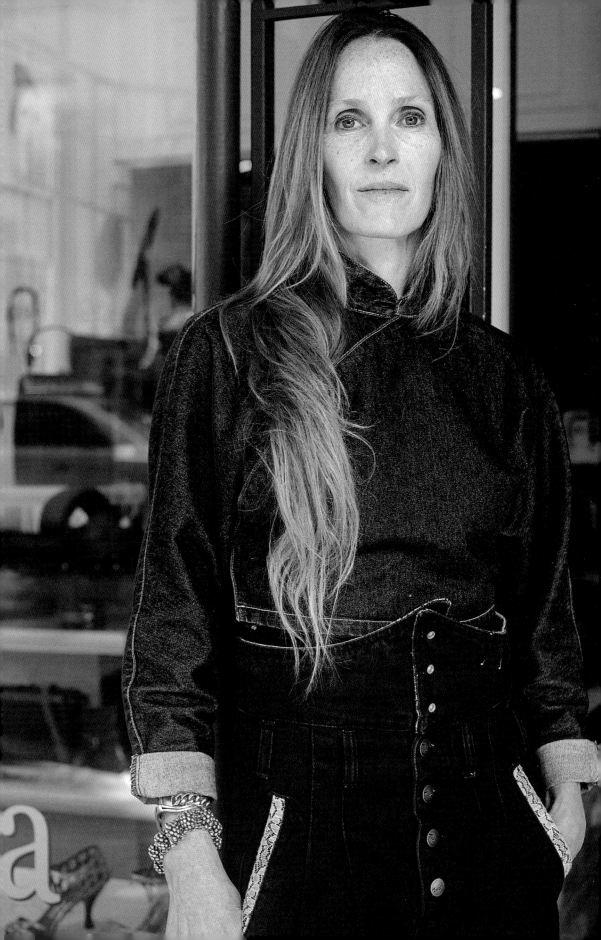

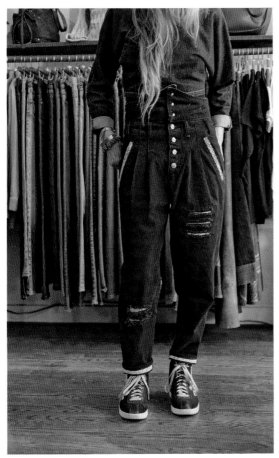
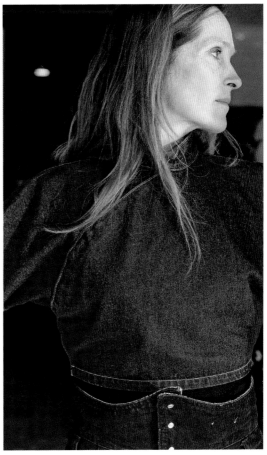

CINDY SPADE,
TWISTED VINTAGE

I've been in the resale business for over twenty years in San Francisco. I've seen many wonderful denim pieces through the years and had a difficult time deciding which denim outfit to wear for this occasion. I choose these two denim items because they are not the usual and appeal to my sense of fashion and comfort. They both so happen to be from the 1980s, but that's not why I chose them. The denim shirt is a Norma Kamali cropped Asian-inspired piece made with Japanese indigo. It feels like home the instant I put it on. The jeans were made by Traffic. There is so much happening with these jeans that they do stop traffic. The denim is dark indigo with a super-high waist that when worn up (as opposed to folding it over) comes to a point midriff. The architechtural shape is special. Then as you move onto more details you see they purposely frayed away holes strategically all over the jeans backed with pink lace. I love the whimsy! My sneakers are denim-embroidered Dries Van Noten, adding to my sense of fashion and day-to-day comfort. I find that when I wear this outfit people of all ages like it and appreciate it.

OWNER, VER UNICA
/
SAN FRANCISCO

NINA KAPLAN,
BIKER BABE

I am a heavy metal maniac and took the Saxon lyrics, "denim and leather, brought us all together, it was you that set the spirit free" very literally, and try to incorporate that free spirit into what I wear. I grew up a blue jean baby and love to incorporate all of my favorite denim eras into my outfits. I love the '60/'70s bells of the jeans I am wearing, which are vintage Levi's, my favorite for fit. I am tall and I also appreciate the short length of these jeans, which flare out just around my ankle. The jacket is a 1960s Lee jacket with Gas Crisis patches on it from the 1970s. I believe the Harley Davidson logo was hand painted on the back, I got this piece from a friend before I embarked on a cross-country motorcycle trip with Harley Davidson in the summer of 2015. The belt and "chaos pouch" are my homage to '80s/'90s denim, as I am a child of the 1980s. I love to represent all the decades this way and mash them up into my outfits. The gloves are denim and leather and were sent to me by an American company called Grifter who are based out of North Carolina. Long live rock and roll!!!!

OCCUPATIONAL THERAPIST/
MOTORCYCLE ENTHUSIAST
/
LOS ANGELES

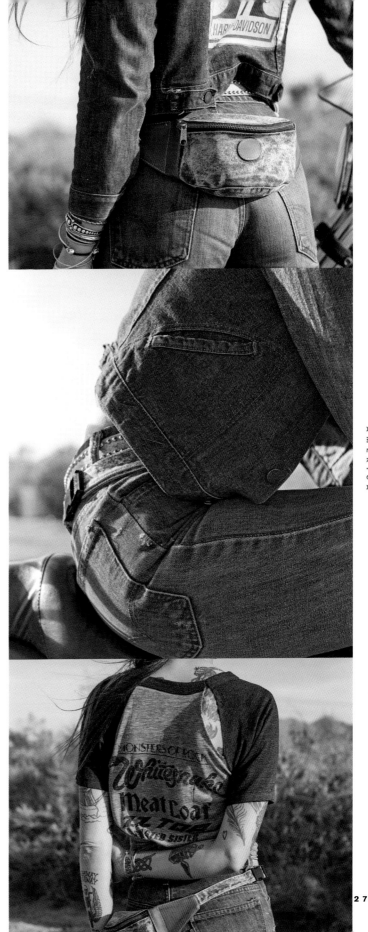

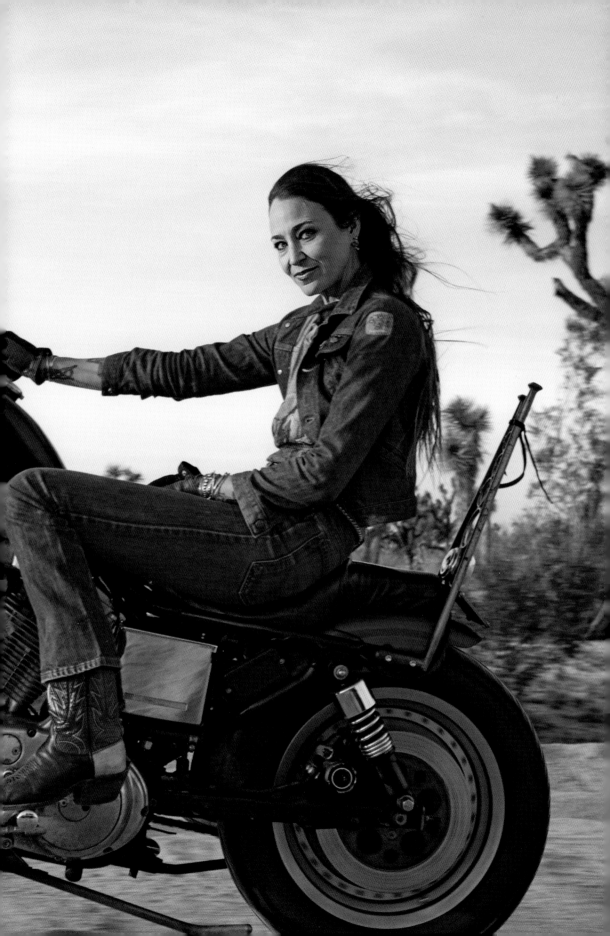

JAYNE MIN,
ECCENTRIC AUTHENTIC

My everyday uniform is some variation of a T-shirt and jeans. Most of the time, it's quite literally a T-shirt and a stock standard pair of jeans (usually Levi's Vintage Clothing men's 603 fit, my holy grail), but on the rare occasion I attempt to "dress up" it will be a T-shirt and, um, more fashion-y jeans. Because I have psychotically high standards in basic denim (100 percent cotton only), I can be more flexible, albeit adventurous, with fashion denim. I err on the side of wacky —Margiela giant overlap front, Dries Van Noten humongous wide leg, or these recent favorites by Y Project, with the stacked, double layered legs. They're weird enough to feel like I'm breaking out of my everyday mold, but still denim at the end of the day, so easy to wear with plain T-shirts and tops, keeping me safely within my casual comfort zone.

CREATIVE DIRECTOR,
STOPITRIGHTNOW
/
LOS ANGELES

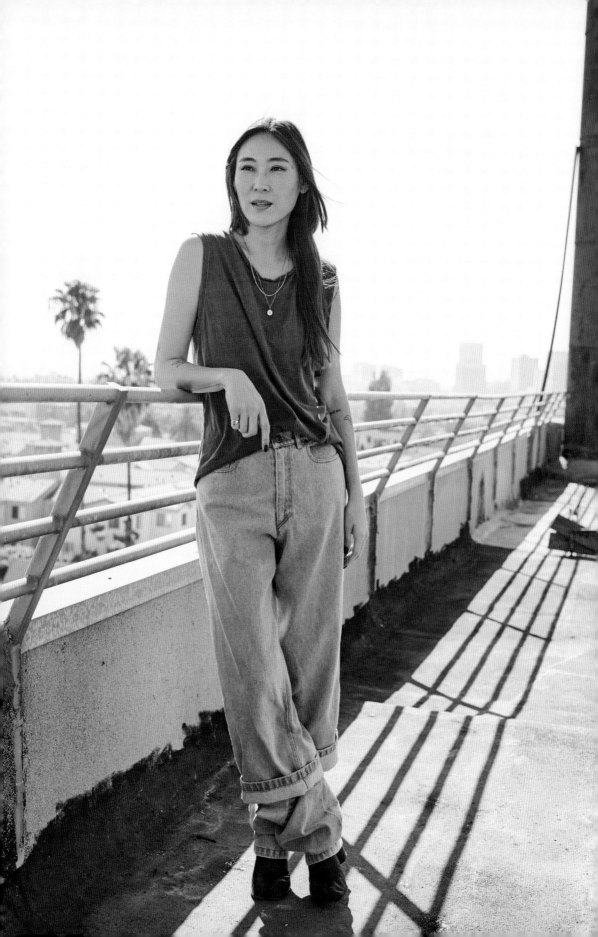

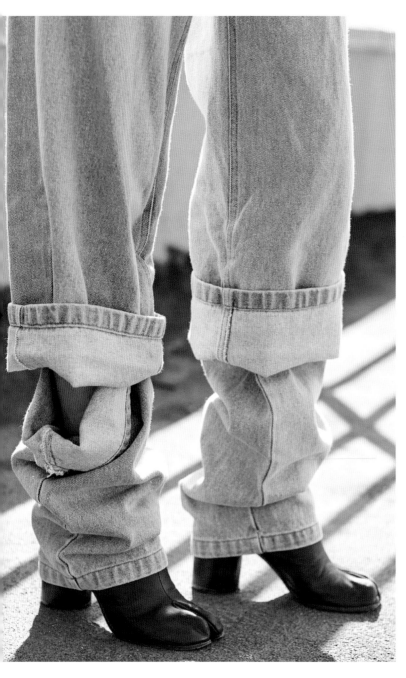
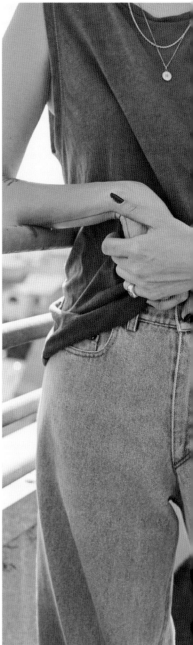

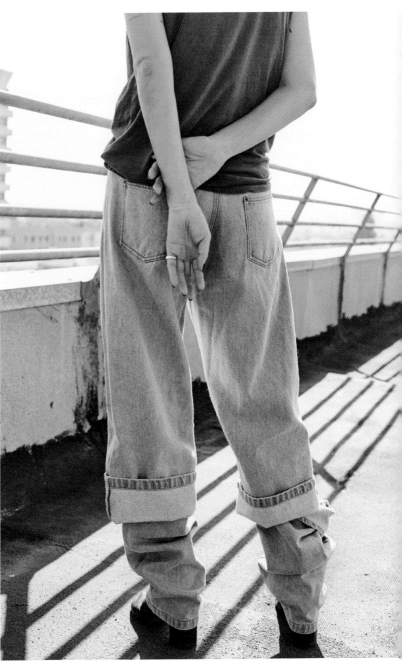

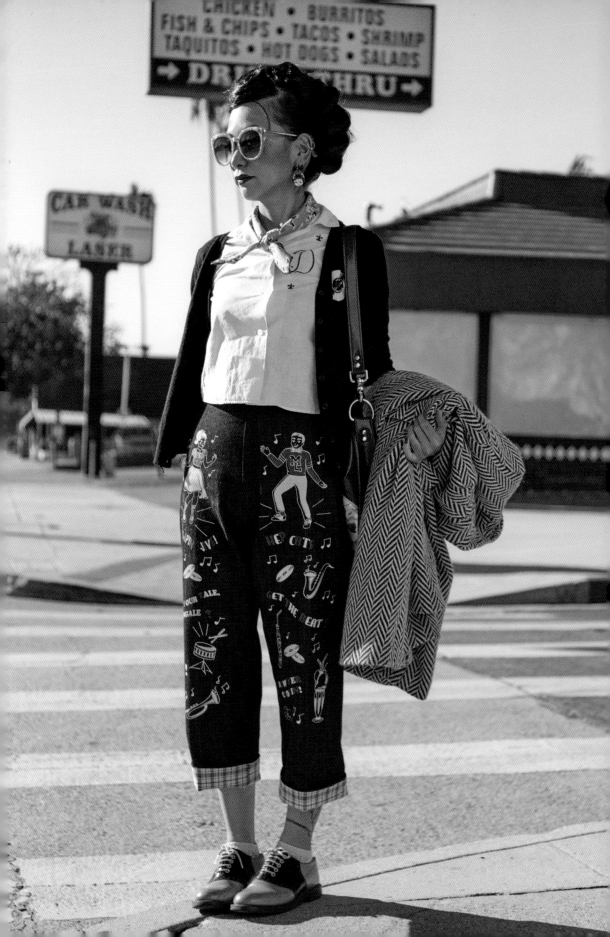

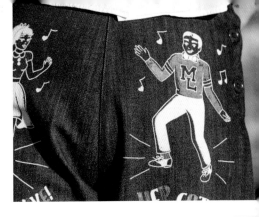

NANA MIURA,
REINVENTED ROCKABILLY

This pair of denim pants is definitely one of my favorite items from my brand, Miss Ladybug. I was inspired by 1940s hand-painted denim pants and was developing an idea of making something fun that would make people want to dance. Then I met a tattooist, Evie from Show Pigeon Tattoo. I fell in love with her artwork and I hit it off with her. We started talking about creating something together and I thought that making this jean was perfect!

The Siamese cat earring, the bandanna, the cardigan, and the coat are all by Miss Ladybug. The purse is another collaboration with Trophy Queen and my brand. I have been a fan of Trophy Queen for over ten years and being able to create something with them is such an honor!

The shoes are a collaboration of Regal and Glad Hand. They complement my denim very well and they're one of my must-have items.

MISS LADYBUG
/
LOS ANGELES

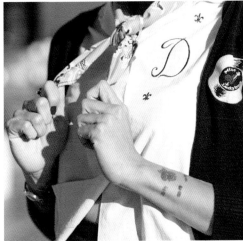

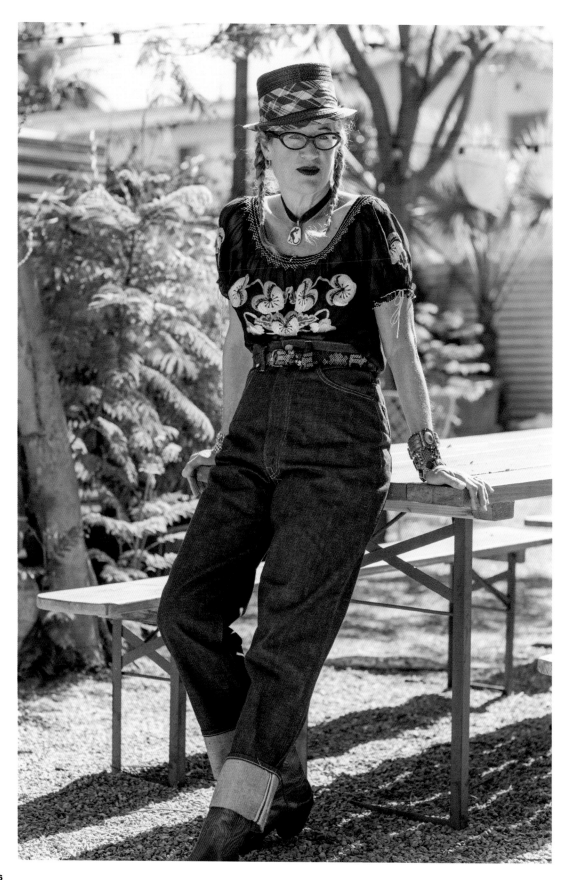

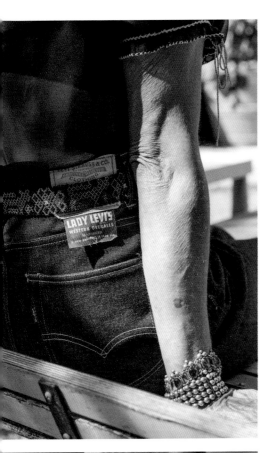

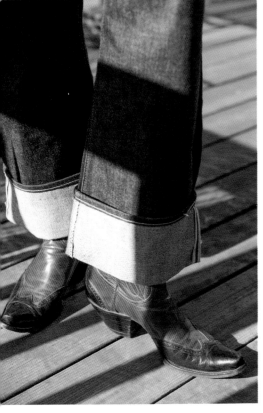

KATHLEEN SCHAAF,
DUDE RANCH DEVOTEE

Compton, California, 1964. My grandmother was taking me ice-skating, but apparently my clothes weren't sturdy enough for skating. She said I needed something tough enough to fall down in, so she took me to the Salvation Army to buy me some old blue jeans. I'd never had a pair of blue jeans before, and buttoning up the fly was weird to me. They were too long so I had to roll them up, and that reminded me of the cowboys in my grandpa's favorite TV show, *Sky King*. Cowboys in the air! How cool!

Funny how one unassuming moment can influence the rest of your life. Today I have the best job in the world; I travel the country shopping for my vintage clothing store. I've owned Meow for over thirty years and I've sold lots of amazing merchandise, but every once in a while I wish I could sneak into the "way back machine" and shop that old Salvation Army.

Regarding personal style, I dress for me, no one else. From rodeo clown to dude ranch divorcée, I say, "Why not?" My style, my way...everyday! That's my fashion voice. My jeans are deadstock "Lady Levi's" '50s 701's with coffee can cuffs, and original tags. I found them hiding on a dusty stockroom shelf in a long-forgotten dry goods store in Arizona way back in the '80s. My cowboy boots are from the '40s and feature custom two-toned leather with bulldog heels. My blouse, belt, and jewelry are all Mexican tourist goods from the 1950s. The blouse is rayon and features embroidered pansies, and the belt has beaded cats on it. My hat is a '60s stingy brim with a madras band and bow.

My "reduce, reuse, and recycle" mind-set has kept me from buying "regular" retail for some time. As a matter of fact, I haven't purchased a lot of retail clothing items since the '70s . Talk about "Make do and mend."

OWNER, MEOW VINTAGE CLOTHING
/
LONG BEACH

FLORENCE TANG,
CONTEMPORARY CUSTOM

The beauty of denim to me is the adaptability it has to every situation, time, and person. Not only can it communicate history but it can also describe the wearer in how he or she chooses to style and pair this functional and timeless fabric. I always prefer the juxtaposition of old and new as it keeps things fun and interesting. The jeans I am wearing are vintage selvedge 501s I found rummaging through a rag mill; they have been repaired countless times and custom tapered. The type III is another gem I found at the flea—it is actually a vintage kids piece that I customized with a Pegasus chain-stitched patch inspired by a vintage Hermès pattern. That patch was one of the first back pieces I made and still love dearly even after ten hours of physical labor. Finally, my boots are from Givenchy, hat from Janessa Leone, tank from Theory.

DESIGNER/COFOUNDER,
LOT, STOCK AND BARREL
/
LOS ANGELES

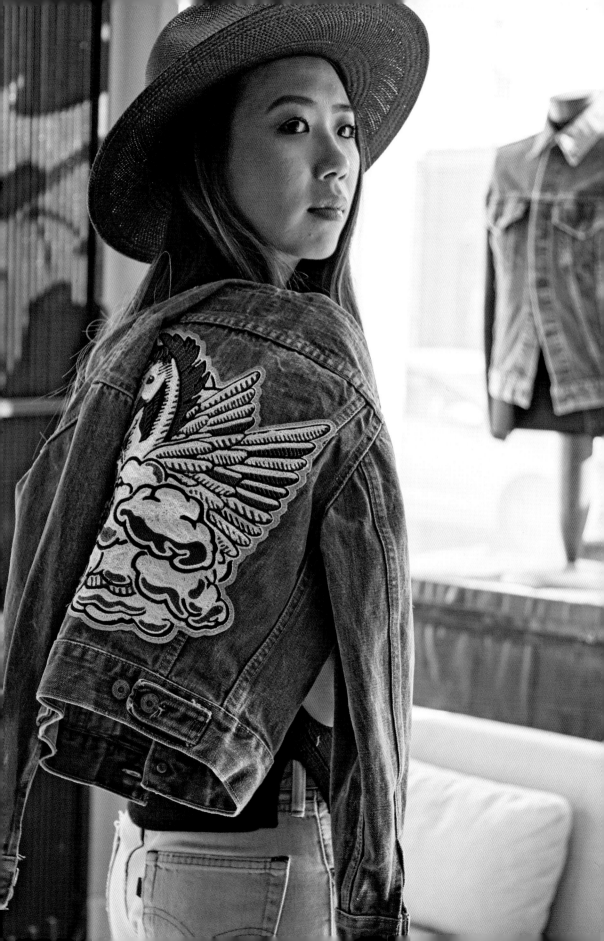

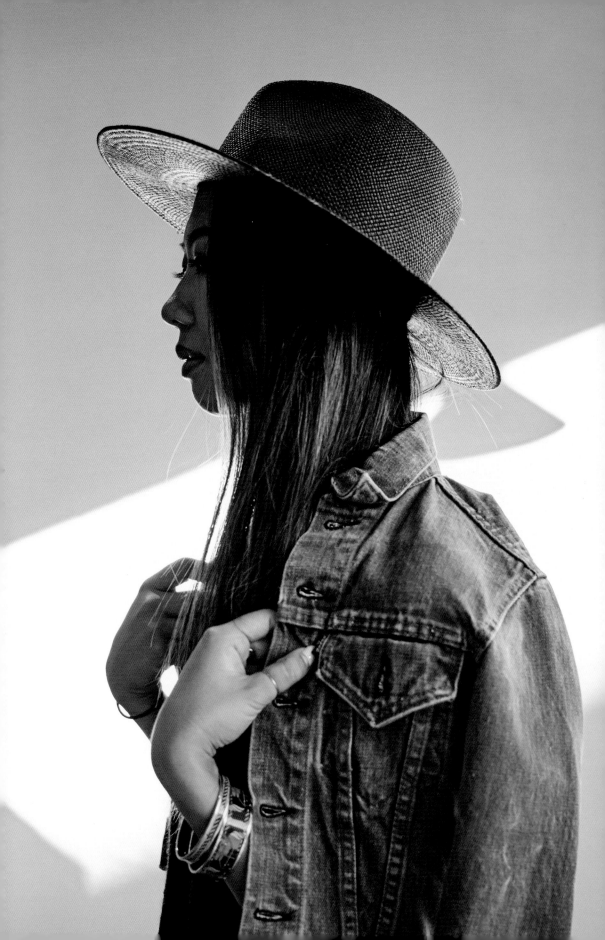

LIZ BACA,
BIG-FIT THRIFTER

Some things we outgrow, maybe they're no longer "age appropriate" or we just aren't into them anymore . . . but a good pair of jeans work at any age or work with any mood you might find yourself in. I may no longer wear cutesy ruffled dresses and Mary Jane shoes as I did as a kid but I still wear jeans.

I followed a jean trend or two (or three) in my life but regardless of the era, a good pair of jeans has always been a mainstay in my wardrobe. At this age my main focus is comfort. There is nothing more comfortable than an oversize chambray shirt. I have so many. They're like a cardigan or a good zip hoodie to me. This one happens to be vintage '90s Versace Jeans, complete with Medusa heads. I'm certain I'll wear it till it's as shredded as my jeans. The jeans are 1950s Levi's 501 big E's with all the bells and whistles....and picked up at a perfect price: a quarter. I could take you right to the house in my hometown of Alameda, California where I purchased them at a yard sale many, many years ago. They belonged to the women's father, they were his work jeans as were the two pairs of selvedge Lee jeans I also picked up. The T-shirt is a crazy airbrushed piece of art dated 1991. My neon socks came from my first trip to Japan in 1998. The sandals are also vintage and weigh about one pound each due to the tire tread soles. The fanny pack is cheap and cheerful '90s goodness and the jewels are various vintage bits of things I love spanning many decades. My best accessory though is my best furry friend and denim dog, Boo Boo. He's a one-eyed bundle of love and affection and although we adopted him, I'm most certain he picked us. He never leaves home without his denim shoe bed. Denim dog and dudette for life.

WARDROBE STYLIST/
VINTAGE CLOTHING DEALER
/
OAKLAND

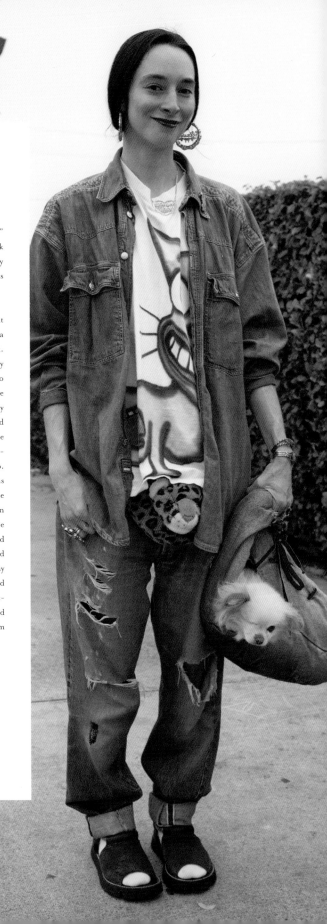

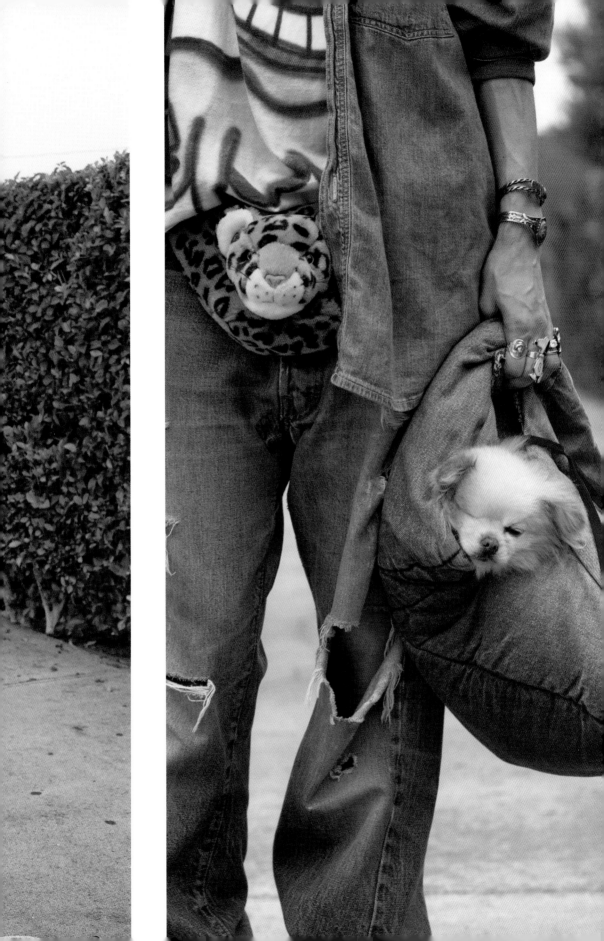

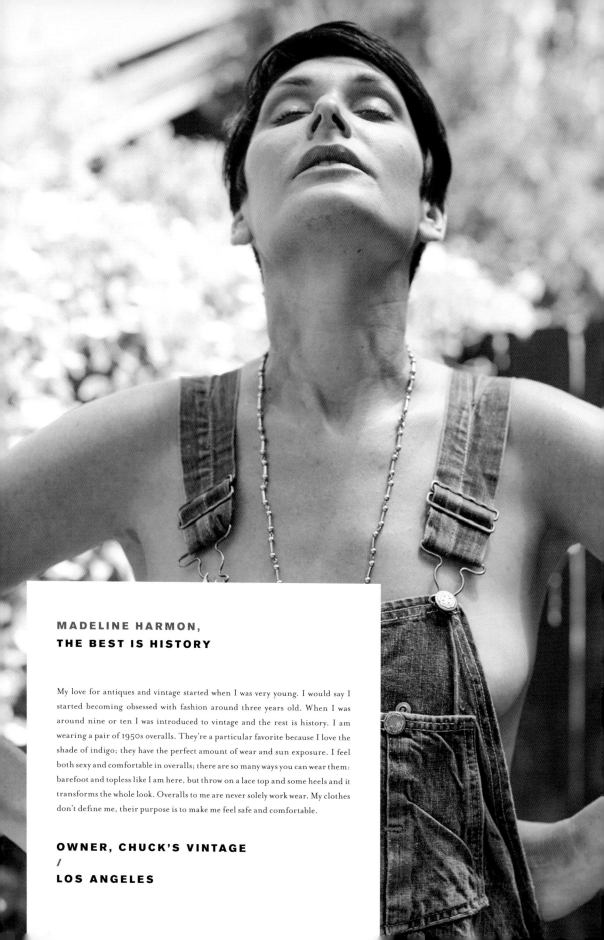

MADELINE HARMON,
THE BEST IS HISTORY

My love for antiques and vintage started when I was very young. I would say I started becoming obsessed with fashion around three years old. When I was around nine or ten I was introduced to vintage and the rest is history. I am wearing a pair of 1950s overalls. They're a particular favorite because I love the shade of indigo; they have the perfect amount of wear and sun exposure. I feel both sexy and comfortable in overalls; there are so many ways you can wear them: barefoot and topless like I am here, but throw on a lace top and some heels and it transforms the whole look. Overalls to me are never solely work wear. My clothes don't define me, their purpose is to make me feel safe and comfortable.

OWNER, CHUCK'S VINTAGE
/
LOS ANGELES

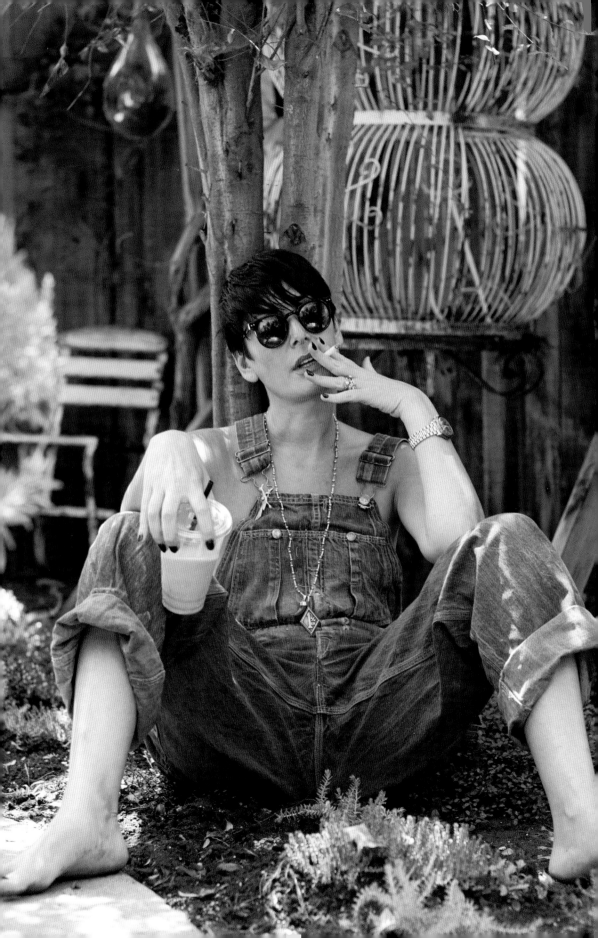

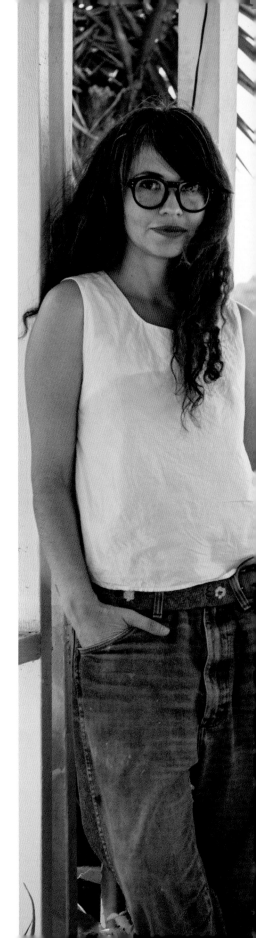

ERIN BARAJAS,
ALTERNATIVE UNIFORM

I am wearing, essentially, my uniform. A nothing white tank and old jeans. To me, old jeans require a bit more effort to find and a bit more effort to achieve that perfect fit—but once you've succeeded, there is literally no more effort. A kick-ass pair of vintage jeans requires almost nothing else and communicates much more about your personal style than any pair of jeans designed to make your ass look amazing.

These jeans are vintage Wranglers I found in a secret warehouse in Vernon. It is the kind of place that only denim people find magical. It is dirty and dark and smells so bad and you could get buried under a ten-foot pile of army boots—or you could find a gem like these Wranglers. They are enormous, they are stained, the back pocket has a wear pattern that is clearly from a snuff tin, they have a hole in the crotch and cigarette burns on the legs—and they are perfect. So soft and heavy and comfortable.

I wear these jeans when I really should be wearing something more presentable, I wore them for the duration of my pregnancy, I wear them while hunting for new old pairs of jeans and I wear them chasing after my kid.

DIRECTOR, KINGPINS SHOW
/
LOS ANGELES

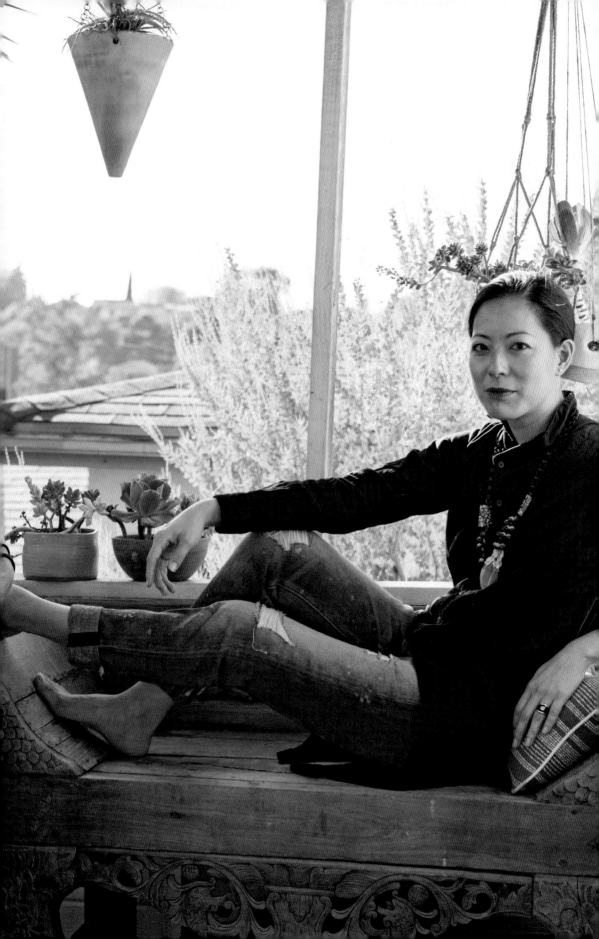

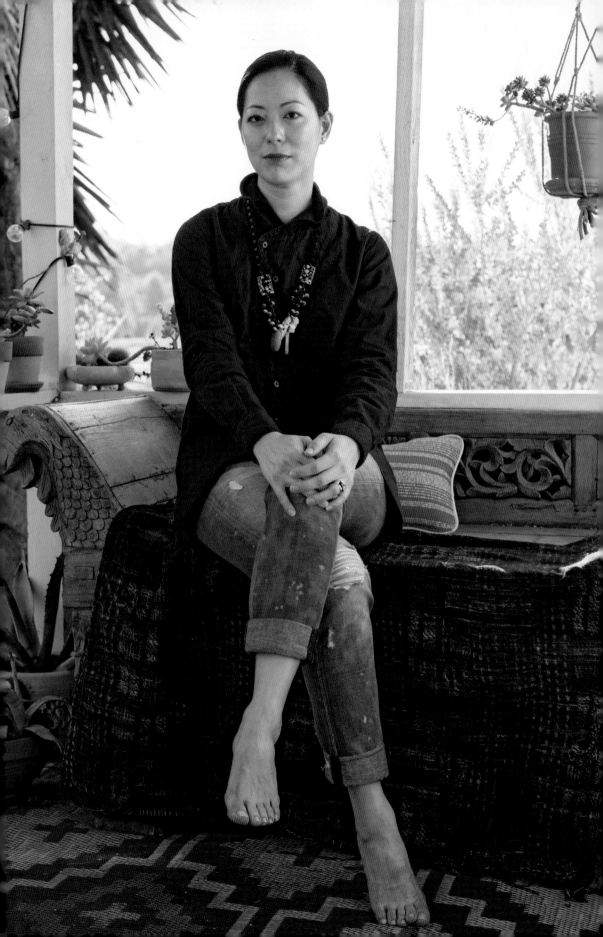

VIVIAN WANG,
INDIGO INNOVATOR

I bought my shirt from Kapital in Japan during my first trip there. The jeans are my favorite pair, from Rag & Bone. Together, they represent what I love about denim—heritage, creativity, comfort and craftsmanship.

Denim to me is more than what I wear every day. It has become a career and also a lifestyle—it influences everything from the cities I travel to and work in to what my home looks like (even my couch is denim!)

I first fell in love with denim a couple years out of college when I went to work for my mentor, Adriano Goldschmied. His passion for the industry is contagious and I was hooked. Now my job is to create environments for people in the denim industry to get together to work, learn, build community, and share ideas. I feel lucky to be surrounded by creative people who work to preserve the heritage of denim and also innovate to make it better.

MANAGING DIRECTOR,
KINGPINS SHOW
/
LOS ANGELES

JAMIE WONG
THE BUDDY-LEE BLUES

The clothes I like the most are clothes that bleed stories. The working class of the late 1800s and early 1900s usually could only afford one outfit. They were worn over and over and repaired again and again. That's what I love about vintage, a lot of love and time was put into maintaining each piece, The overalls I'm wearing are Bartel Company lowbacks, complete with original patching, repairs, and added suspender straps. A good, worn-in white tee is a staple in my daily wear; they are soft and comfortable and go with everything. The hat is one of my favorite pieces, it's very special to me. I got it from the original owner who wore it everyday working at or riding in rodeos. My Buddy Lee collection is slowly growing but I love these little guys. They bring a good energy to my shop and they add to the history I'm projecting to my audience.

OWNER, RAGGEDY THREADS
/
LOS ANGELES

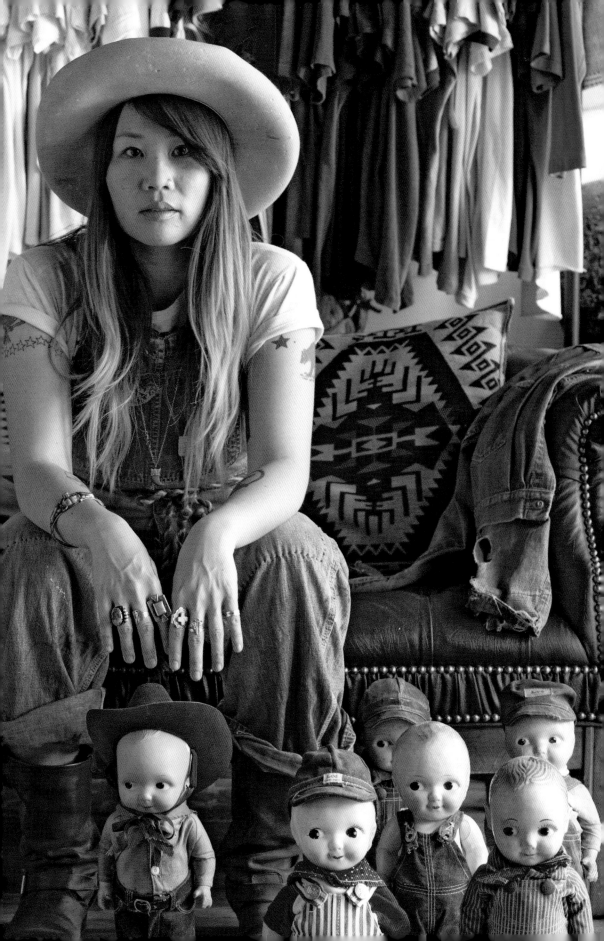

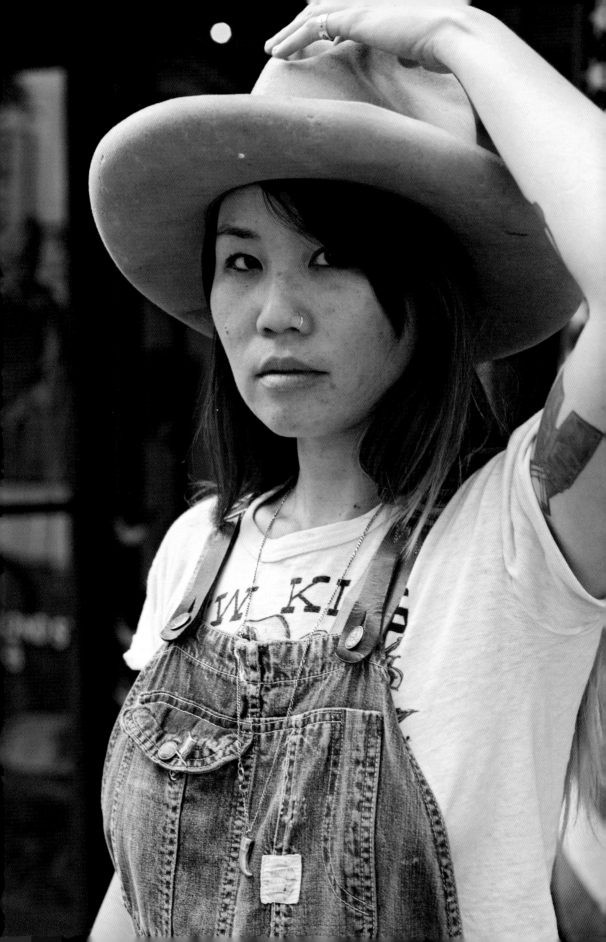

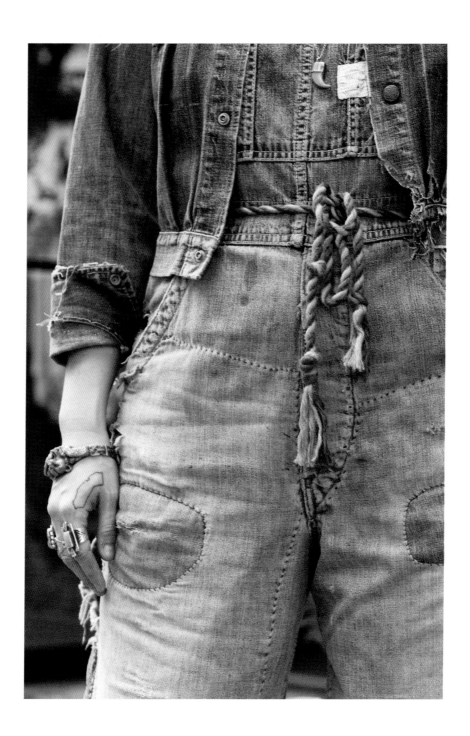

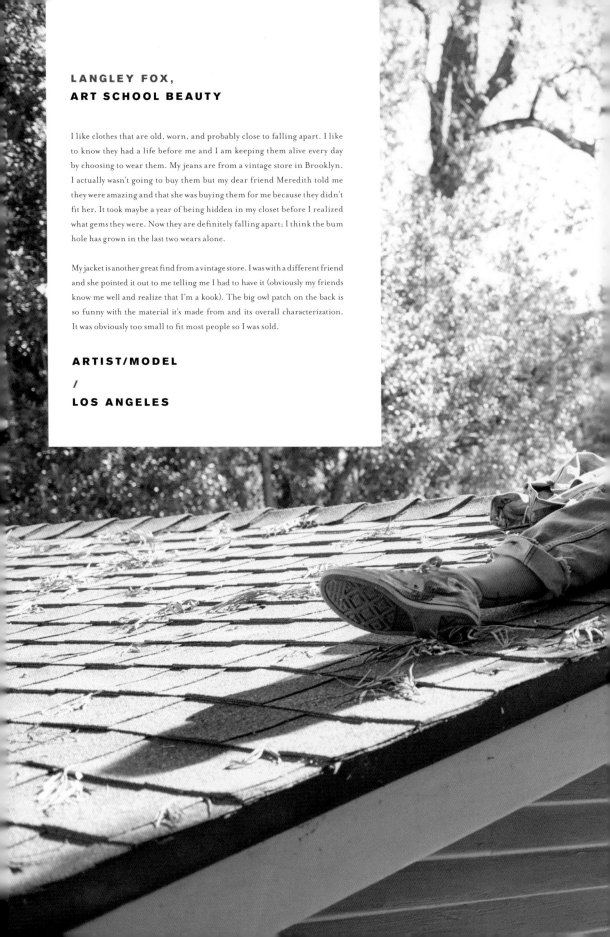

LANGLEY FOX,
ART SCHOOL BEAUTY

I like clothes that are old, worn, and probably close to falling apart. I like to know they had a life before me and I am keeping them alive every day by choosing to wear them. My jeans are from a vintage store in Brooklyn. I actually wasn't going to buy them but my dear friend Meredith told me they were amazing and that she was buying them for me because they didn't fit her. It took maybe a year of being hidden in my closet before I realized what gems they were. Now they are definitely falling apart; I think the bum hole has grown in the last two wears alone.

My jacket is another great find from a vintage store. I was with a different friend and she pointed it out to me telling me I had to have it (obviously my friends know me well and realize that I'm a kook). The big owl patch on the back is so funny with the material it's made from and its overall characterization. It was obviously too small to fit most people so I was sold.

ARTIST/MODEL
/
LOS ANGELES

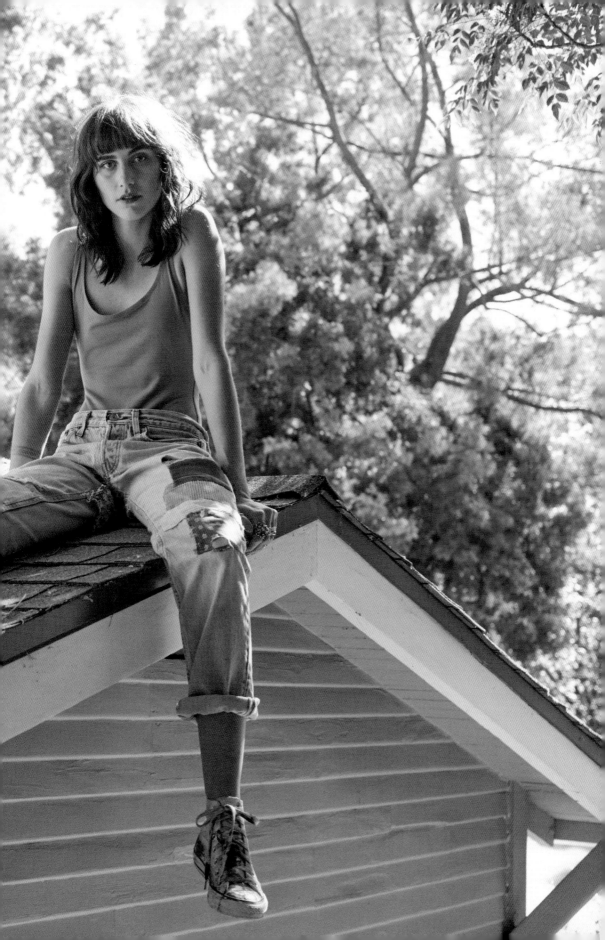

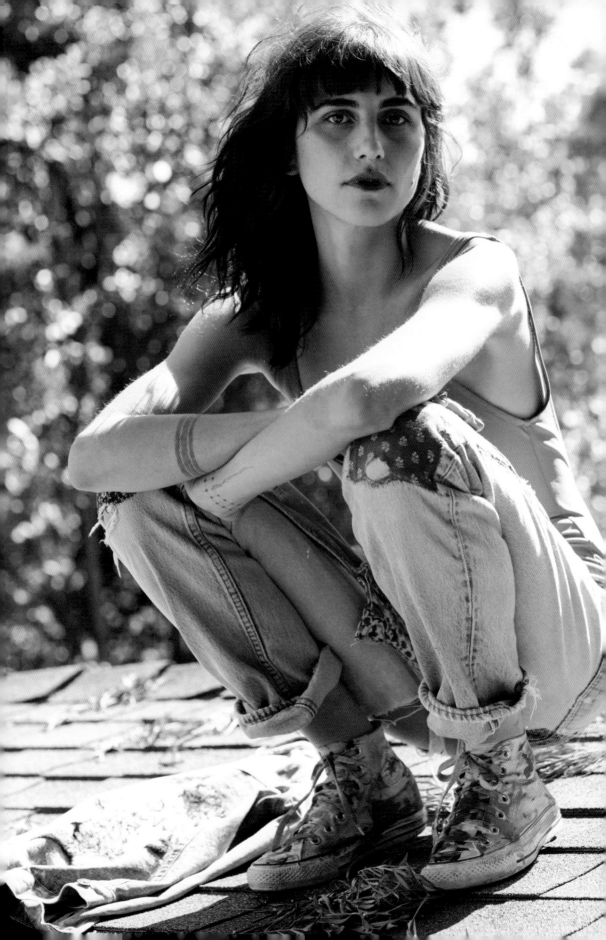

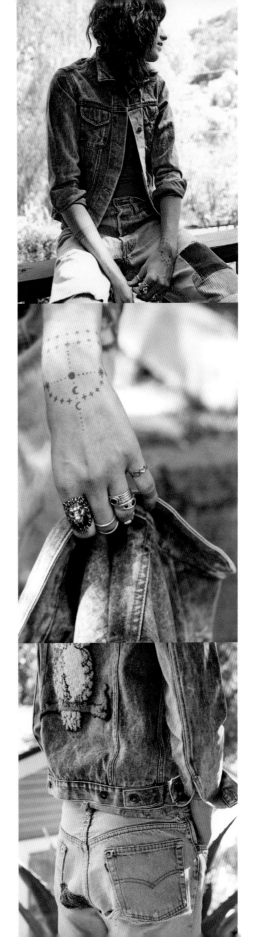

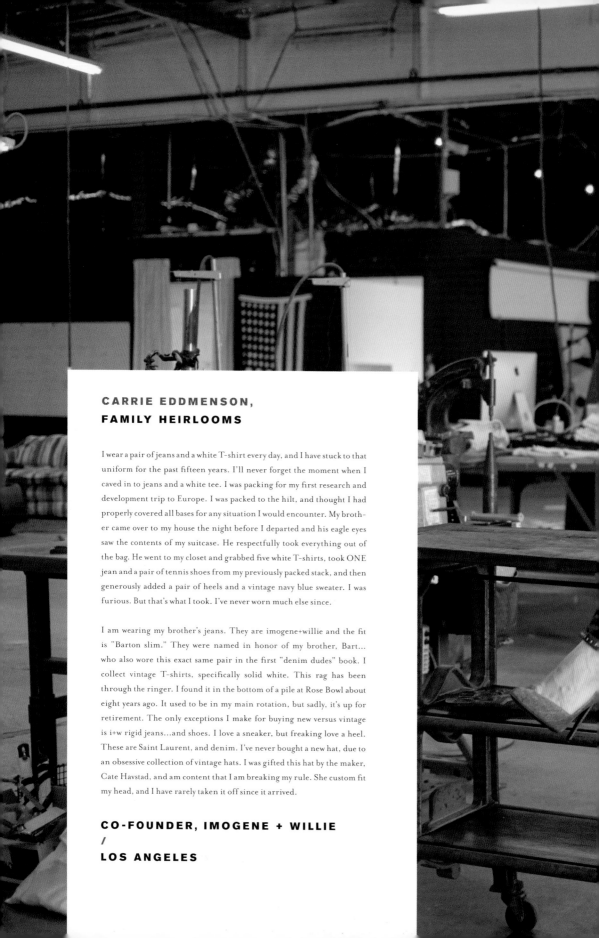

CARRIE EDDMENSON,
FAMILY HEIRLOOMS

I wear a pair of jeans and a white T-shirt every day, and I have stuck to that uniform for the past fifteen years. I'll never forget the moment when I caved in to jeans and a white tee. I was packing for my first research and development trip to Europe. I was packed to the hilt, and thought I had properly covered all bases for any situation I would encounter. My brother came over to my house the night before I departed and his eagle eyes saw the contents of my suitcase. He respectfully took everything out of the bag. He went to my closet and grabbed five white T-shirts, took ONE jean and a pair of tennis shoes from my previously packed stack, and then generously added a pair of heels and a vintage navy blue sweater. I was furious. But that's what I took. I've never worn much else since.

I am wearing my brother's jeans. They are imogene+willie and the fit is "Barton slim." They were named in honor of my brother, Bart... who also wore this exact same pair in the first "denim dudes" book. I collect vintage T-shirts, specifically solid white. This rag has been through the ringer. I found it in the bottom of a pile at Rose Bowl about eight years ago. It used to be in my main rotation, but sadly, it's up for retirement. The only exceptions I make for buying new versus vintage is i+w rigid jeans...and shoes. I love a sneaker, but freaking love a heel. These are Saint Laurent, and denim. I've never bought a new hat, due to an obsessive collection of vintage hats. I was gifted this hat by the maker, Cate Havstad, and am content that I am breaking my rule. She custom fit my head, and I have rarely taken it off since it arrived.

CO-FOUNDER, IMOGENE + WILLIE
/
LOS ANGELES

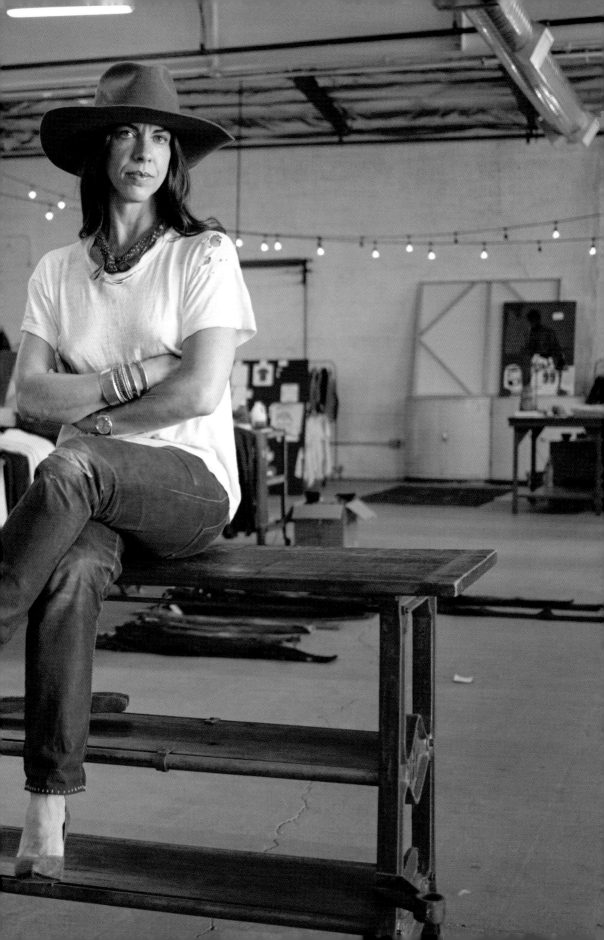

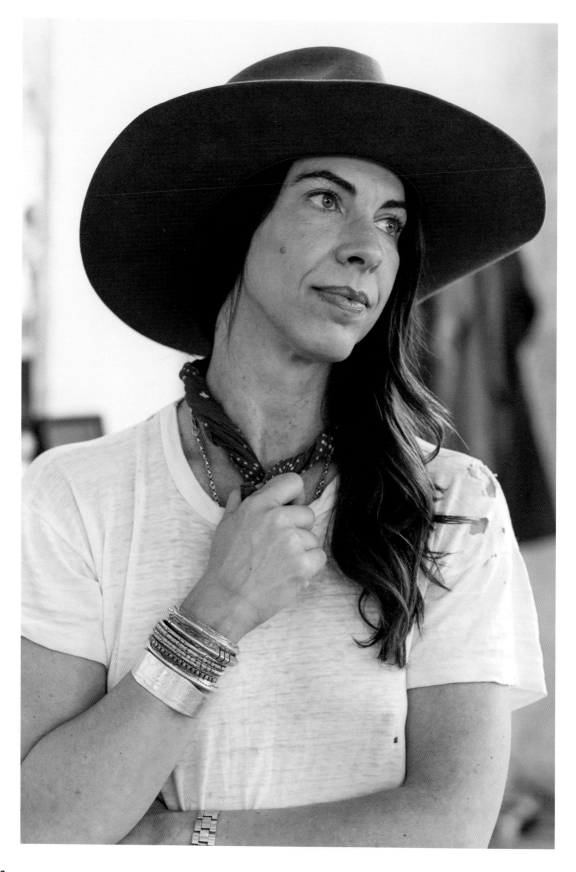

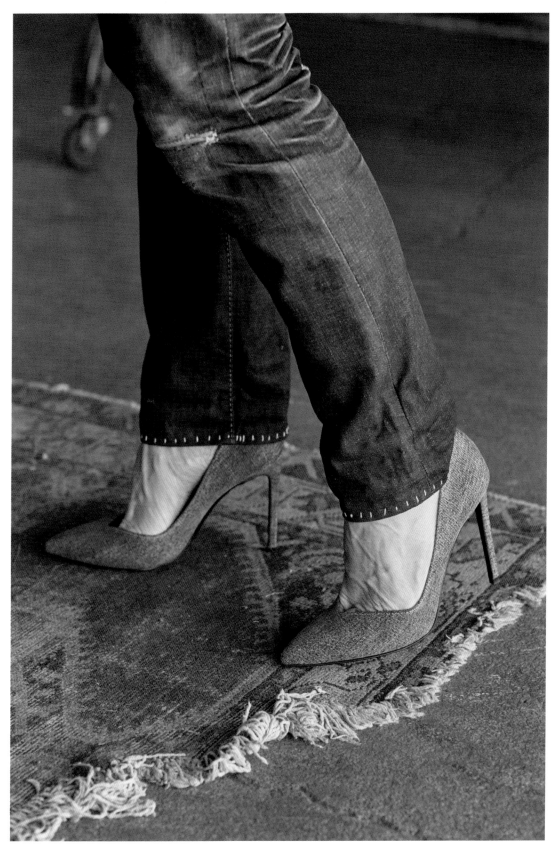

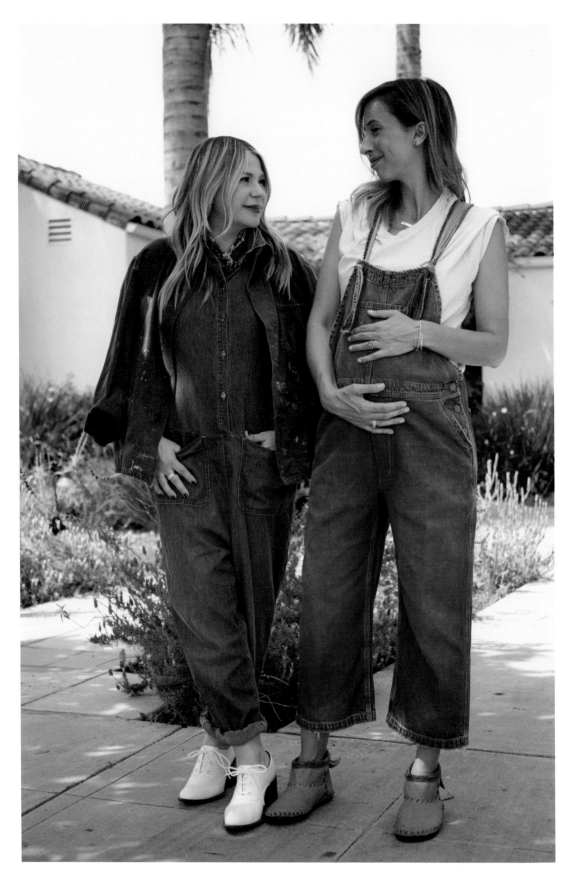

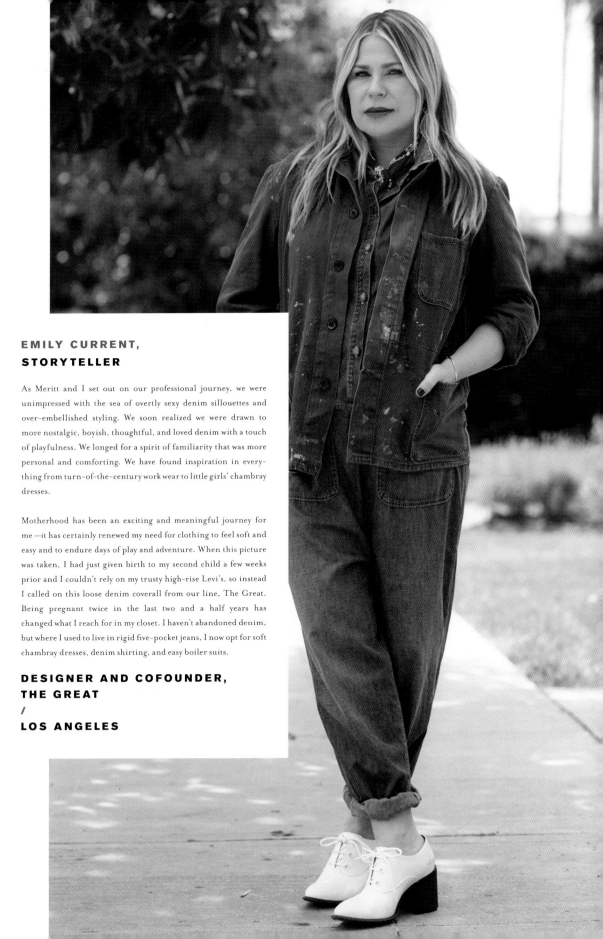

EMILY CURRENT,
STORYTELLER

As Meritt and I set out on our professional journey, we were unimpressed with the sea of overtly sexy denim sillouettes and over-embellished styling. We soon realized we were drawn to more nostalgic, boyish, thoughtful, and loved denim with a touch of playfulness. We longed for a spirit of familiarity that was more personal and comforting. We have found inspiration in everything from turn-of-the-century work wear to little girls' chambray dresses.

Motherhood has been an exciting and meaningful journey for me —it has certainly renewed my need for clothing to feel soft and easy and to endure days of play and adventure. When this picture was taken, I had just given birth to my second child a few weeks prior and I couldn't rely on my trusty high-rise Levi's, so instead I called on this loose denim coverall from our line, The Great. Being pregnant twice in the last two and a half years has changed what I reach for in my closet. I haven't abandoned denim, but where I used to live in rigid five-pocket jeans, I now opt for soft chambray dresses, denim shirting, and easy boiler suits.

DESIGNER AND COFOUNDER,
THE GREAT
/
LOS ANGELES

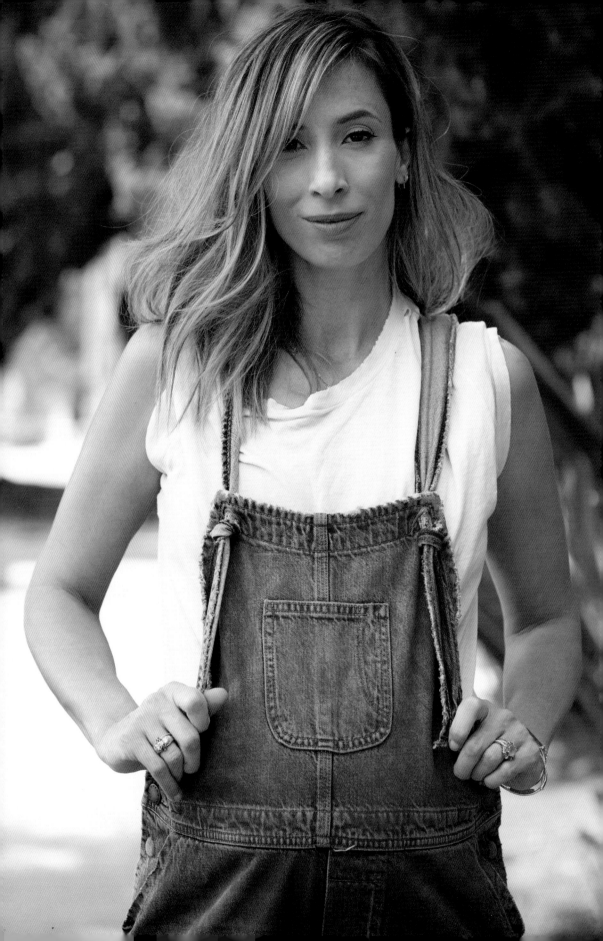

MERITT ELLIOTT,
EFFORTLESS EASE

Emily and I met as teenagers and realized we shared not only a love of vintage Levi's 646's but a yearning for denim that possessed effortlessness and ease. Through the years we have come to fancy ourselves as storytellers—and to imagine denim as the main character, the star of our narrative.

Over the years, my job has become multifaceted and my lifestyle has changed to include kids. I've found that what makes a denim moment especially captivating is when a girl is feeling most comfortable and at home in her jeans. Emily and I like to explore denim as a medium outside of the traditional five-pocket jean. In these photos, I'm six-months pregnant with my third child and have found that I feel most myself—and most creative—in a loose denim dress. This nostalgic ease is what we try to evoke in our line, The Great. We're designing clothes for the woman who loves denim and giving her a way to wear it through all aspects of her life.

DESIGNER AND COFOUNDER,
THE GREAT
/
LOS ANGELES

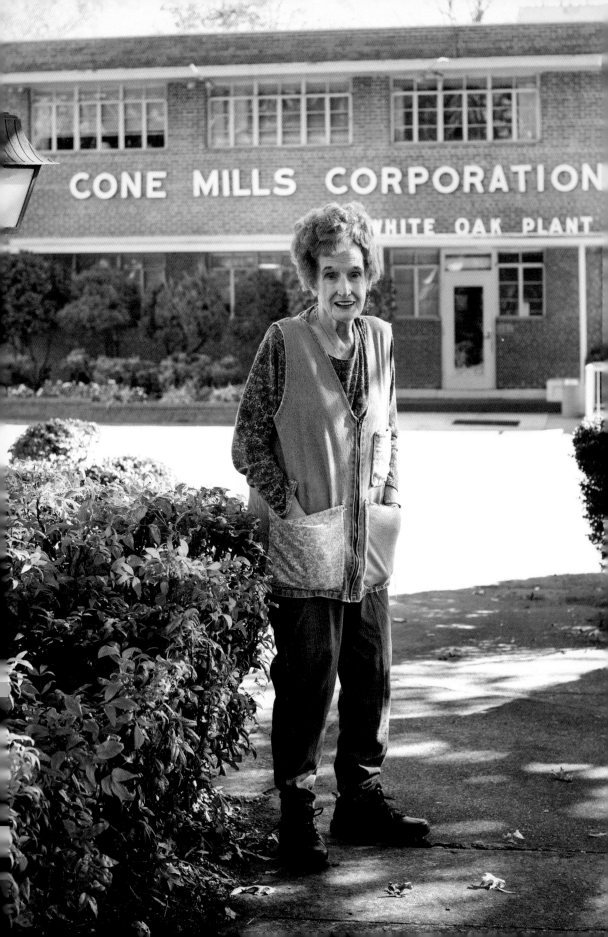

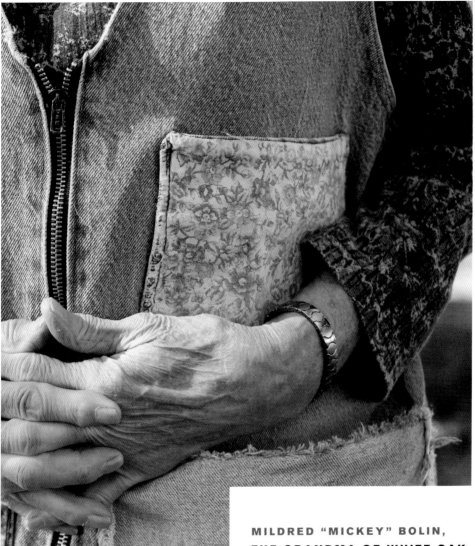

MILDRED "MICKEY" BOLIN,
THE GRANDMA OF WHITE OAK

I worked for Cone for fifty-five years, two months, and twenty-four days and specialized in the White Oak American Draper x-3 model shuttle looms. I retired on June 22, 2014, and if I were able to I would still be here weaving. I'm wearing the apron vest I worked in: a lady in Winston, Salem made it for me; she did sewing on the side. The pockets were doubled to make it last longer. I have worn this particular vest for at least seven years and it's now part of the Cone Denim archives and has a home at White Oak's Archive + Design studio. I am wearing Lee jeans simply because they are not expensive. This pair is about six or seven years old and I wore them to work at White Oak all this time. I'm also carrying a Reed Hook, scissors and pouch that I got from White Oak and have had at least ten years.

X-3 WEAVER, CONE DENIM
/
GREENSBORO

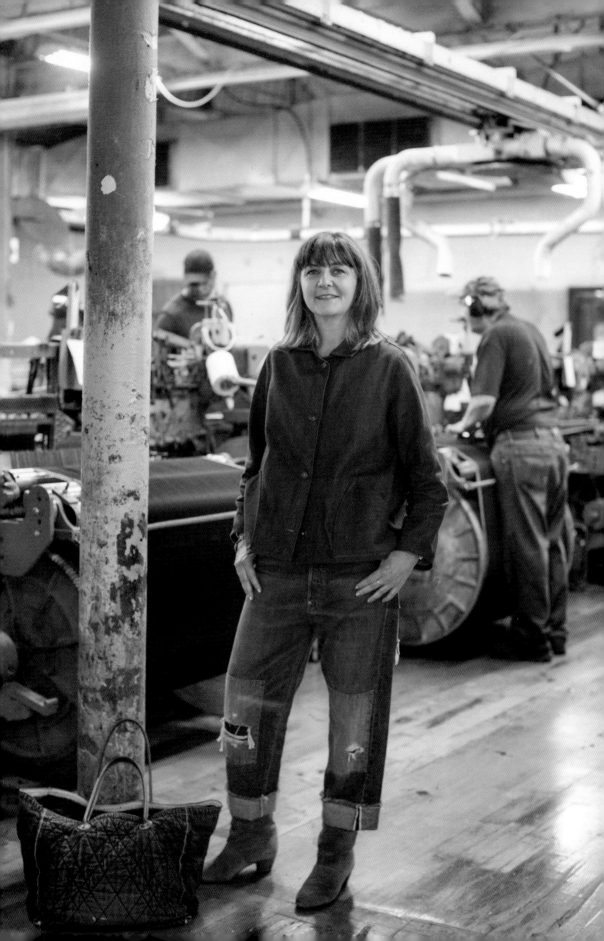

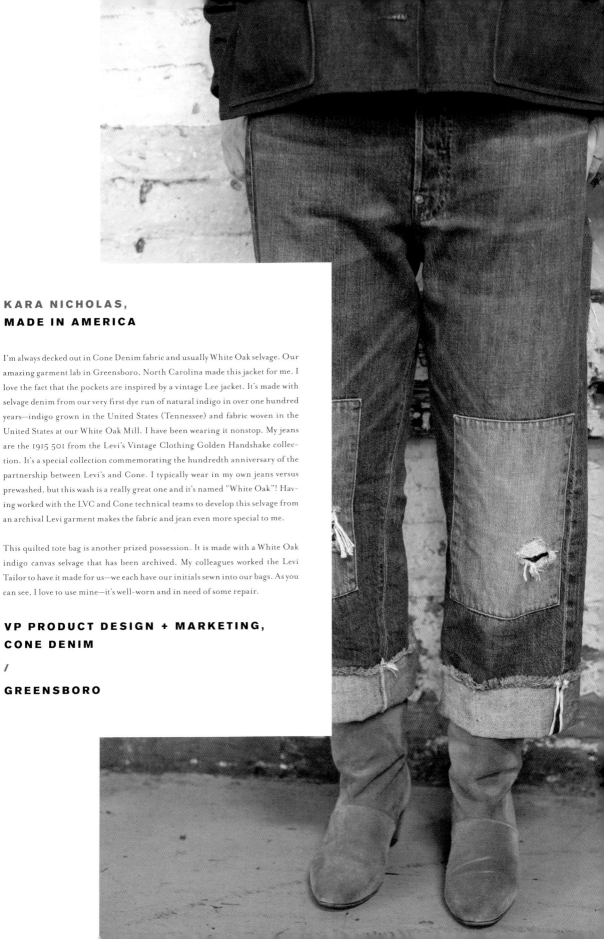

KARA NICHOLAS,
MADE IN AMERICA

I'm always decked out in Cone Denim fabric and usually White Oak selvage. Our amazing garment lab in Greensboro, North Carolina made this jacket for me. I love the fact that the pockets are inspired by a vintage Lee jacket. It's made with selvage denim from our very first dye run of natural indigo in over one hundred years—indigo grown in the United States (Tennessee) and fabric woven in the United States at our White Oak Mill. I have been wearing it nonstop. My jeans are the 1915 501 from the Levi's Vintage Clothing Golden Handshake collection. It's a special collection commemorating the hundredth anniversary of the partnership between Levi's and Cone. I typically wear in my own jeans versus prewashed, but this wash is a really great one and it's named "White Oak"! Having worked with the LVC and Cone technical teams to develop this selvage from an archival Levi garment makes the fabric and jean even more special to me.

This quilted tote bag is another prized possession. It is made with a White Oak indigo canvas selvage that has been archived. My colleagues worked the Levi Tailor to have it made for us—we each have our initials sewn into our bags. As you can see, I love to use mine—it's well-worn and in need of some repair.

VP PRODUCT DESIGN + MARKETING,
CONE DENIM

/

GREENSBORO

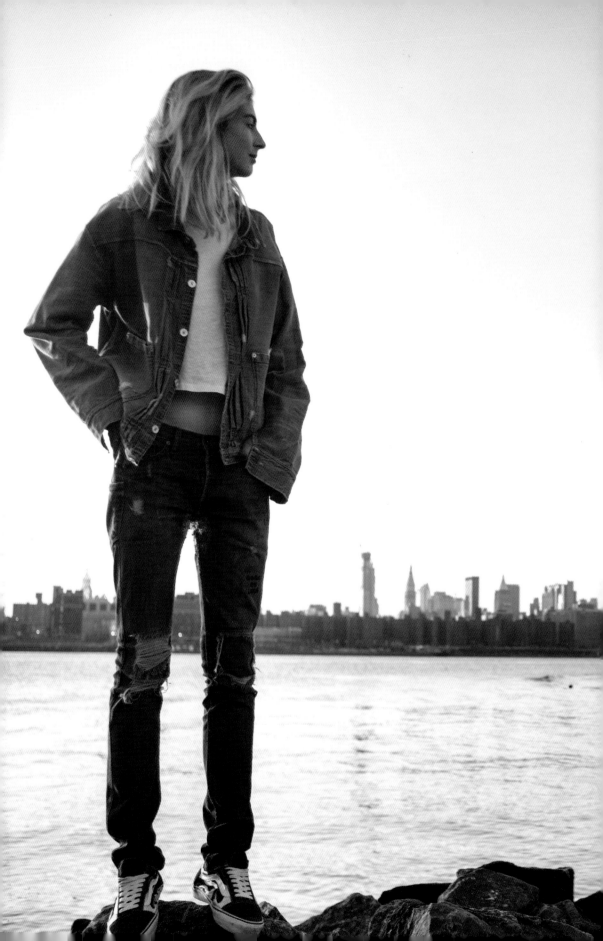

KELLY CONNOR,
PUNKED PURIST

I really never thought I could love a denim reproduction the way that I love my vintage. This jacket, however, is incredibly special. It is the 1880 triple pleat blouse, based off of Levi's oldest and earliest denim jacket. I had the pleasure of collaborating with the Levi's team about a year ago and got to explore their San Francisco archives where I fell in love with the original archival jacket. It was worn by a miner, showing wear and abrasion from operating heavy machinery and its iconic pleats were designed to allow for expansion by clipping the threads…today they allow me to be swaddled in perfectly washed 9-oz Cone Mills Loomstate denim. Heaven, essentially.

These jeans…! They are a collaboration between two of my very dear friends at The/End and Blackfist. Actually, these jeans are probably the reason that we are friends…a friendship so raw that it quite literally (and as indicated on the left thigh) "hurts so good." They are called "Jodie's jeans"— inspired by a photo of Brian Brannon of JFA (Jodie Foster's Army) screaming in to a microphone in incredibly beat-up filthy Levi's—an iconic image that defines the '80s SoCal skate punk scene that I grew up obsessed with in San Diego. I am wearing them with my favorite '80s deadstock Vans and my vintage Hanes tee.

Side note—in case you thought I was a Smurf, my hands are stained blue because I spent the morning dyeing white selvedge denim at Buaisou, this incredible traditional Japanese indigo studio out in Bushwick. While indigo dye miraculously does not bleed, it certainly stains. I was dunked in indigo dye when I went to Levi's Eureka lab and had indigo blue hair for a moment, too.

VOGUE.COM MARKET EDITOR
/
BROOKLYN

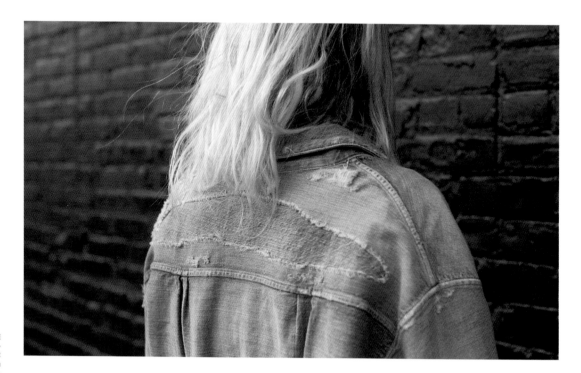

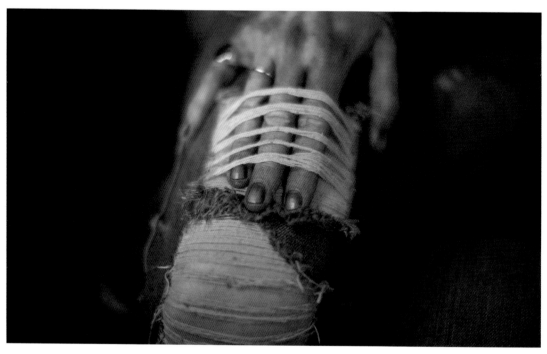

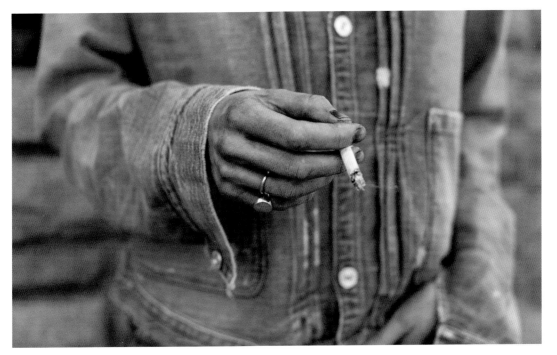

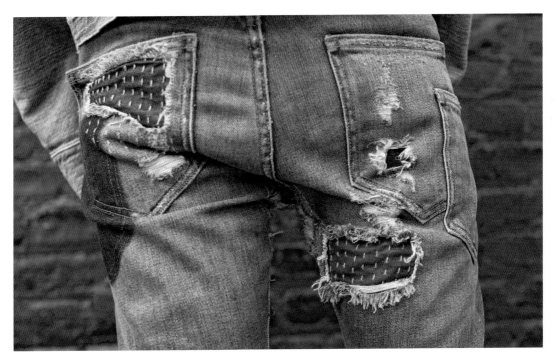

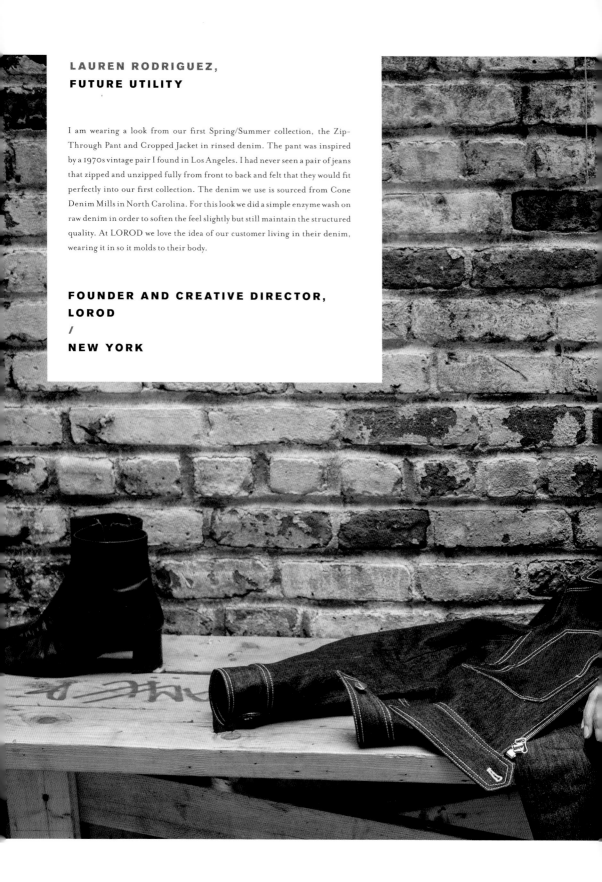

LAUREN RODRIGUEZ,
FUTURE UTILITY

I am wearing a look from our first Spring/Summer collection, the Zip-Through Pant and Cropped Jacket in rinsed denim. The pant was inspired by a 1970s vintage pair I found in Los Angeles. I had never seen a pair of jeans that zipped and unzipped fully from front to back and felt that they would fit perfectly into our first collection. The denim we use is sourced from Cone Denim Mills in North Carolina. For this look we did a simple enzyme wash on raw denim in order to soften the feel slightly but still maintain the structured quality. At LOROD we love the idea of our customer living in their denim, wearing it in so it molds to their body.

FOUNDER AND CREATIVE DIRECTOR, LOROD
/
NEW YORK

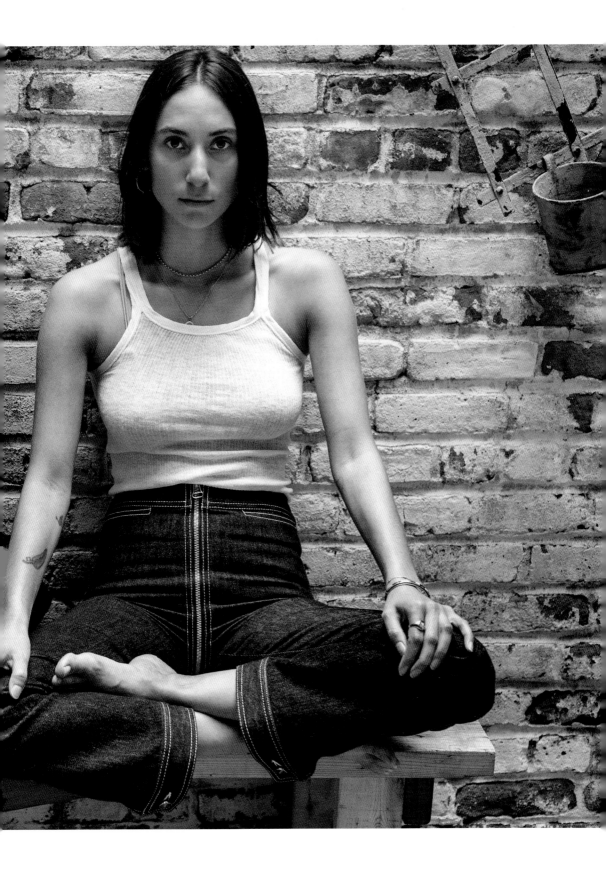

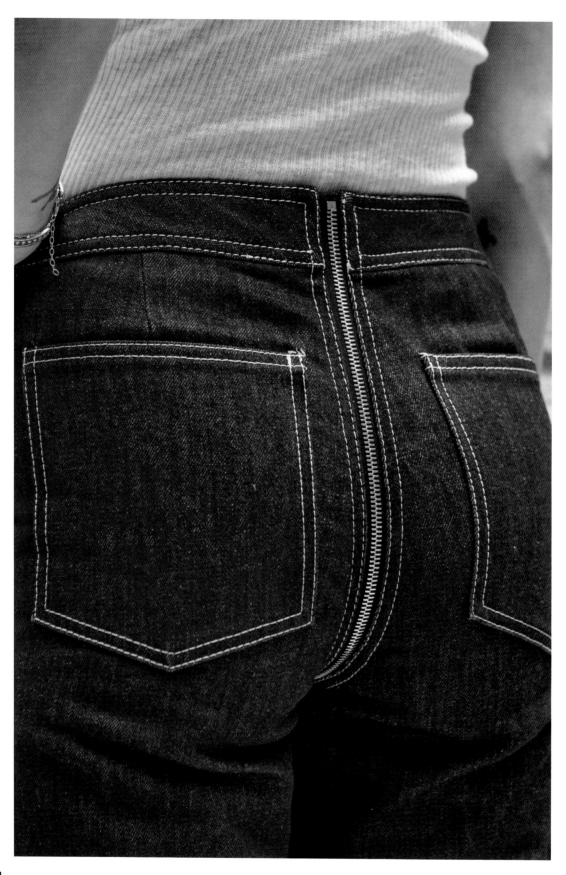

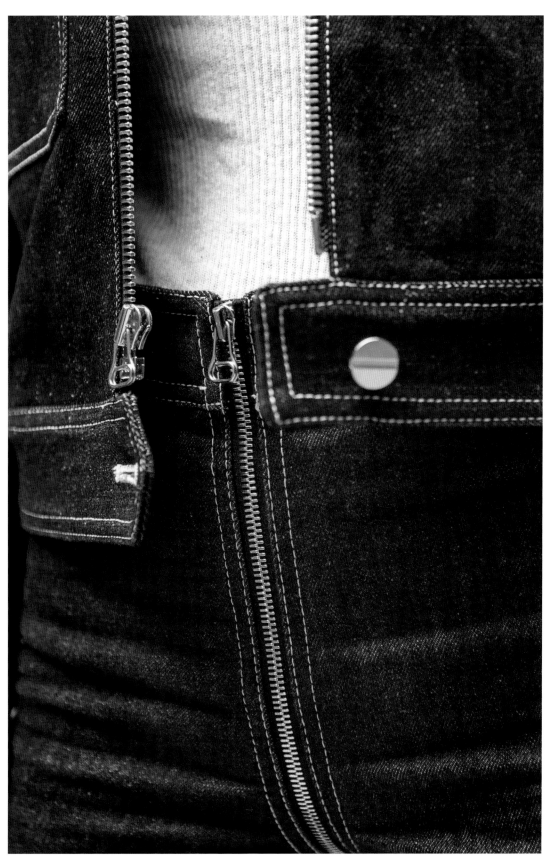

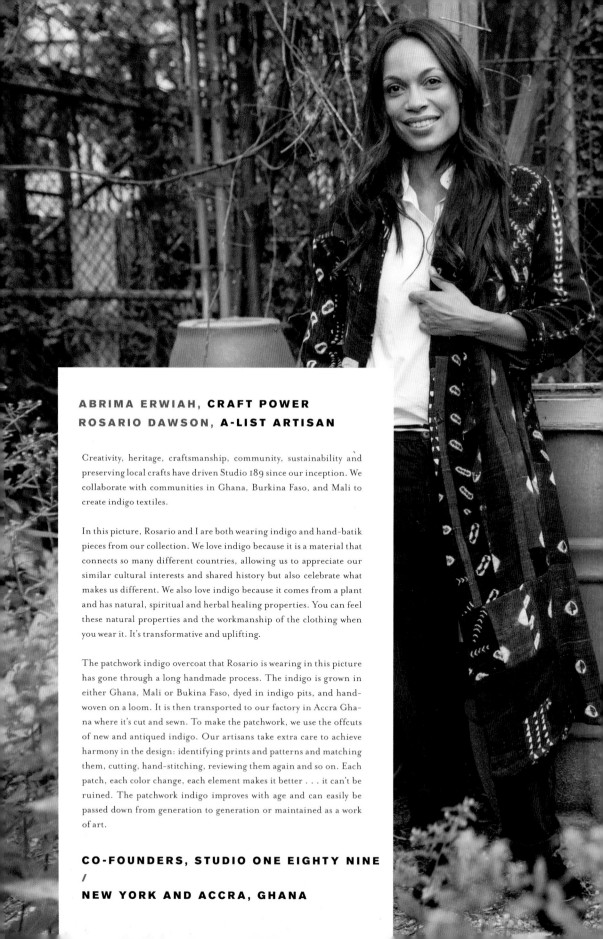

ABRIMA ERWIAH, **CRAFT POWER**
ROSARIO DAWSON, **A-LIST ARTISAN**

Creativity, heritage, craftsmanship, community, sustainability and preserving local crafts have driven Studio 189 since our inception. We collaborate with communities in Ghana, Burkina Faso, and Mali to create indigo textiles.

In this picture, Rosario and I are both wearing indigo and hand-batik pieces from our collection. We love indigo because it is a material that connects so many different countries, allowing us to appreciate our similar cultural interests and shared history but also celebrate what makes us different. We also love indigo because it comes from a plant and has natural, spiritual and herbal healing properties. You can feel these natural properties and the workmanship of the clothing when you wear it. It's transformative and uplifting.

The patchwork indigo overcoat that Rosario is wearing in this picture has gone through a long handmade process. The indigo is grown in either Ghana, Mali or Bukina Faso, dyed in indigo pits, and hand-woven on a loom. It is then transported to our factory in Accra Ghana where it's cut and sewn. To make the patchwork, we use the offcuts of new and antiqued indigo. Our artisans take extra care to achieve harmony in the design: identifying prints and patterns and matching them, cutting, hand-stitching, reviewing them again and so on. Each patch, each color change, each element makes it better . . . it can't be ruined. The patchwork indigo improves with age and can easily be passed down from generation to generation or maintained as a work of art.

CO-FOUNDERS, STUDIO ONE EIGHTY NINE
/
NEW YORK AND ACCRA, GHANA

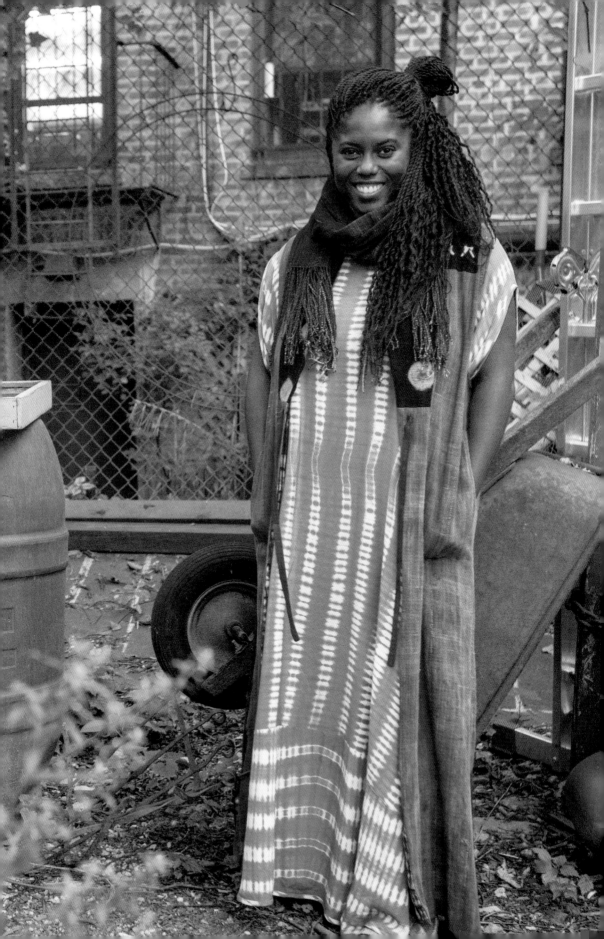

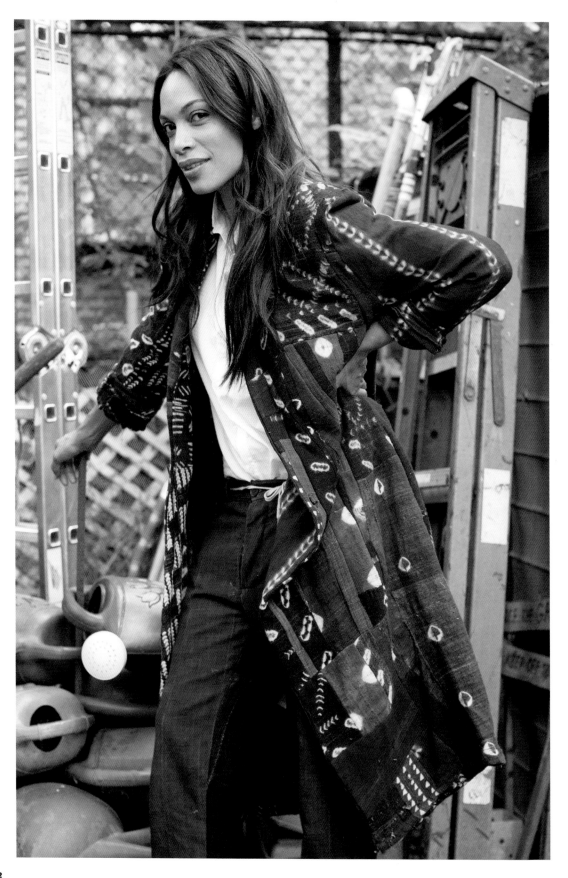

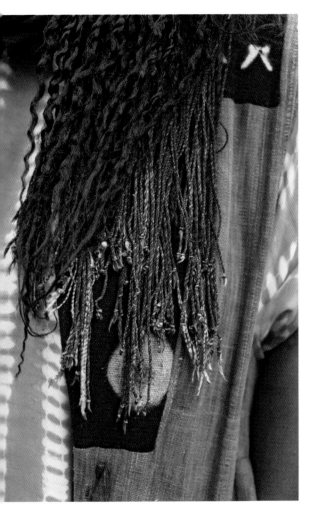
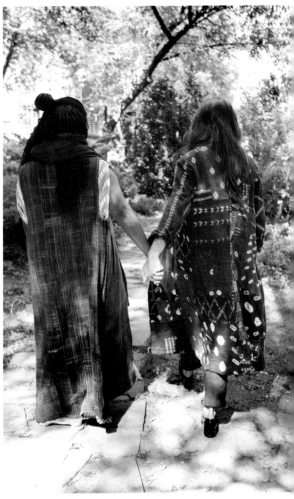

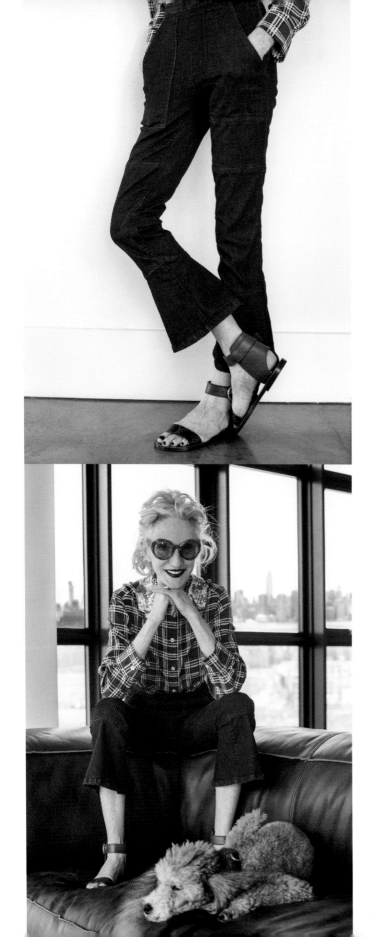

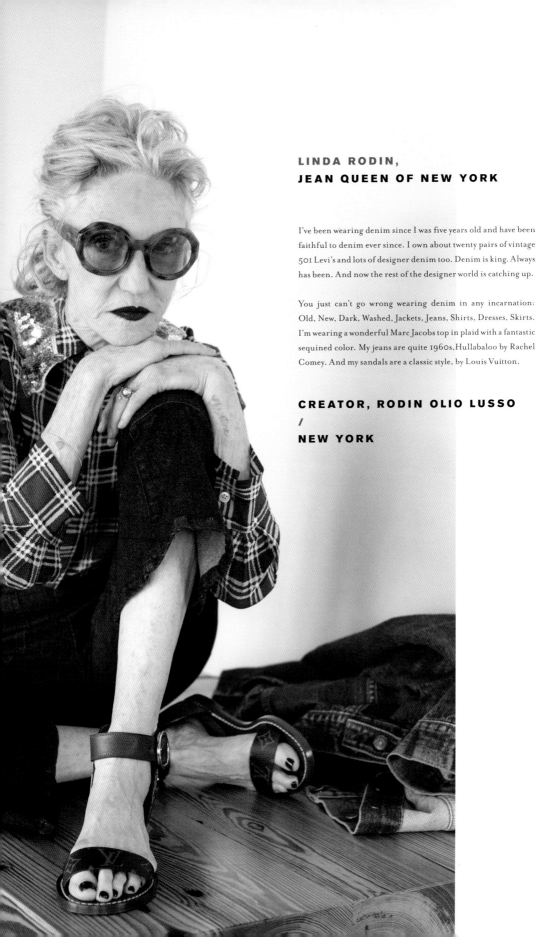

LINDA RODIN,
JEAN QUEEN OF NEW YORK

I've been wearing denim since I was five years old and have been faithful to denim ever since. I own about twenty pairs of vintage 501 Levi's and lots of designer denim too. Denim is king. Always has been. And now the rest of the designer world is catching up.

You just can't go wrong wearing denim in any incarnation: Old, New, Dark, Washed, Jackets, Jeans, Shirts, Dresses, Skirts. I'm wearing a wonderful Marc Jacobs top in plaid with a fantastic sequined color. My jeans are quite 1960s, Hullabaloo by Rachel Comey. And my sandals are a classic style, by Louis Vuitton.

CREATOR, RODIN OLIO LUSSO
/
NEW YORK

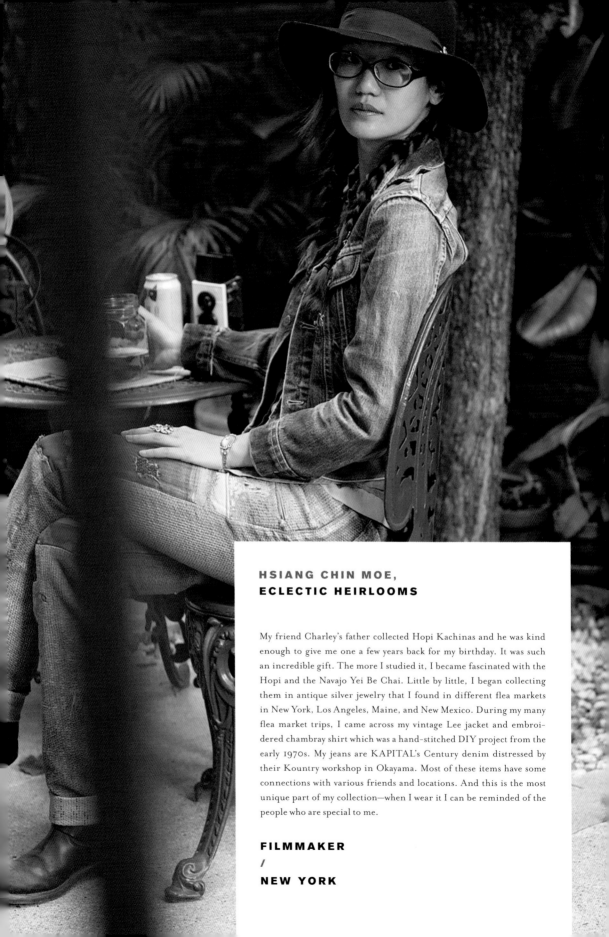

HSIANG CHIN MOE,
ECLECTIC HEIRLOOMS

My friend Charley's father collected Hopi Kachinas and he was kind enough to give me one a few years back for my birthday. It was such an incredible gift. The more I studied it, I became fascinated with the Hopi and the Navajo Yei Be Chai. Little by little, I began collecting them in antique silver jewelry that I found in different flea markets in New York, Los Angeles, Maine, and New Mexico. During my many flea market trips, I came across my vintage Lee jacket and embroidered chambray shirt which was a hand-stitched DIY project from the early 1970s. My jeans are KAPITAL's Century denim distressed by their Kountry workshop in Okayama. Most of these items have some connections with various friends and locations. And this is the most unique part of my collection—when I wear it I can be reminded of the people who are special to me.

FILMMAKER
/
NEW YORK

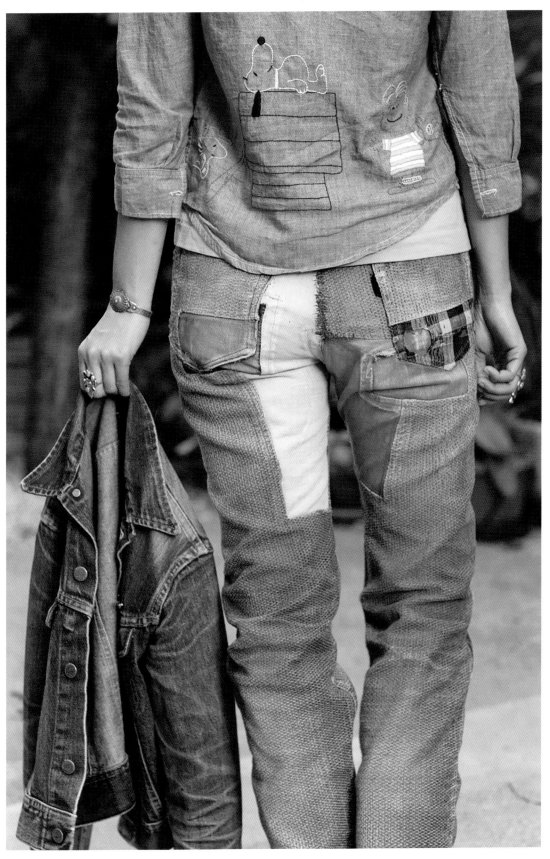

IATION

Kinlichiinii

he Red House People)

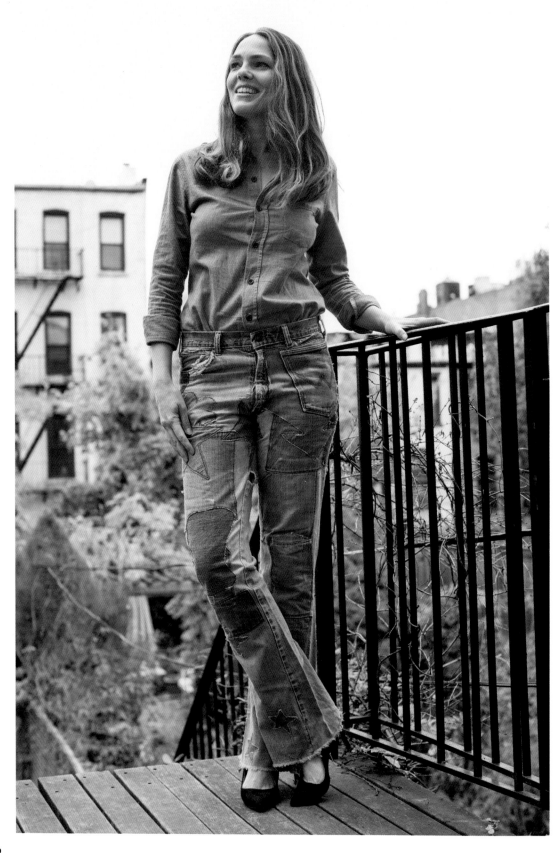

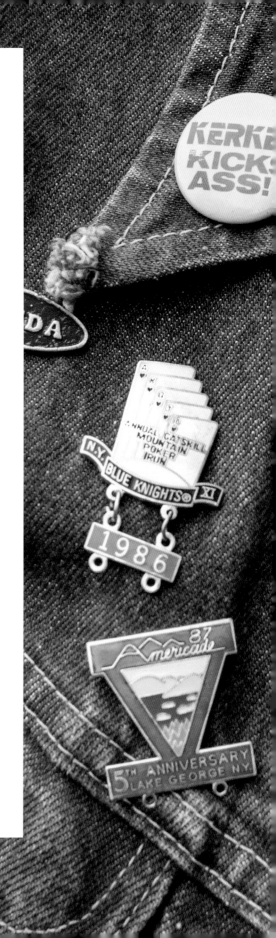

FLORENCE KANE,
THE FRANKENSTEIN JEAN

My husband's father bought this jacket at a motorcycle shop when my husband was about ten years old. Each year, they'd go to the bike show at the Javit's Center in New York and he'd collect pins from different motorcycle companies to add to it. I was excited that I could wear it—albeit it in a very, very shrunken way. The way I see it, I'm just the keeper of this piece until our young sons are big enough to wear daddy's old denim.

I call this superpatched pair of denims "Frankenstein" jeans. They're made of so many different pieces of denim, from who knows how many and what kind of other jeans. It looks like they began as a simple, nondescript pair of blue flares. There's no tag inside, so I don't know what brand they are. The snap reveals no company's logo. But someone sewed patch upon patch to get them in the wonderful state they're in now. This person cut an entire swath—pocket included—off the rear of a pair of Wranglers and put it on the left front of these jeans; the pocket with a square outline faded in (wallet? cigarettes?). There are several stars of various sizes stitched on, triangles, an arrow, and regular old squares. There's even a denim footprint on the left rear, with each "toe" perfectly placed. At the bottom of the left leg there's a tiny, hand-embroidered heart done in red thread—the only bit of color besides blue anywhere.

Why would someone have taken up such a time-consuming endeavor? Some bits are machine sewed, others are by hand. These jeans took time, they evolved. Perhaps the owner loved the original pair (its soft denim so thin, and now threadbare in places) so much he or she couldn't bear to let them dissolve. Maybe it started with one patch and then more were added to keep the jeans alive. But who did this? I know a little. They were once in the possession of my father-in-law John's brother (my husband's Uncle Mike, and the guy he's named after). Uncle Mike Mraz was at Woodstock; he was in the navy, and was stationed in Hawaii, where he was part of the military surfing group.

Very sadly, Mike passed away in 1977 at the age of thirty from heatstroke while training for a long-distance race in the desert. He was living in San Francisco at the time, and his roommate packed up his belongings—these jeans included—and sent them to Mike's family. My father-in-law held onto them, and a few weeks ago he handed them to me. I tried them on and they fit perfectly. Almost eerily so. Which could mean that they weren't Mike's at all, but a girlfriend's. He was over six feet tall (I'm just nearly 5'8), so they would have been short on him. I haven't worn them really, though I did take them to Amsterdam on a Jean Stories trip to Denim Day. And it was so fun (both the city and wearing the jeans). But I'm too afraid of damaging them. Someone else once loved them.

COFOUNDER AND EDITORIAL DIRECTOR, JEAN STORIES
/
BROOKLYN

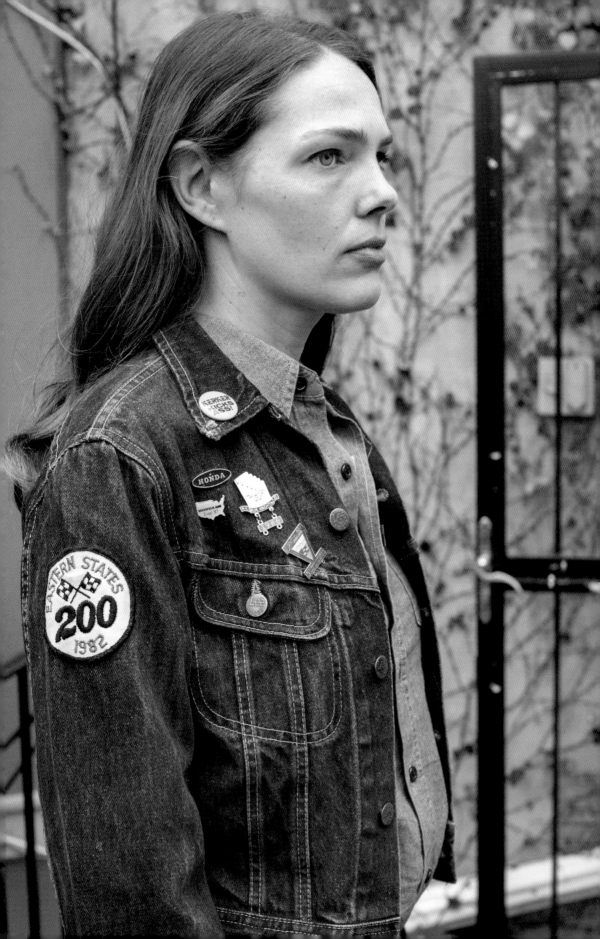

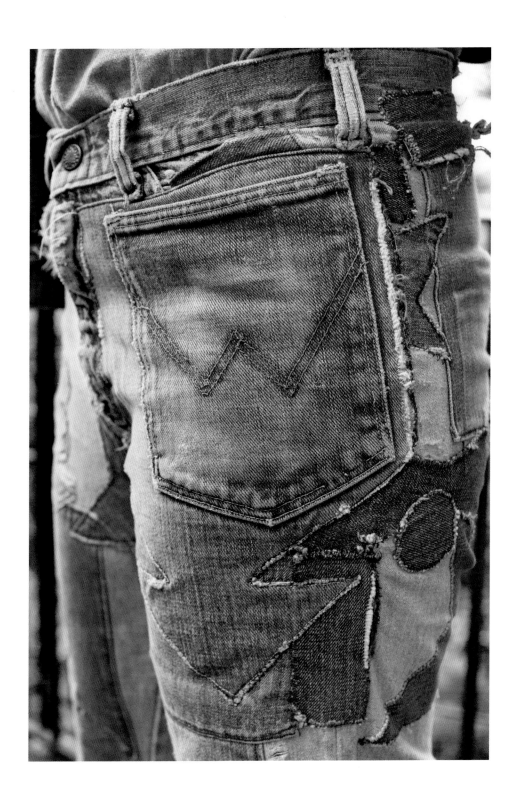

JANE HERMAN BISHOP,
CLEAN JEAN QUEEN

My jacket is a men's Iron Heart/Self Edge collaboration in black overdyed 18-oz denim, and the rocker I had custom chainstitched for me by Jerry Lee of Hoosier Chainstitch. It's a portrait of my better half: the Singer 47W70, which is the machine I do all my repair work on. Indigo Proof is my repairing alter ego, the name I work and blog under. I feel like I'm in a one-woman gang in this jacket, and I pretty much live in it!

I made these jeans the week of this shoot—I was actually indigo dyeing them the night before! They are natural white pima cotton 3sixteen's that I dyed in a four-process rainbow and then bound and overdyed indigo. I love how the indigo reacts with the chemical dyes, eating away at the color leaving these cool yellowish tones streaked throughout.

Both pieces are pretty much as customized as they can be, which is something I feel pretty strongly about.

COFOUNDER AND CREATIVE
DIRECTOR, JEAN STORIES
/
BROOKLYN

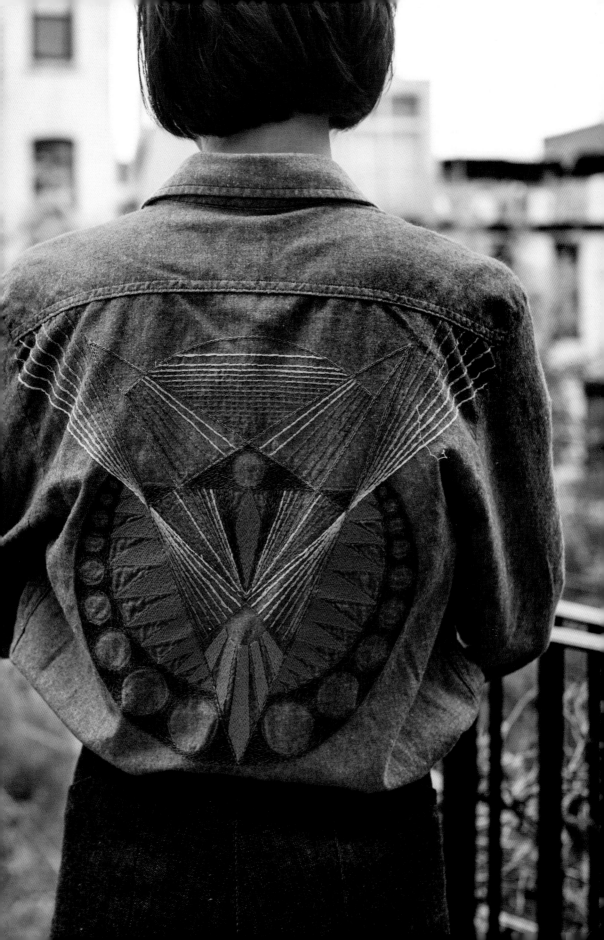

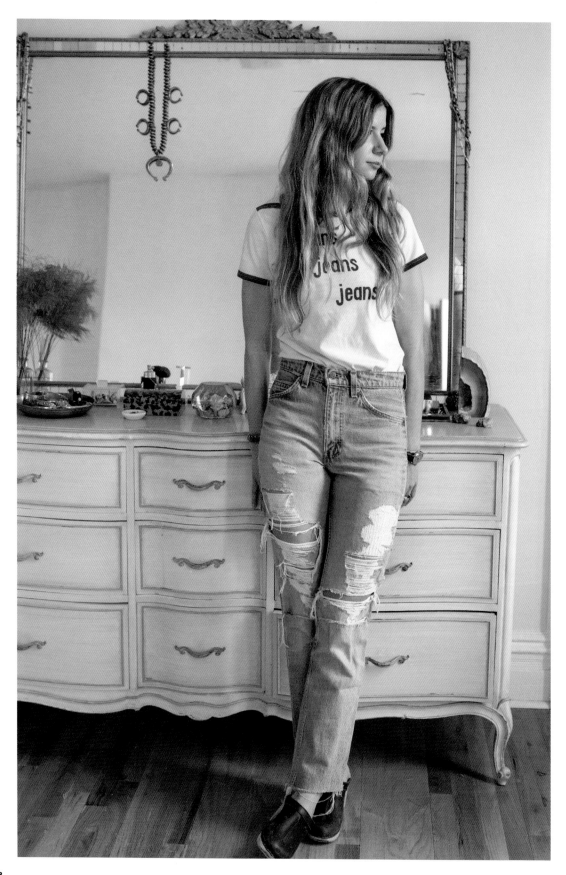

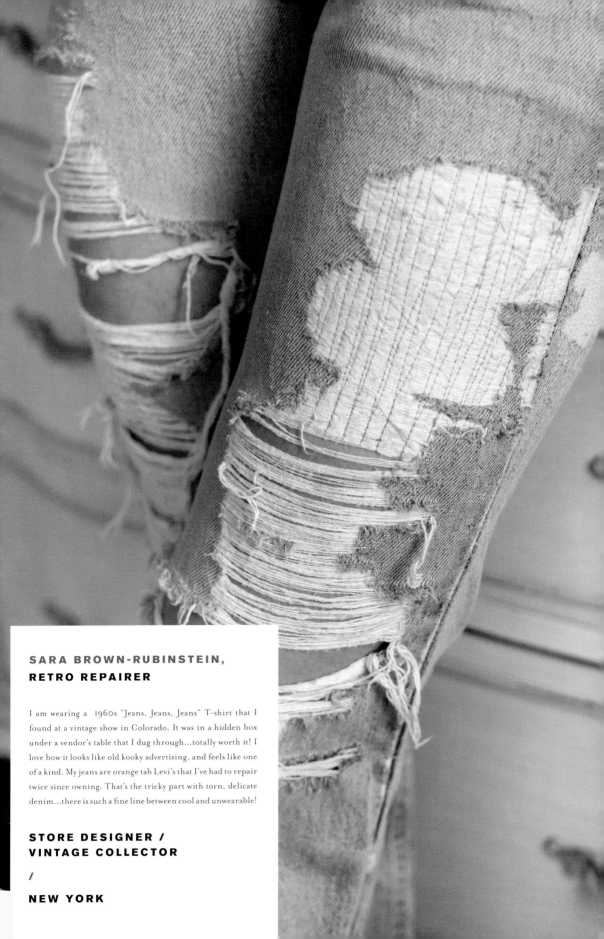

SARA BROWN-RUBINSTEIN, RETRO REPAIRER

I am wearing a 1960s "Jeans, Jeans, Jeans" T-shirt that I found at a vintage show in Colorado. It was in a hidden box under a vendor's table that I dug through...totally worth it! I love how it looks like old kooky advertising, and feels like one of a kind. My jeans are orange tab Levi's that I've had to repair twice since owning. That's the tricky part with torn, delicate denim...there is such a fine line between cool and unwearable!

STORE DESIGNER / VINTAGE COLLECTOR

/

NEW YORK

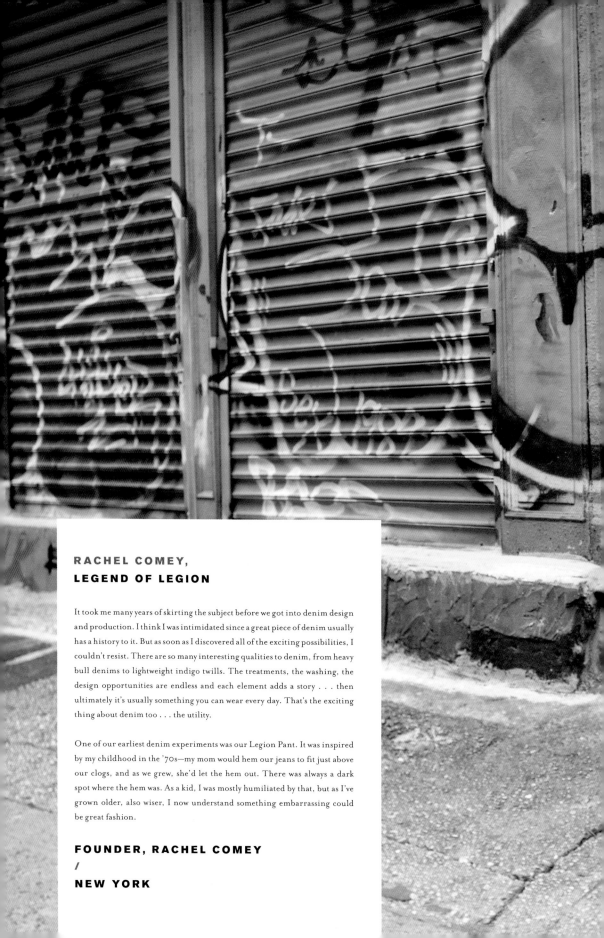

RACHEL COMEY,
LEGEND OF LEGION

It took me many years of skirting the subject before we got into denim design
and production. I think I was intimidated since a great piece of denim usually
has a history to it. But as soon as I discovered all of the exciting possibilities, I
couldn't resist. There are so many interesting qualities to denim, from heavy
bull denims to lightweight indigo twills. The treatments, the washing, the
design opportunities are endless and each element adds a story . . . then
ultimately it's usually something you can wear every day. That's the exciting
thing about denim too . . . the utility.

One of our earliest denim experiments was our Legion Pant. It was inspired
by my childhood in the '70s—my mom would hem our jeans to fit just above
our clogs, and as we grew, she'd let the hem out. There was always a dark
spot where the hem was. As a kid, I was mostly humiliated by that, but as I've
grown older, also wiser, I now understand something embarrassing could
be great fashion.

FOUNDER, RACHEL COMEY
/
NEW YORK

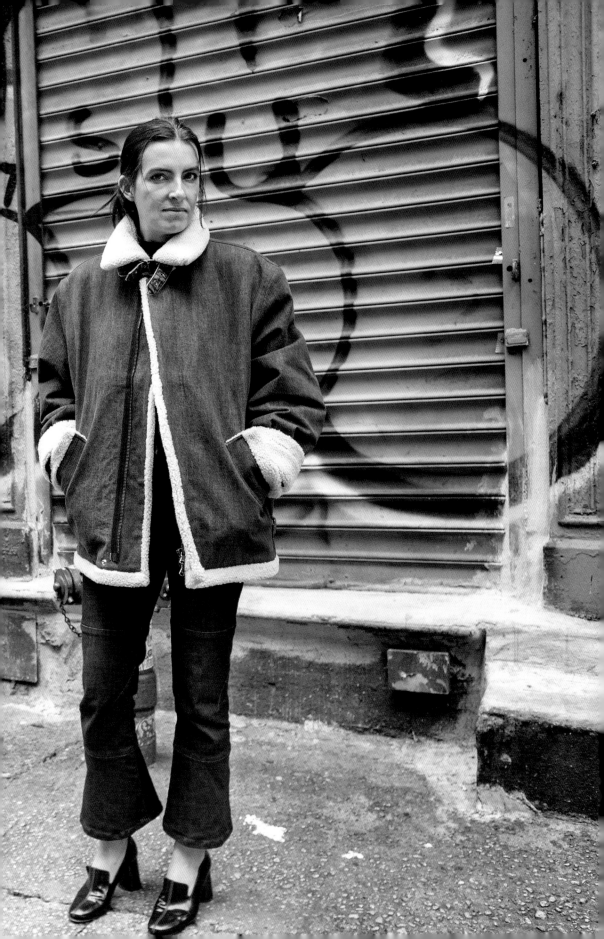

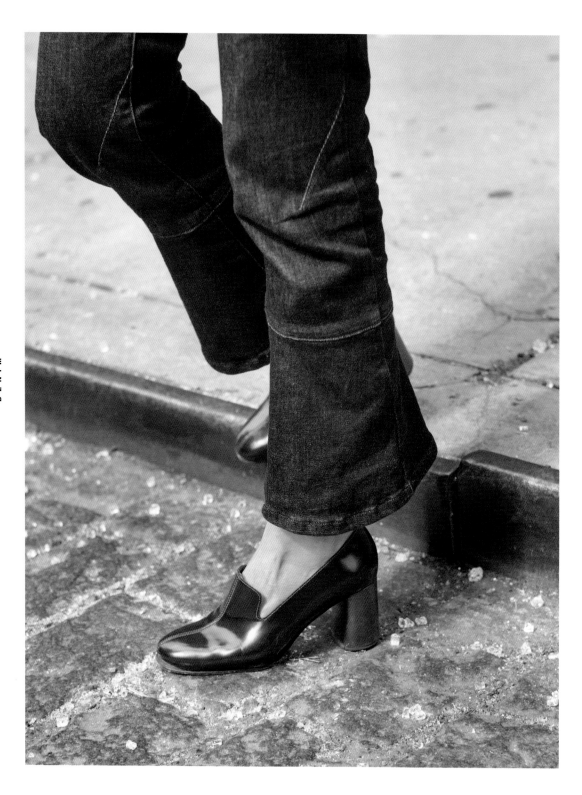

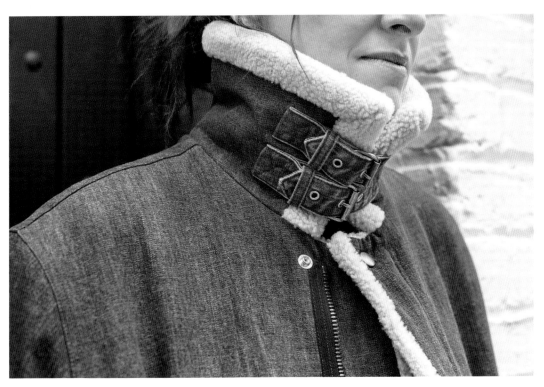

EUROPE

AMERICANS MIGHT HAVE BUILT DENIM BUT THE EUROPEANS HAVE GIVEN IT ATTITUDE.

Euro denim is eclectic, progressive, and spirited. Nothing beats the undone and disheveled appeal of London; the High Street drives experimental trends through cash registers and onto the streets at an astounding rate while high fashion icons invent catwalk trends; from Alexander McQueen's Bumsters in 1995 to the raw hem trend by such recent runway revolutionaries as Marques'Almeida.

But it was the chic sophisticated sexiness of France and the passion of Italian denim during the '60s and '70s that really made European denim famous. With the emergence of brands such as Marithé + François Girbaud, Diesel, and Fiorucci, came a sexiness that took over the continent, introducing stretch denim, laundered finishes, and an ostentation that was celebrated the world over. In more recent years Isabel Marant and Vetements have driven the industry forward while Fiorucci is making its comeback, showing us that Italian flamboyance is on its way back. And let's not forget the Nordic regions; the simplicity and paired-back attitude of Scandinavian denim drove the latest evolution of indigo in the mid- to late noughties with brands from Acne to Cheap Monday helping to push denim design into tomorrow.

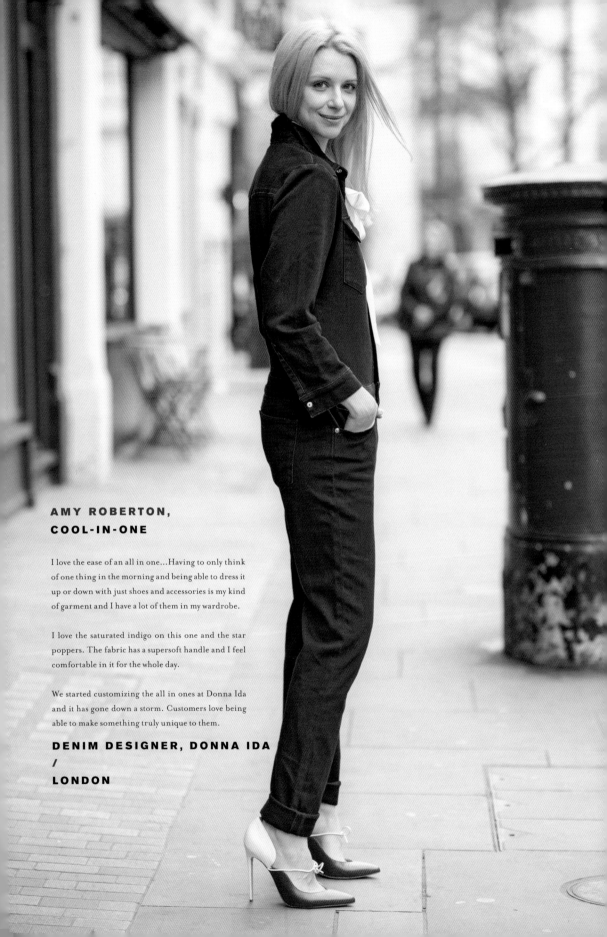

AMY ROBERTON,
COOL-IN-ONE

I love the ease of an all in one...Having to only think
of one thing in the morning and being able to dress it
up or down with just shoes and accessories is my kind
of garment and I have a lot of them in my wardrobe.

I love the saturated indigo on this one and the star
poppers. The fabric has a supersoft handle and I feel
comfortable in it for the whole day.

We started customizing the all in ones at Donna Ida
and it has gone down a storm. Customers love being
able to make something truly unique to them.

DENIM DESIGNER, DONNA IDA
/
LONDON

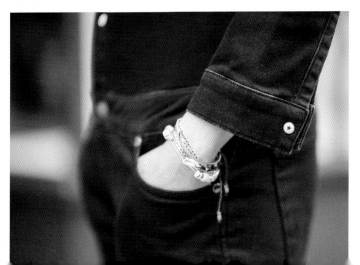

KELLY DAWSON,
MADE-IN-BRIGHTON

I wear what I make. Owning my own brand and workshop
means if I want something new I can go into my workshop and
make it. I've been working with denim for twenty years this
year; it's not often I'm not wearing it. I have an admiration for
mid-century design, an era when we still had style, also goods
that have been made by hand. I'm wearing a Dawson Denim
Wabash jacket. This fabric is printed exclusively in Okayama
for us; it's an indigo-dyed twill and has started fading around
the elbows and pocket openings, the fit is based on a sack
jacket worn by workers from the 1800s. The jeans are also
our own 13-oz Japanese red line selvedge from our mill in
Japan; it's woven on traditional 1920s Toyoda looms. The
fit is wide with a cinch back, which we made from trawling
through photos of the 1930s Dust Bowl era, I wear them
short. I'm also wearing a 1940s deadstock French henley I
bought from Dustbowl Vintage in Bristol. I'm lucky to have
a mum who's an ace knitter and the Fair Isle is an original
1940s pattern that we sourced the correct wool for. The shoes
are Trickers, British-made brogues in Northampton since
1829, and the socks are by Chup in Japan.

COFOUNDER,
DAWSON DENIM
/
BRIGHTON

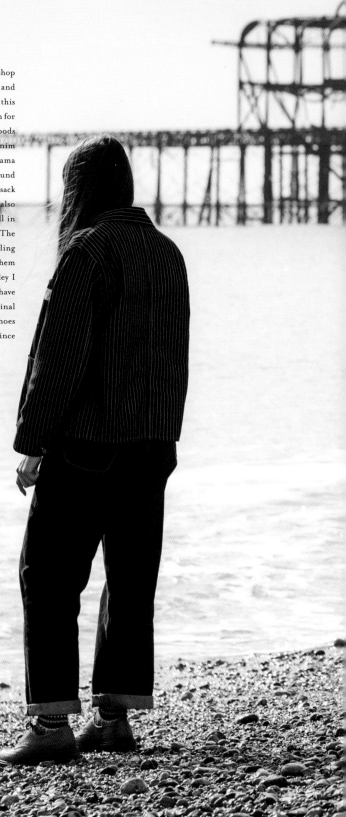

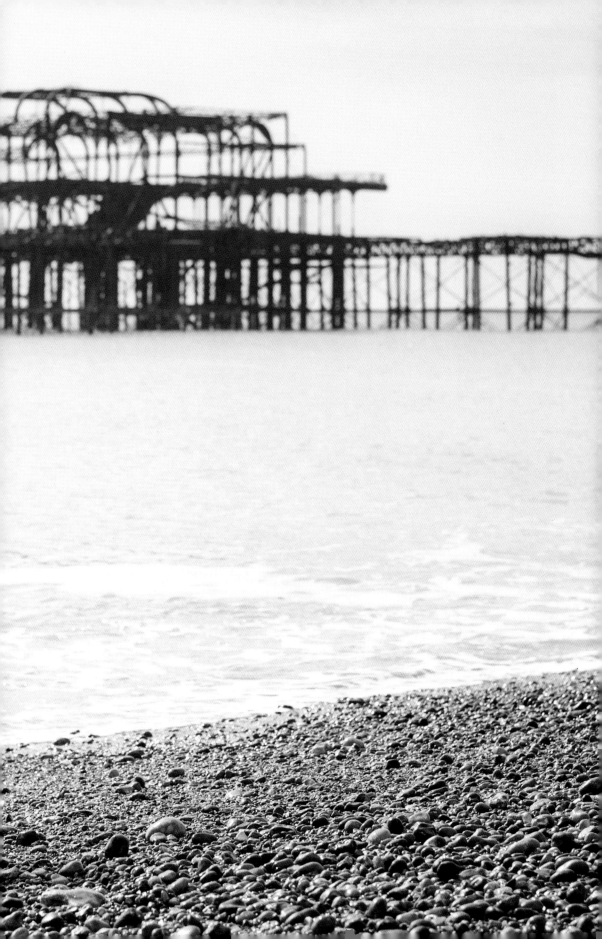

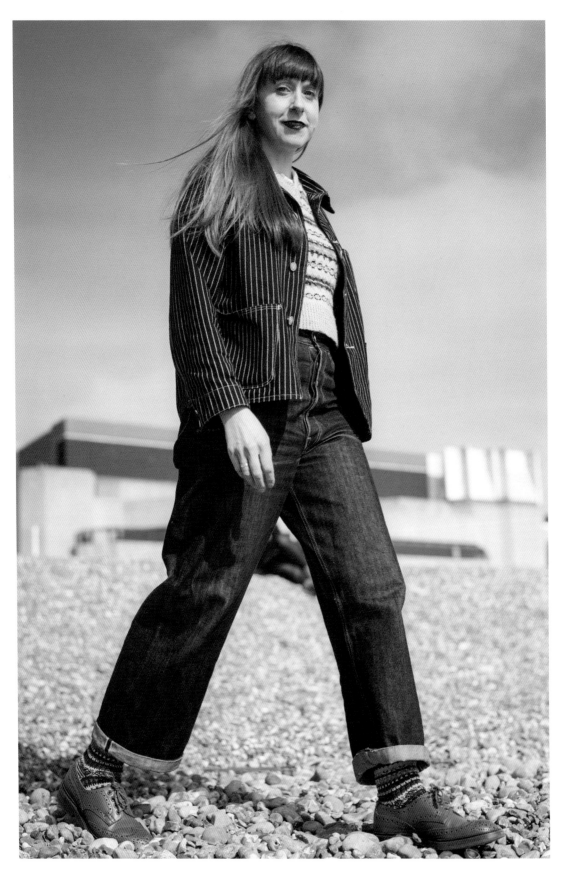

KATHARINE HAMNETT,
DENIM ACTIVIST

I did my first denim collection working with Adriano Goldschmied in Italy in the late '70s. I love all the games you can play with denim and I particularly like the look of worn denim, but in those days you could only get it new—so in the process I invented stonewashing to achieve the worn effect, and also made the first stretch denim—denim as a spray-on corset—which didn't exist then.

I feel pretty bad about this now. Stonewashing got so popular it has silted up rivers and there are empty places in Mexico where once there were pumice mountains. Ten thousand-plus people die a year from accidental pesticide poisoning in conventional cotton agriculture and regular elasthane is not a sustainable fiber. In those days we didn't realize there was anything wrong. Now we know better.

There are sustainable processes now that can create the worn look, you can get great organic cotton denim, and the world's first sustainable elastane is coming on the market.

In the photograph I'm wearing an outsize men's jacket. I love that look—I am protected/my boyfriend is bigger than yours. Scattered around me are a few favorite pieces that I have made over the years.

FASHION DESIGNER, INDUSTRY
WHISTLEBLOWER, AND ADVOCATE FOR
SOCIAL AND ENVIRONMENTAL ISSUES
/
LONDON

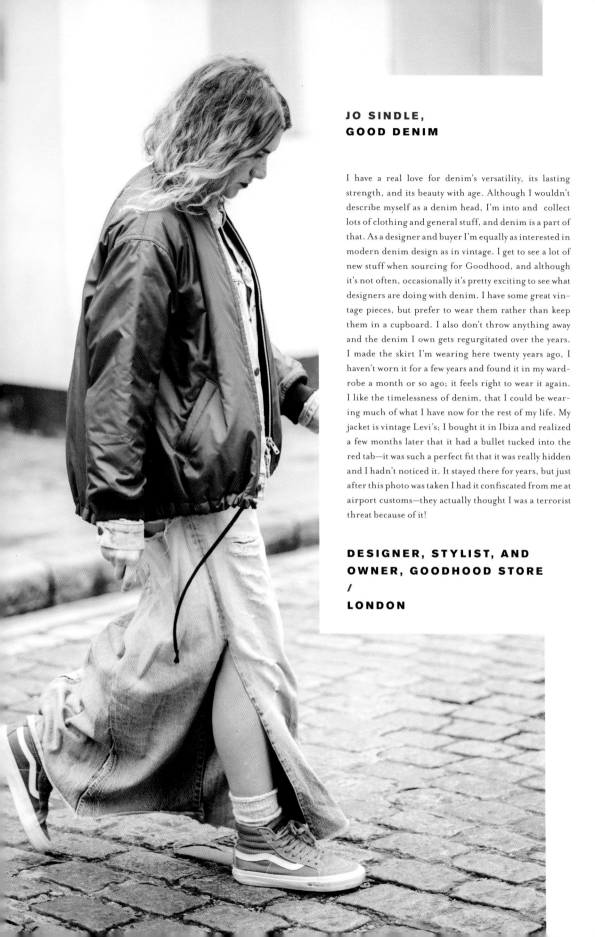

JO SINDLE,
GOOD DENIM

I have a real love for denim's versatility, its lasting strength, and its beauty with age. Although I wouldn't describe myself as a denim head, I'm into and collect lots of clothing and general stuff, and denim is a part of that. As a designer and buyer I'm equally as interested in modern denim design as in vintage. I get to see a lot of new stuff when sourcing for Goodhood, and although it's not often, occasionally it's pretty exciting to see what designers are doing with denim. I have some great vintage pieces, but prefer to wear them rather than keep them in a cupboard. I also don't throw anything away and the denim I own gets regurgitated over the years. I made the skirt I'm wearing here twenty years ago, I haven't worn it for a few years and found it in my wardrobe a month or so ago; it feels right to wear it again. I like the timelessness of denim, that I could be wearing much of what I have now for the rest of my life. My jacket is vintage Levi's; I bought it in Ibiza and realized a few months later that it had a bullet tucked into the red tab—it was such a perfect fit that it was really hidden and I hadn't noticed it. It stayed there for years, but just after this photo was taken I had it confiscated from me at airport customs—they actually thought I was a terrorist threat because of it!

DESIGNER, STYLIST, AND
OWNER, GOODHOOD STORE
/
LONDON

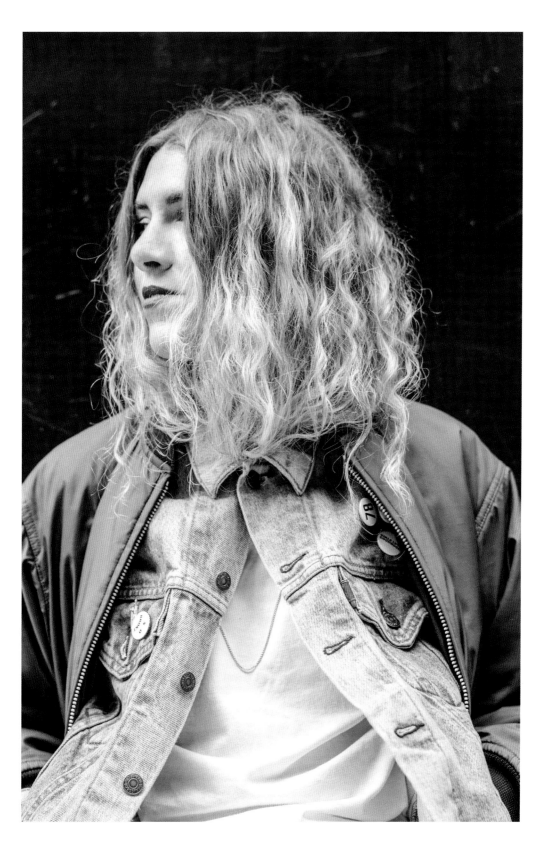

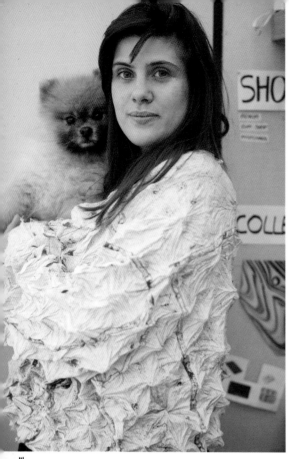

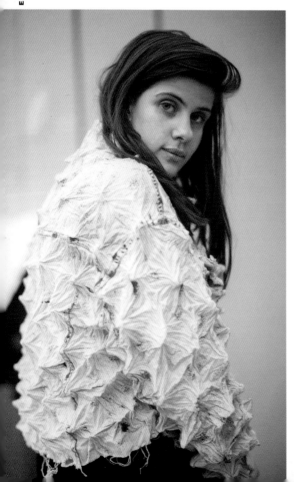

FAUSTINE STIENMETZ
HAUTE-DENIM

I guess I am an unusual denim designer in that I rarely work with typical denim fabrics. When I do I usually unthread old pairs of Levi's jeans until I have a big pile of indigo yarn which I might re-weave or felt into something completely different.

The piece I'm wearing in the picture has all the elements of a classic denim jacket: the felled seams, the flap pockets, the marbling, etc. Except it has been made from a polyester twill that has been hand-painted with indigo and then pleated using the old Japanese technique of shibori. I like to confront the unusual textiles I craft with the reality of a familiar piece such as a denim jacket.

What really interests me, however, is the fact that denim pieces are so codified and that they are so recognizable. Almost everyone owns a pair of denim jeans no matter what part of the world they come from, or what social class they come from, or what type of music they listen to. It's probably the most popular piece of clothing in the world.

FOUNDER, FAUSTINE STIENMETZ
/
LONDON

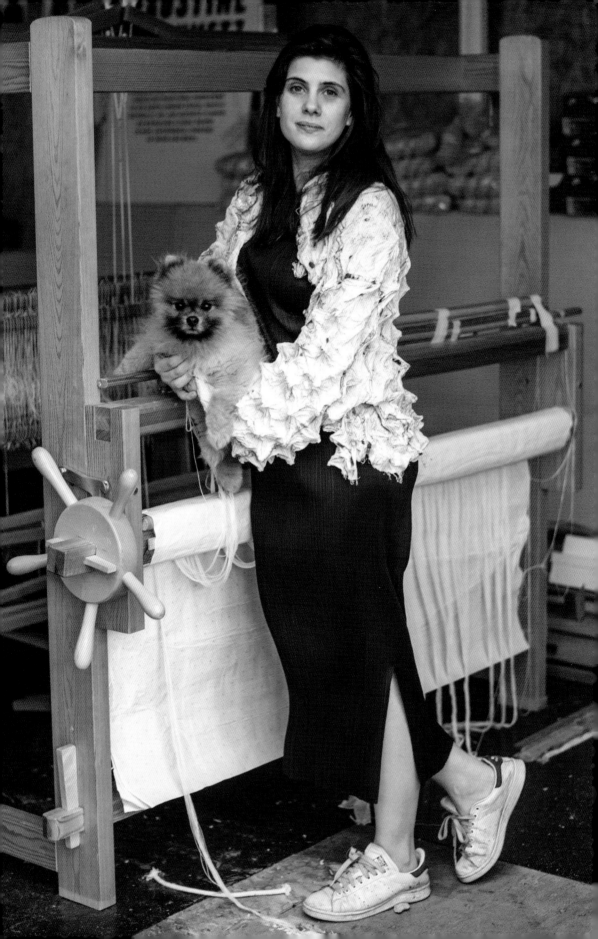

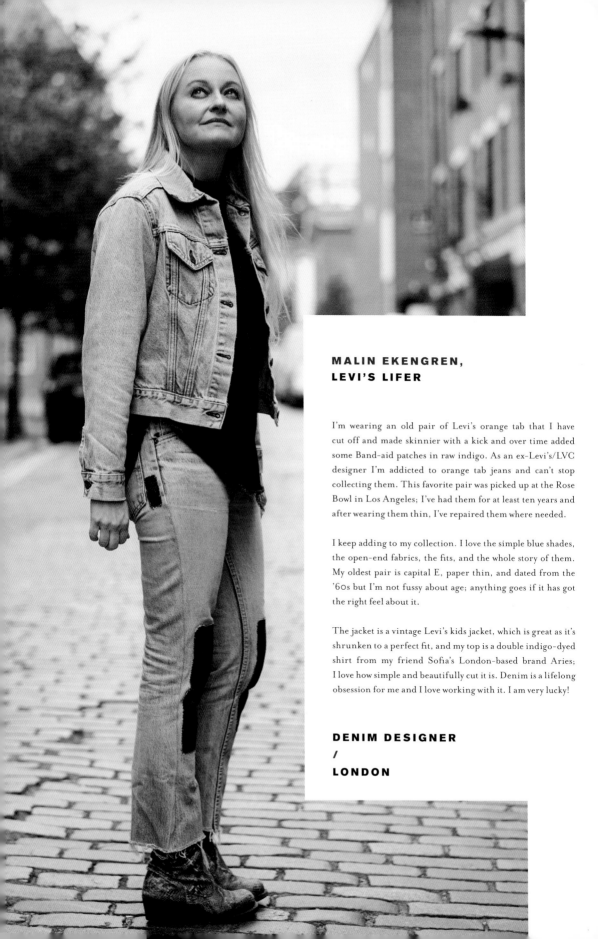

MALIN EKENGREN,
LEVI'S LIFER

I'm wearing an old pair of Levi's orange tab that I have cut off and made skinnier with a kick and over time added some Band-aid patches in raw indigo. As an ex-Levi's/LVC designer I'm addicted to orange tab jeans and can't stop collecting them. This favorite pair was picked up at the Rose Bowl in Los Angeles; I've had them for at least ten years and after wearing them thin, I've repaired them where needed.

I keep adding to my collection. I love the simple blue shades, the open-end fabrics, the fits, and the whole story of them. My oldest pair is capital E, paper thin, and dated from the '60s but I'm not fussy about age; anything goes if it has got the right feel about it.

The jacket is a vintage Levi's kids jacket, which is great as it's shrunken to a perfect fit, and my top is a double indigo-dyed shirt from my friend Sofia's London-based brand Aries; I love how simple and beautifully cut it is. Denim is a lifelong obsession for me and I love working with it. I am very lucky!

DENIM DESIGNER
/
LONDON

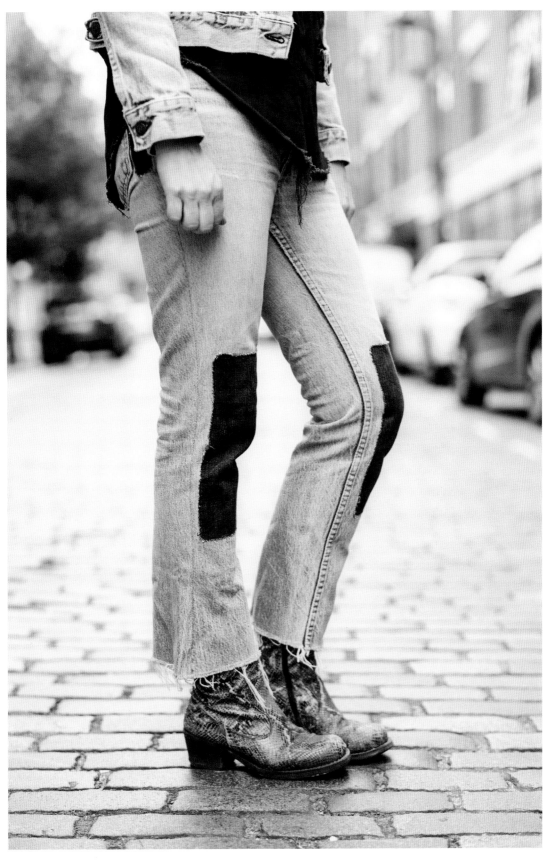

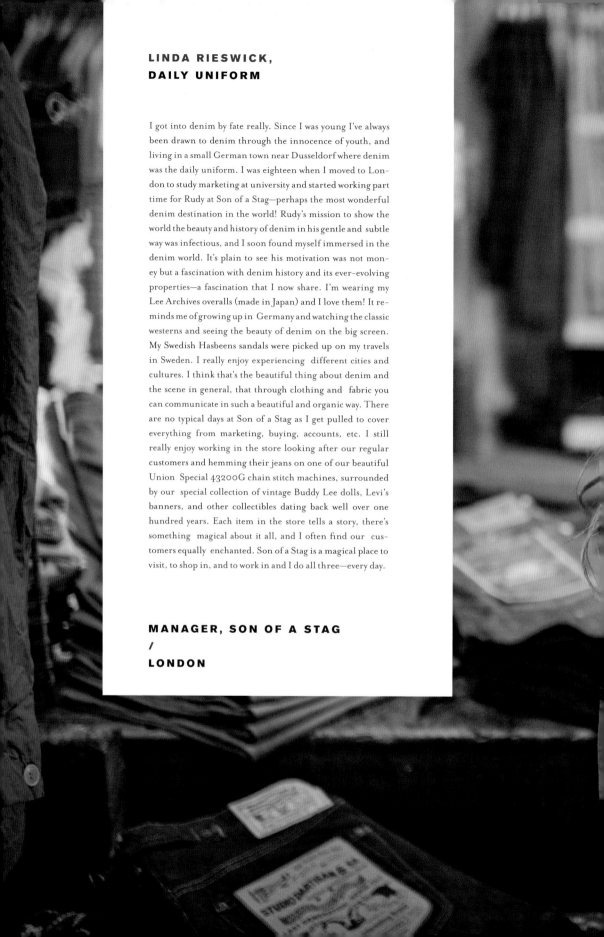

LINDA RIESWICK,
DAILY UNIFORM

I got into denim by fate really. Since I was young I've always been drawn to denim through the innocence of youth, and living in a small German town near Dusseldorf where denim was the daily uniform. I was eighteen when I moved to London to study marketing at university and started working part time for Rudy at Son of a Stag—perhaps the most wonderful denim destination in the world! Rudy's mission to show the world the beauty and history of denim in his gentle and subtle way was infectious, and I soon found myself immersed in the denim world. It's plain to see his motivation was not money but a fascination with denim history and its ever-evolving properties—a fascination that I now share. I'm wearing my Lee Archives overalls (made in Japan) and I love them! It reminds me of growing up in Germany and watching the classic westerns and seeing the beauty of denim on the big screen. My Swedish Hasbeens sandals were picked up on my travels in Sweden. I really enjoy experiencing different cities and cultures. I think that's the beautiful thing about denim and the scene in general, that through clothing and fabric you can communicate in such a beautiful and organic way. There are no typical days at Son of a Stag as I get pulled to cover everything from marketing, buying, accounts, etc. I still really enjoy working in the store looking after our regular customers and hemming their jeans on one of our beautiful Union Special 43200G chain stitch machines, surrounded by our special collection of vintage Buddy Lee dolls, Levi's banners, and other collectibles dating back well over one hundred years. Each item in the store tells a story, there's something magical about it all, and I often find our customers equally enchanted. Son of a Stag is a magical place to visit, to shop in, and to work in and I do all three—every day.

MANAGER, SON OF A STAG
/
LONDON

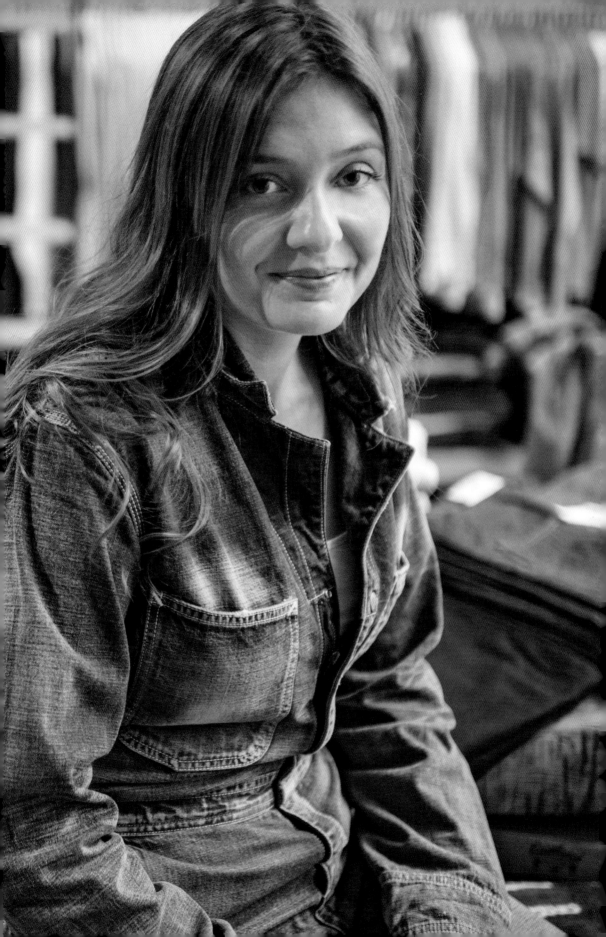

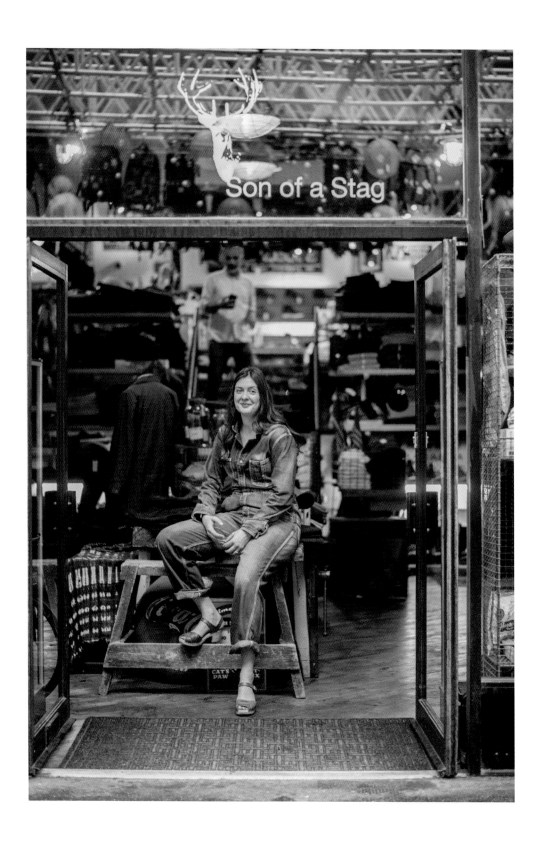

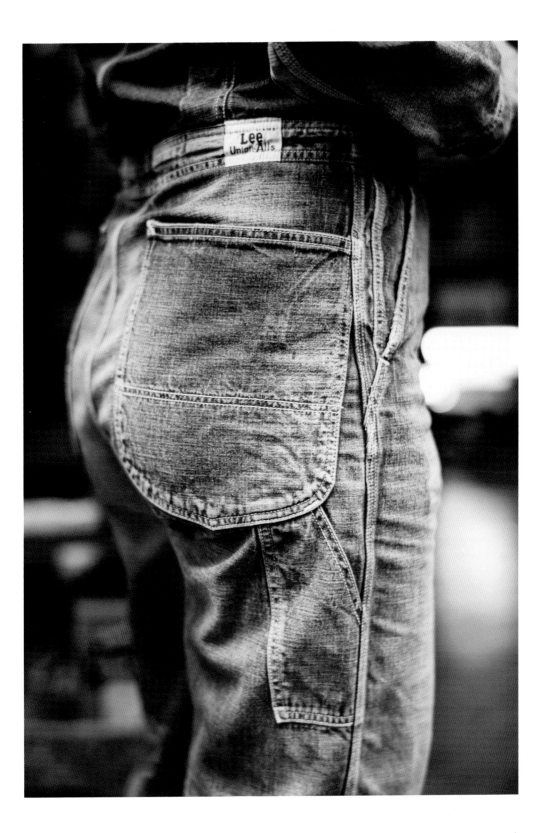

DONNA IDA THORNTON,
RETAIL THERAPIST

I'm wearing a special denim piece from my AW16 To The Moon & Back Collection, which celebrates the tenth anniversary of DONNA IDA. When I opened my first store in Chelsea a decade ago, denim could almost have been called traditional compared to today but now the fashion winners are a lot more fashion forward and directional. IDA's Eliza the Relaxed Skinny Dungaree is my current favorite and comes in a dark washed denim with a secret flash of leopard inside, which is why it's called Guilty Pleasures. I've teamed it with a classic DONNA IDA Poet Don't Know Silk Blouse, and since I'm petite, a pair of stacked '70s-style wedges to add height.

CEO, DONNA IDA
/
LONDON

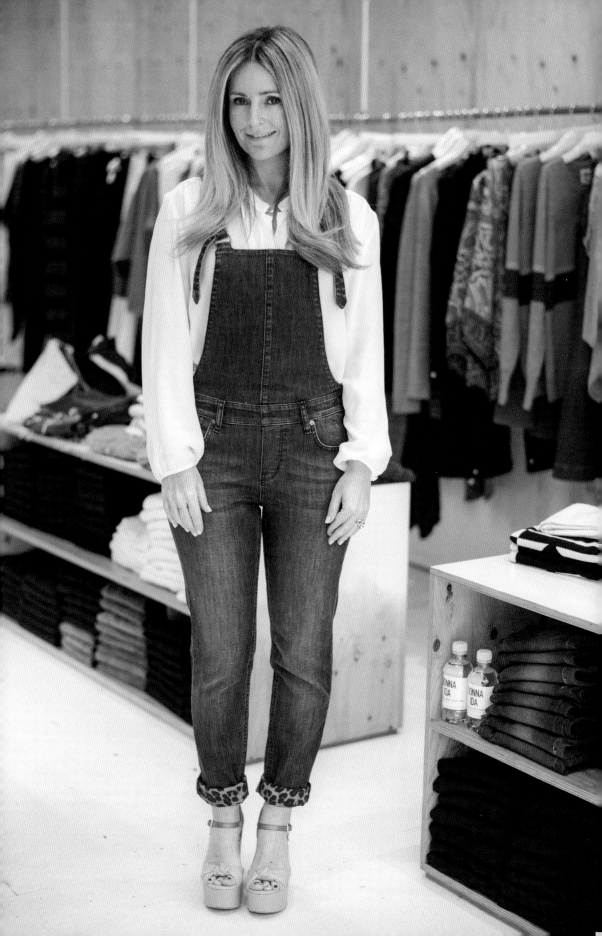

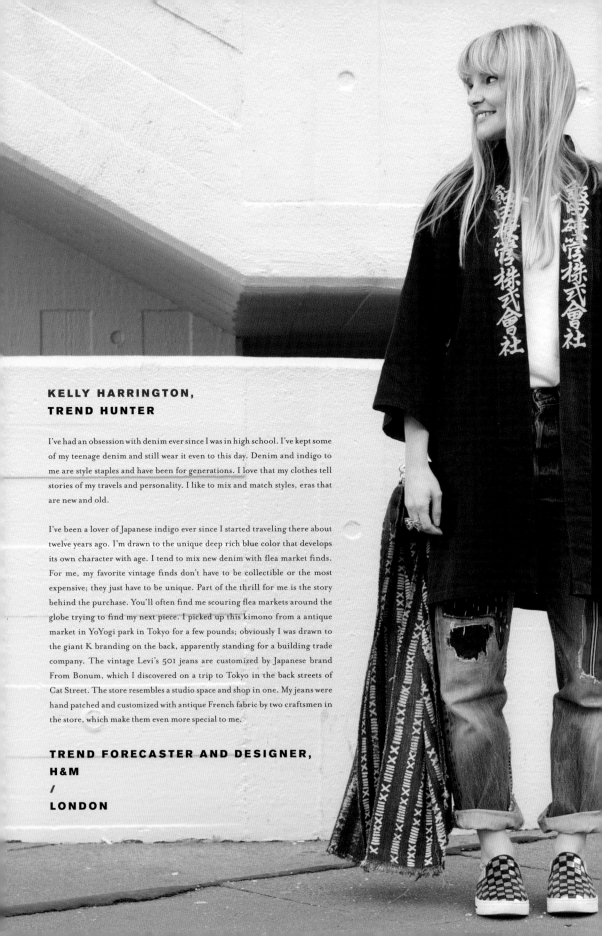

KELLY HARRINGTON,
TREND HUNTER

I've had an obsession with denim ever since I was in high school. I've kept some of my teenage denim and still wear it even to this day. Denim and indigo to me are style staples and have been for generations. I love that my clothes tell stories of my travels and personality. I like to mix and match styles, eras that are new and old.

I've been a lover of Japanese indigo ever since I started traveling there about twelve years ago. I'm drawn to the unique deep rich blue color that develops its own character with age. I tend to mix new denim with flea market finds. For me, my favorite vintage finds don't have to be collectible or the most expensive; they just have to be unique. Part of the thrill for me is the story behind the purchase. You'll often find me scouring flea markets around the globe trying to find my next piece. I picked up this kimono from a antique market in YoYogi park in Tokyo for a few pounds; obviously I was drawn to the giant K branding on the back, apparently standing for a building trade company. The vintage Levi's 501 jeans are customized by Japanese brand From Bonum, which I discovered on a trip to Tokyo in the back streets of Cat Street. The store resembles a studio space and shop in one. My jeans were hand patched and customized with antique French fabric by two craftsmen in the store, which make them even more special to me.

TREND FORECASTER AND DESIGNER,
H&M
/
LONDON

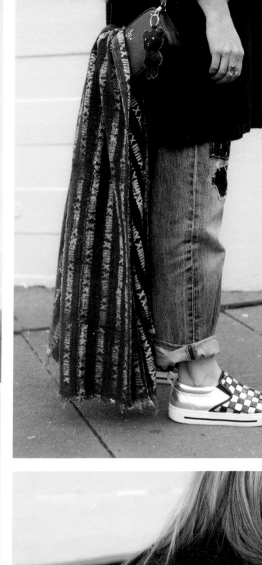

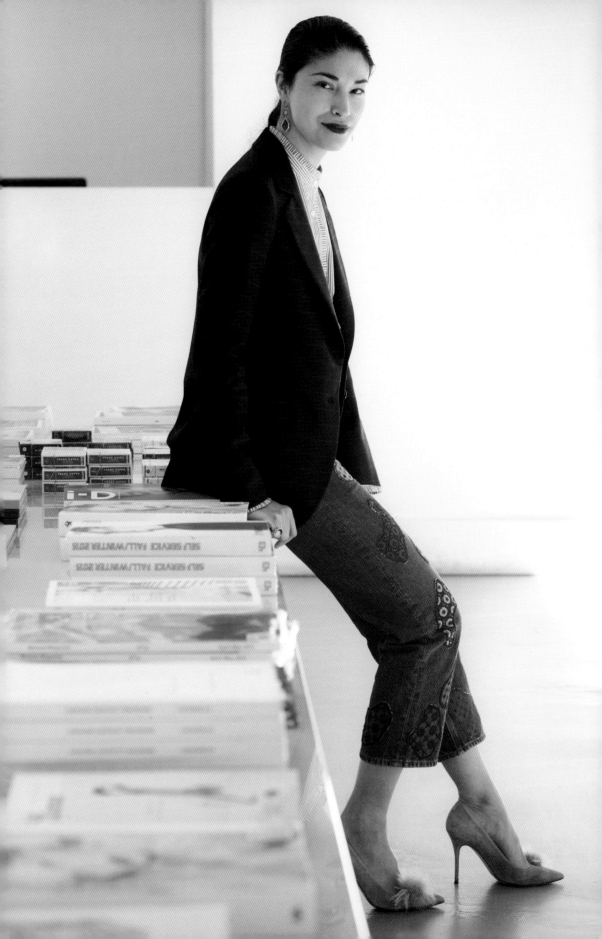

CAROLINE ISSA,
CANADIAN TUXEDO

Despite being Canadian, and the legend of our Canadian Tuxedo (which I certainly indulge in from time to time), I love incorporating denim into my wardrobe in a more formal way—no rips, tears, or exposed knees for me, please. There's nothing I love more than a great pair of jeans and a crisp white shirt and jacket—a truly iconic outfit finished off with a splash of red lipstick. I use denim as my suiting, instead of more formal trousers—it signals a bit of *je ne sais quois* and disruptive energy, but I think it brings an otherwise formal outfit into a much more contemporary realm. And hey, technically, denim comes from work wear—sure, the work was more on the wrangling of cattle side, but it's work nonetheless so I try to find ways of incorporating my jeans into my work week, while figuring out how to make denim look its most polished. This is my ideal denim outfit because the jeans are comfortable with an added bit of flair, but classic enough they work with the white shirt and Dior blazer. High-low at (my personal) best.

FASHION DIRECTOR, TANK MAGAZINE
AND CEO OF TANK GROUP
/
LONDON

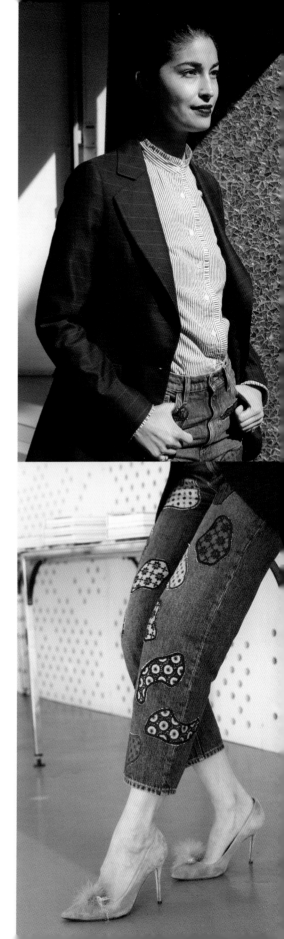

**CHLOE LONSDALE,
JEAN MACHINE**

I love denim. I grew up in a family that was instrumental in the denim industry in London in the '70s so I've always been surrounded by it. I don't think I've ever worn anything but jeans; it's when I feel my most confident. My favorites at the moment are these Mimi Jeans, a new style we launched last summer. I love the high rise and easy tapered fit, and the denim has an amazing character and authenticity. All my best jeans are nonstretch; they get better with age, taking on my personality in a way that stretch denim can't. They remind me of the vintage jeans that I used to buy in Portobello as a fashion student and those that I have inherited from my mum—with all the attitude but maybe a little more finesse. My fallback uniform is always jeans and a white shirt or T-shirt but I also like to wear something playful like this scallop detail shirt. These No.7 clogs make me smile; they are such a strong echo of the brand's '70s heritage. They're my take on modern retro.

**FOUNDER AND CHIEF CREATIVE
OFFICER, M.I.H JEANS
/
LONDON**

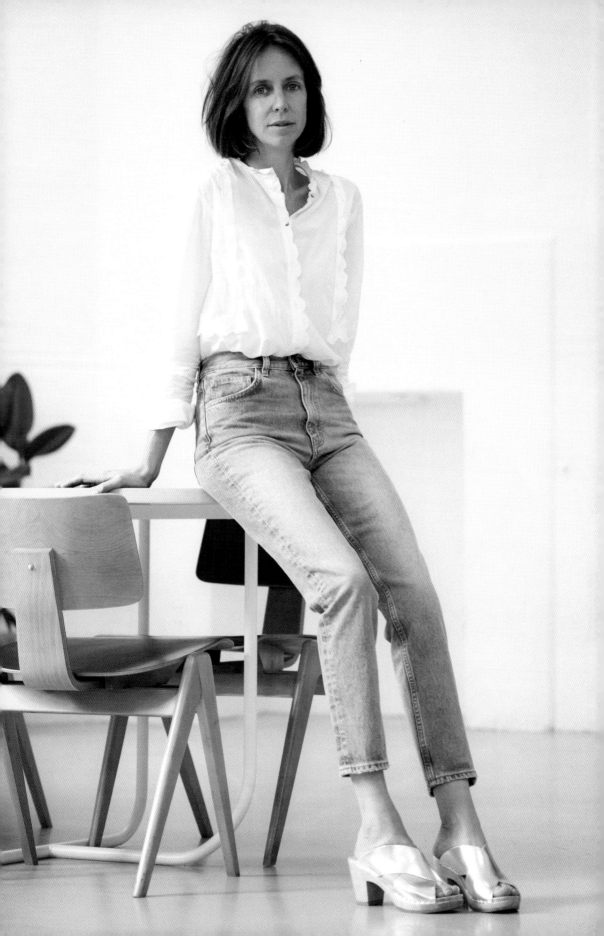

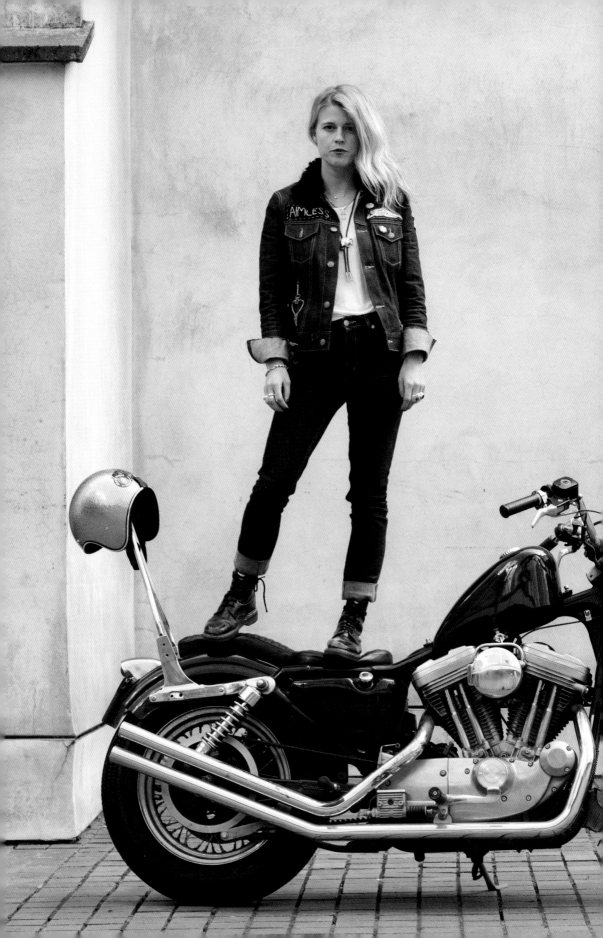

AME PEARCE,
RAW RIDER

My denim world began when I became a designer for Levi's ten years ago; this spurred my love of denim and I have been designing and collecting denim ever since. After this I started designing for Edwin where I learned to ride a motorcycle on a shoot; my motorbike obsession followed shortly. Burds was born in 2015 when I tried to combine my love of motorcycles, fashion, and denim and was struggling to find anything I could wear that looked cool to ride in. I have a studio in East London where I make our initial samples on an old Juki 563. Collecting old machines is also important to me to maintain traditional denim constructions and techniques. My all-time favorite is the 43200G Union Special and I have one of the first models from 1939.

For me wearing my denim in from raw has become the only way, so in years to come it will have a story to tell, especially the amount of road trips I intend the denim to endure. I am currently living in my Burds raw stretch selvedge and have been wearing these in for three months now; my jacket is also Burds, customized and five months worn, made from 14-oz raw Japanese selvedge.

FOUNDER AND CO-OWNER, BURDS
/
LONDON

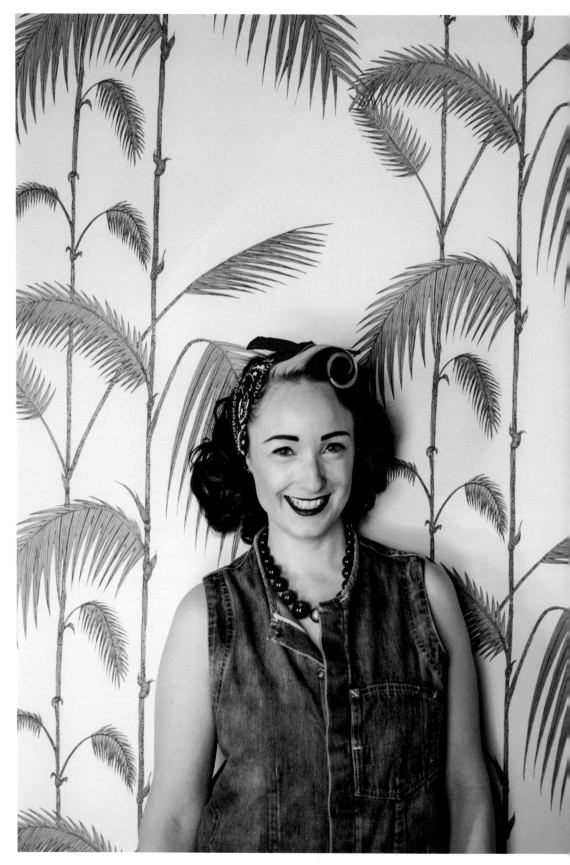

HELEN LARGE,
BLUE JEANS, RED LIPSTICK

My overalls are a pair of repro miners overalls by Levi's Vintage Clothing, I've had them around three years now and they just get better and better. I especially love them as they were an anniversary gift from my husband, Mark. At first I was unsure of whether I loved them or not; they're not my usual style of denim, which tends to be dark indigo wide leg, high waist '40s and '50s style from labels such as Freddies of Pinewood or LVC 701s. These overalls were a complete mystery to me when I first saw them; with their boxy shape they just felt odd. However, I soon managed to work out how to style them and now they're my "go to" outfit, dressing them up or down, for summer or winter. As you can see from this picture, despite covering almost all of my body, they can still give off a summer vibe with wedges and a cute headscarf. For winter I usually wear a henley underneath, a chunky cardigan and a pair of Red Wing Iron Ranger boots. I love how distressed they are, I don't feel like I'm wearing something too precious to enjoy myself in; if they get stained or ripped it just adds to them.

PERSONAL ASSISTANT, TIME INC.

/

LONDON

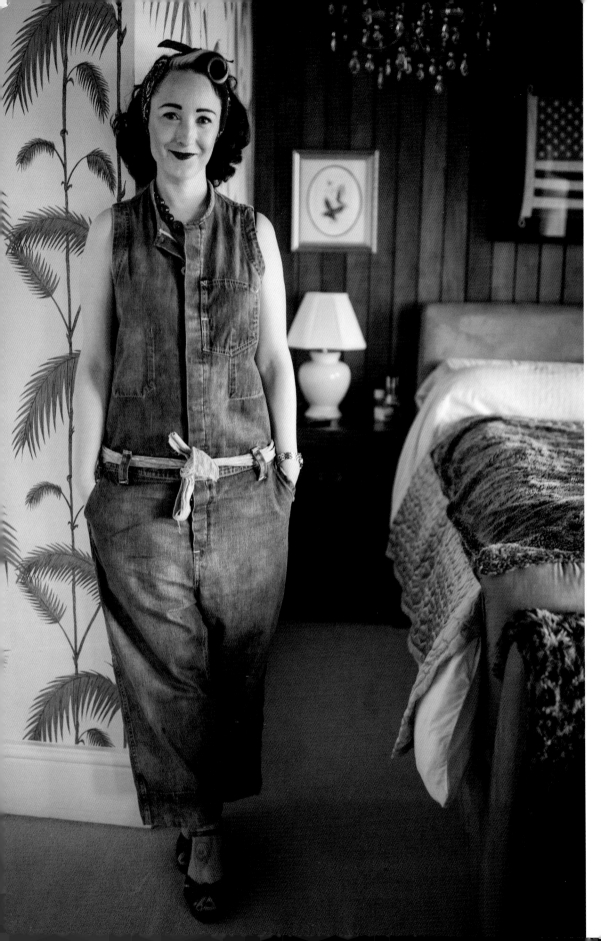

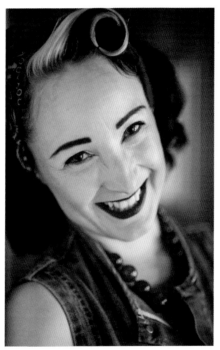
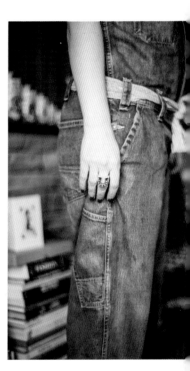

KATY RUTHERFORD,
SLOW MADE

The day of this shoot we were also shooting STORY mfg.'s AW look book in France so I pretty much just threw on my usual mix of STORY and vintage for ease. The indigo noragi is an antique that I found in Kyoto (the flea markets there are so good!) while I was researching there a few years ago. I was so pleased with it that I wore it home from the market and attracted the attention of a group of elderly Japanese passengers who were tickled that a foreigner was wearing old farm wear! Since then it's proved to be one of the most treasured and versatile pieces of my wardrobe—I love the color, the woven kasuri pattern, the incredible softness and all the little bits of wear and repair.

The trousers are STORY mfg.'s first "proper" collection and I've worn our first sample almost every other day since they were made. The jeans themselves were sewn in a small factory in England using hand-loomed natural ecru selvedge denim, then batik block printed and dipped in natural fermented indigo in India. The motto of the brand is "Slow Made," and between the hand weaving (which takes months), dyeing (days), and sewing (hours) they're one of the slowest items we ever made.

CO-OWNER, STORY MFG. AND
WORN PUBLICATIONS

LONDON AND FRANCE

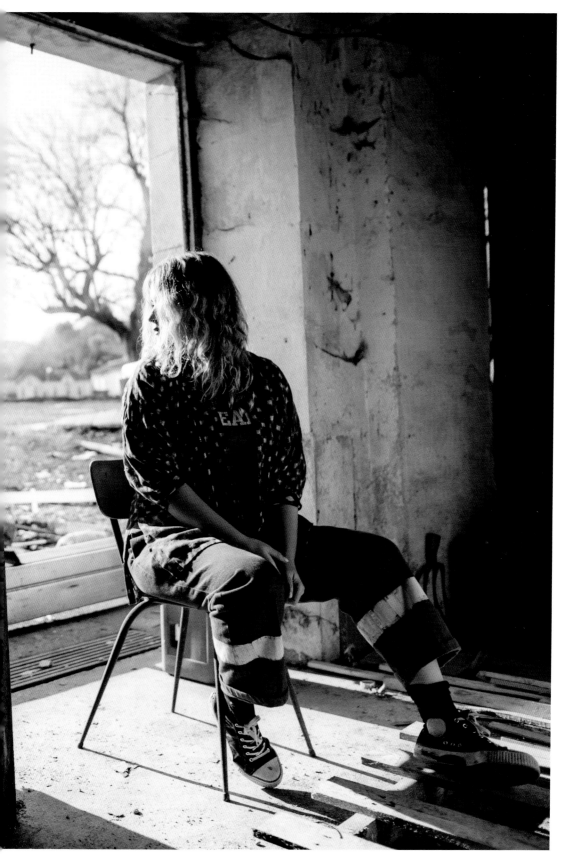

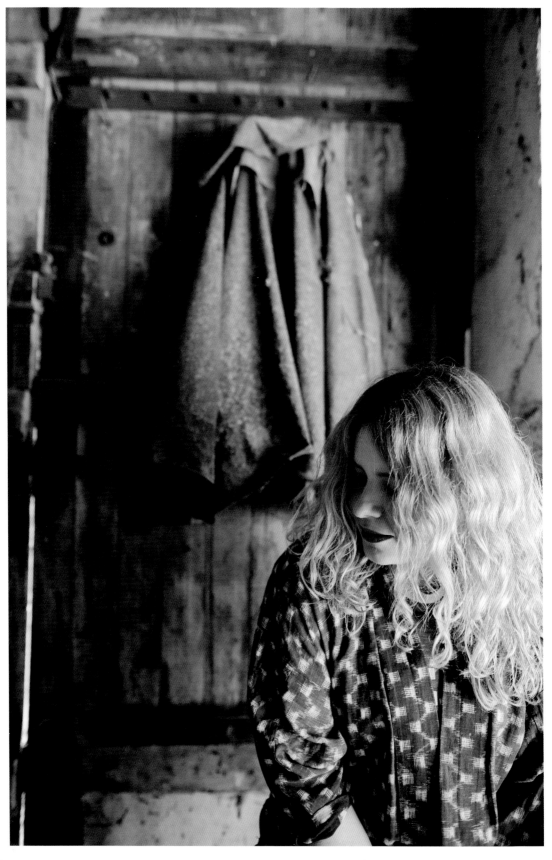

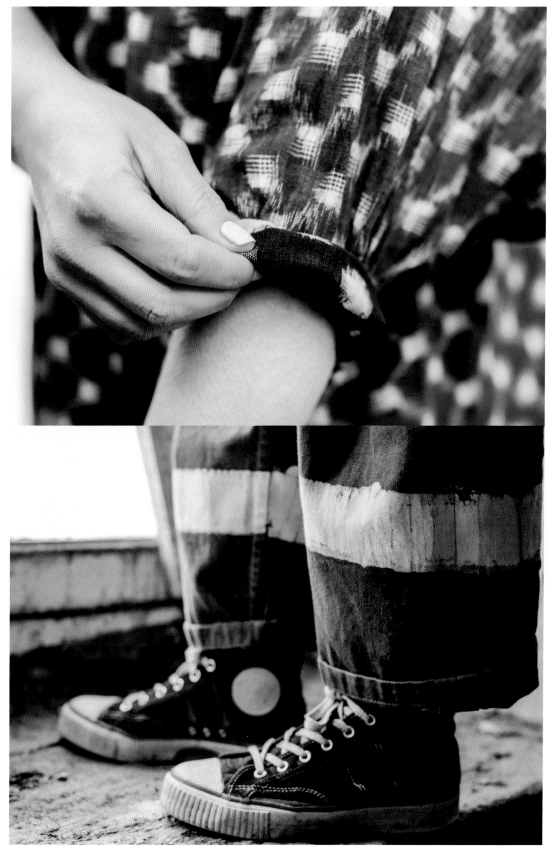

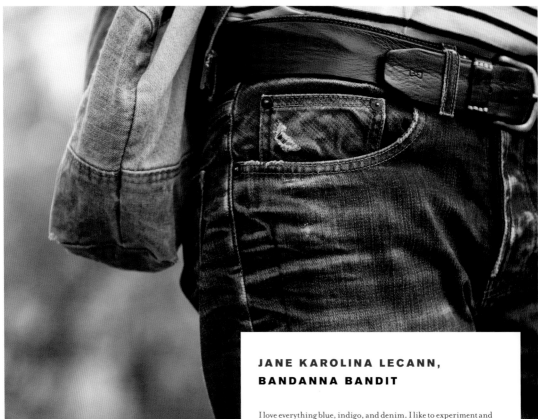

JANE KAROLINA LECANN, BANDANNA BANDIT

I love everything blue, indigo, and denim. I like to experiment and mix my denim with other shades of blue, off-white tint, and army green. I always want to create a palette and more importantly, tell a story.

My usual look is a mix of vintage, great classics from Levi's and Wrangler, custom-made pieces and clothes from independent artisans or through my label.

I am wearing a Blue Blood jean, which was a gift from my boss back when I designed for the brand—I love the depth and highlight of the fabric. My overshirt is a piece I got in a vintage clothing store in Paris that is really fitted. By examining the stitch work and finishing, it seems to be a homemade piece and I love the uniqueness of that. My cape is from Mister Bandit. It's a double weave denim: heavy, warm, and comfy (I love bandannas, scarves, capes, and layers!) My bag is from Jyumoku. I met Ted, the designer, in Los Angeles while I was street scouting. I instantly fell for his work and label. He repurposes fabrics and goods to create unique bags and accessories, and I admire and respect the ethic beyond the products. This bag mixes denim with army details and reflects my favorite color duet! It's been with me a couple of years and I always have it wherever I travel.

FOUNDER, BLEU-INDIGO BLOG OWNER AND CREATIVE DIRECTOR, MISTER BANDIT
/
PARIS

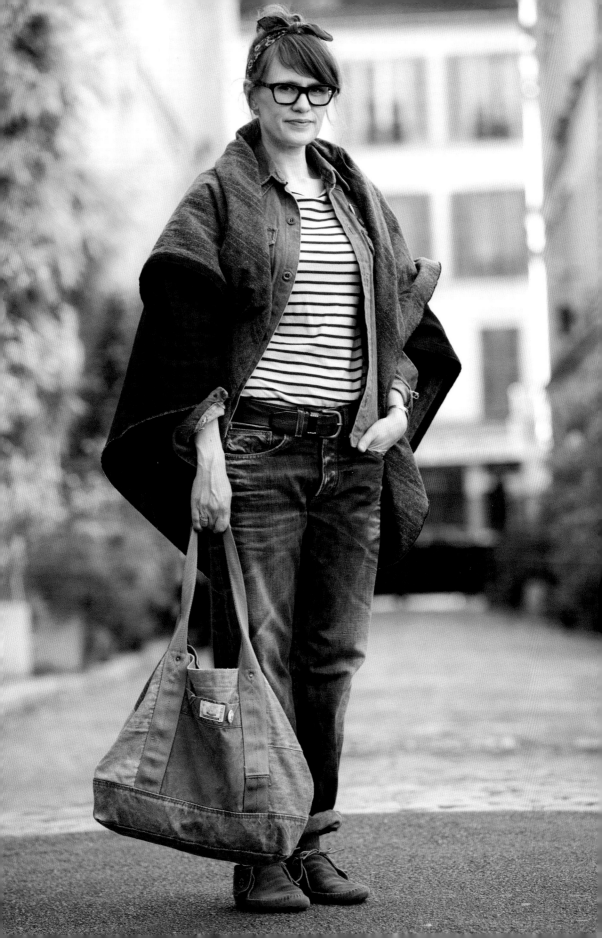

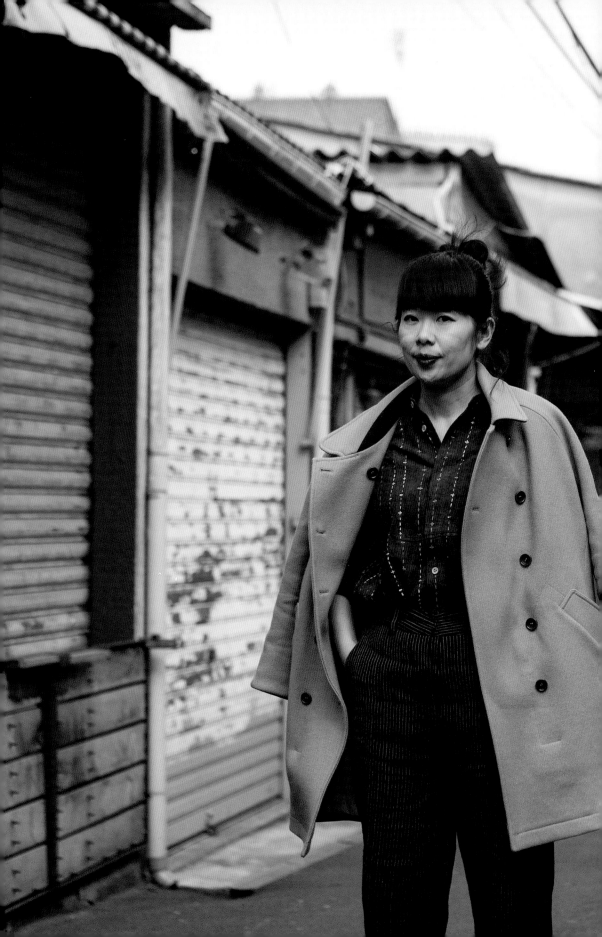

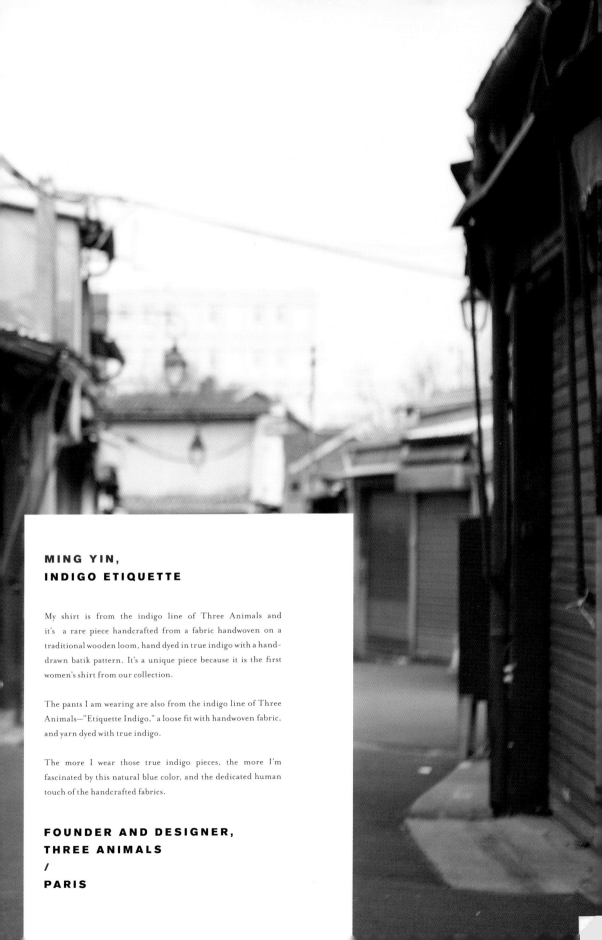

MING YIN,
INDIGO ETIQUETTE

My shirt is from the indigo line of Three Animals and it's a rare piece handcrafted from a fabric handwoven on a traditional wooden loom, hand dyed in true indigo with a hand-drawn batik pattern. It's a unique piece because it is the first women's shirt from our collection.

The pants I am wearing are also from the indigo line of Three Animals—"Etiquette Indigo," a loose fit with handwoven fabric, and yarn dyed with true indigo.

The more I wear those true indigo pieces, the more I'm fascinated by this natural blue color, and the dedicated human touch of the handcrafted fabrics.

FOUNDER AND DESIGNER,
THREE ANIMALS
/
PARIS

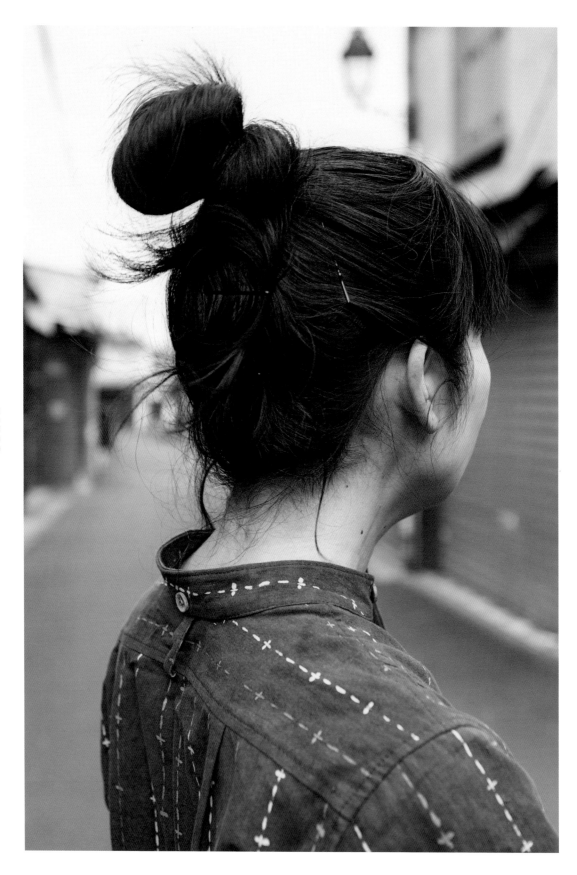

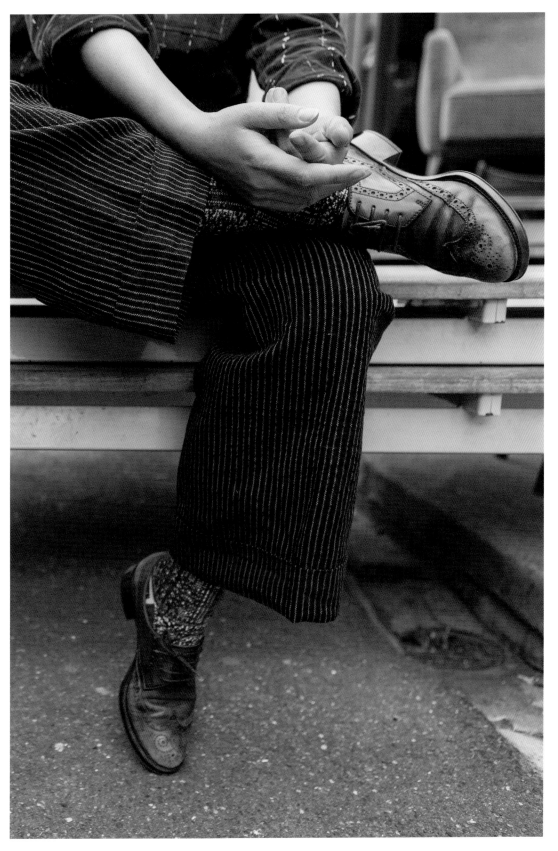

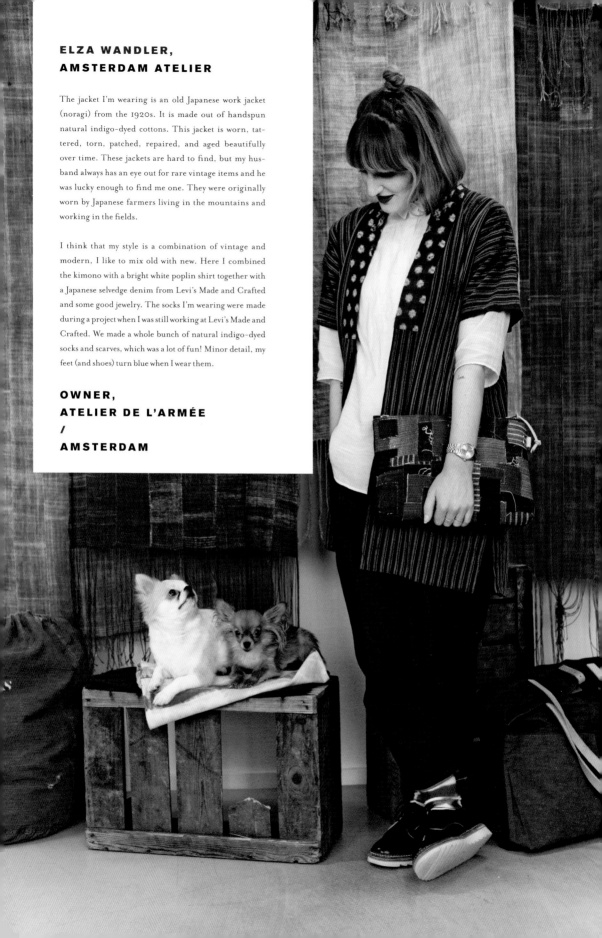

ELZA WANDLER,
AMSTERDAM ATELIER

The jacket I'm wearing is an old Japanese work jacket (noragi) from the 1920s. It is made out of handspun natural indigo-dyed cottons. This jacket is worn, tattered, torn, patched, repaired, and aged beautifully over time. These jackets are hard to find, but my husband always has an eye out for rare vintage items and he was lucky enough to find me one. They were originally worn by Japanese farmers living in the mountains and working in the fields.

I think that my style is a combination of vintage and modern, I like to mix old with new. Here I combined the kimono with a bright white poplin shirt together with a Japanese selvedge denim from Levi's Made and Crafted and some good jewelry. The socks I'm wearing were made during a project when I was still working at Levi's Made and Crafted. We made a whole bunch of natural indigo-dyed socks and scarves, which was a lot of fun! Minor detail, my feet (and shoes) turn blue when I wear them.

OWNER,
ATELIER DE L'ARMÉE
/
AMSTERDAM

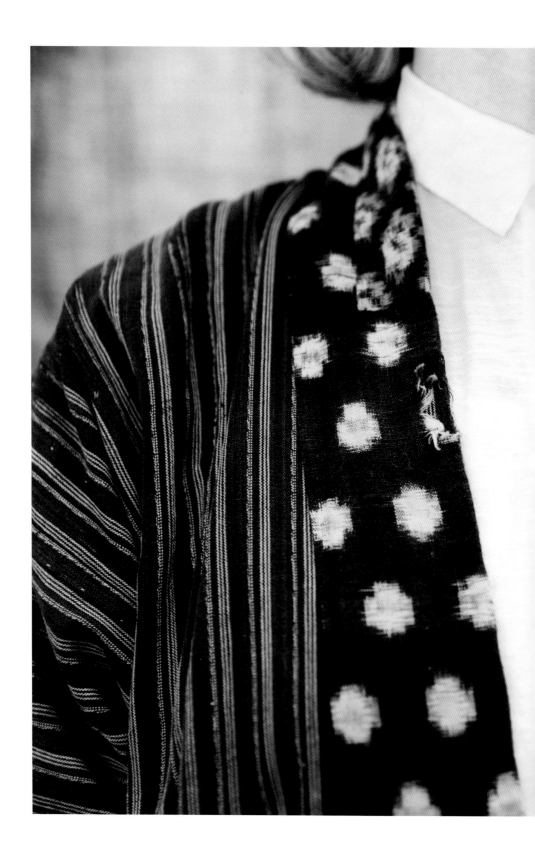

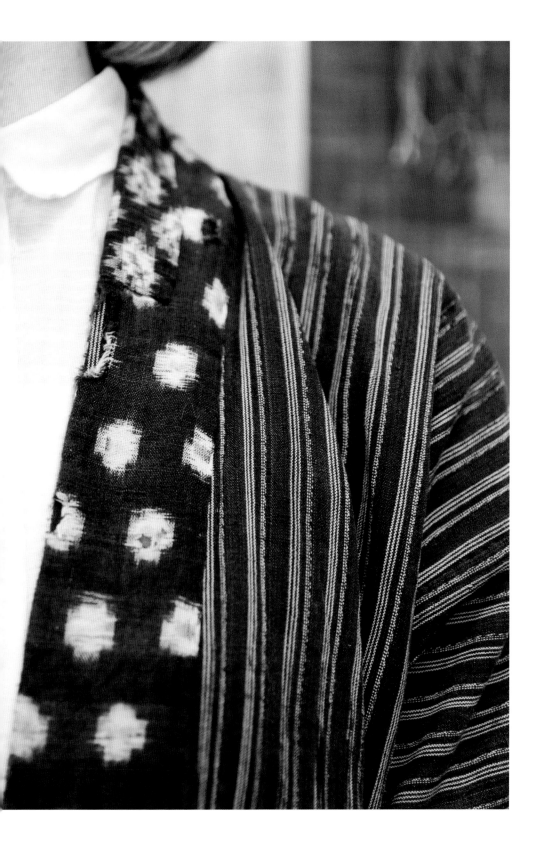

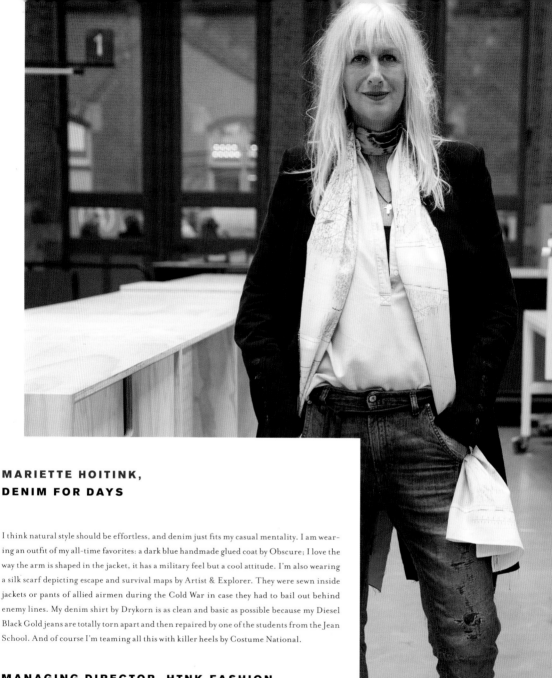

MARIETTE HOITINK,
DENIM FOR DAYS

I think natural style should be effortless, and denim just fits my casual mentality. I am wear-
ing an outfit of my all-time favorites: a dark blue handmade glued coat by Obscure; I love the
way the arm is shaped in the jacket, it has a military feel but a cool attitude. I'm also wearing
a silk scarf depicting escape and survival maps by Artist & Explorer. They were sewn inside
jackets or pants of allied airmen during the Cold War in case they had to bail out behind
enemy lines. My denim shirt by Drykorn is as clean and basic as possible because my Diesel
Black Gold jeans are totally torn apart and then repaired by one of the students from the Jean
School. And of course I'm teaming all this with killer heels by Costume National.

MANAGING DIRECTOR, HTNK FASHION
RECRUITMENT & CONSULTANCY

COFOUNDER, HOUSE OF DENIM, DENIM CITY,
JEAN SCHOOL, AND AMSTERDAM DENIM DAYS
/
AMSTERDAM

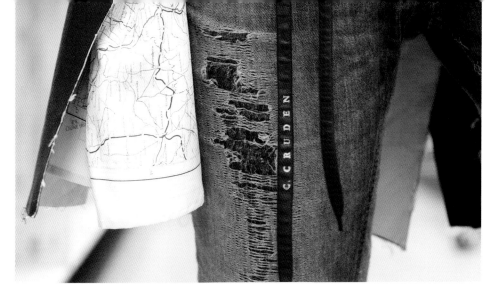

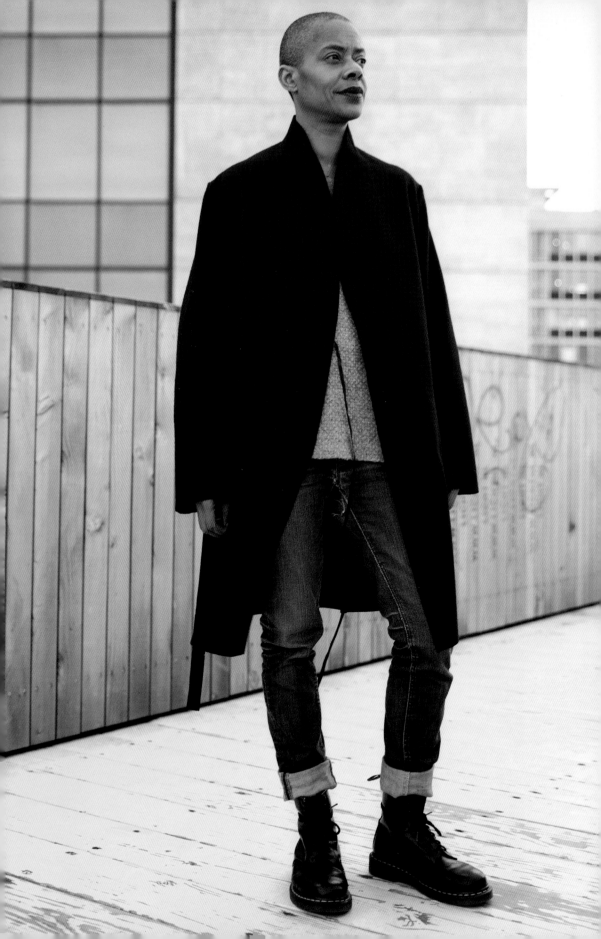

C. CRUDEN,
LUXE DU TRAVAIL

The vision I have for my brand is to merge the idea of "style du travail" with the concept of luxury—making a simple garment like a dust coat combined with the traditional kimono. Exactly like the coat I'm wearing; it's a C. Cruden and it is precisely what I just described; a combo between a dustcoat and a kimono. Not only do I enjoy the idea of merging workmen's clothes with the essence of something fancy, I also take to the idea of timelessness; in my opinion that means something simple that directly translates to the jeans I'm wearing. They are from April '77, and as one can see right away they are have survived many a mending! I LOVE KINTSUGI. That kind of wear gives clothes some character, and those are the kind of clothes I enjoy wearing. Next up is my C. Cruden sweater; it's also a combo of a kimono and the traditional idea of a sweater. I've felted it by hand and with a lot of love.

And last but not least are the Dr. Martens on my feet, they're comfy, they were just laying around for five years in my home so I attached them to my body.

OWNER, C. CRUDEN
/
ROTTERDAM

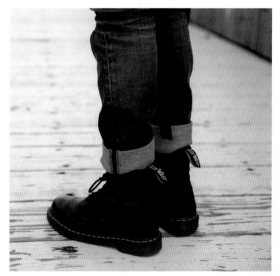

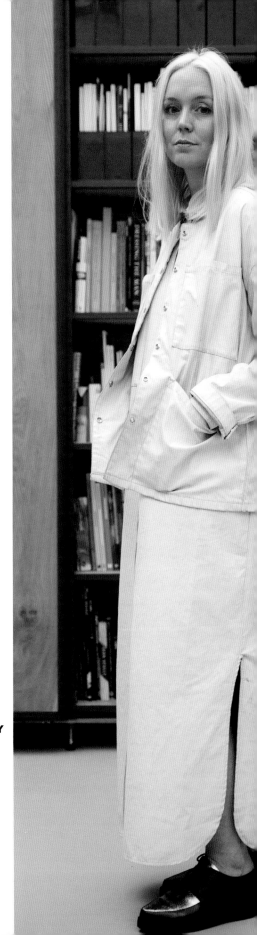

ALEXANDRA MELGAARD LEWTY, WASTE-LESS

I'm donning a calf-length shirtdress by INK that uses denim from Royo Mills. Our entire collection is made using leftover fabrics from production houses. Our brand stands for INKLUSIVE. We wanted to promote the entire community that stands behind denim. It came about from seeing so much waste thanks to the fast pace of the industry. So we decided to make collections based on leftover fabrics, using age-old techniques handcrafted by people who have been working with denim for generations. Everything we buy now is about newness, about the next trend . . . yet with denim, it's about looking back as a means of looking forward. We can learn so much from the industry if only we would make the time to listen.

For us, it is about so much more than another pair of indigo blue jeans.

This dress is coated with white, mattelike paint that washes down beautifully. The back has a lasered layer off the top of the coating, which reveals the natural color of the denim underneath. It is about one to two shades in difference. I like the idea of a twinset, but not the knitted kind you wear with pearls. I wear this shirtdress with its matching box cut denim jacket with oversize pockets. It is finished in shiny silver hardware detail.

I'm not your typical denim fan. I've been described as a comfy pair of jeans, but that is only due to my friendly nature, not because you will catch me in a pair. I am rarely in a pair of blues but I have an appreciation for them. I live with an enormous amount of vintage denim. One piece, found in Beyond Retro off Brick Lane, I am particularly proud of—a flared 1970s padded Levi's ski suit. Not quite the look I was going for in this shoot but it sure is a special find.

DESIGNER AND COFOUNDER, INK INKLUSIVE AND THE STYLE FOUNDRY
/
AMSTERDAM

DENIM

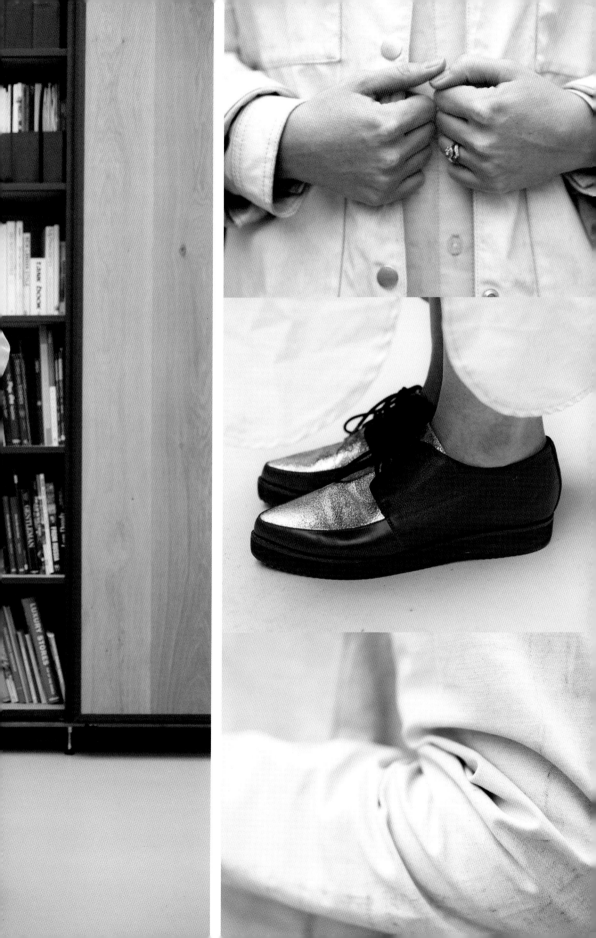

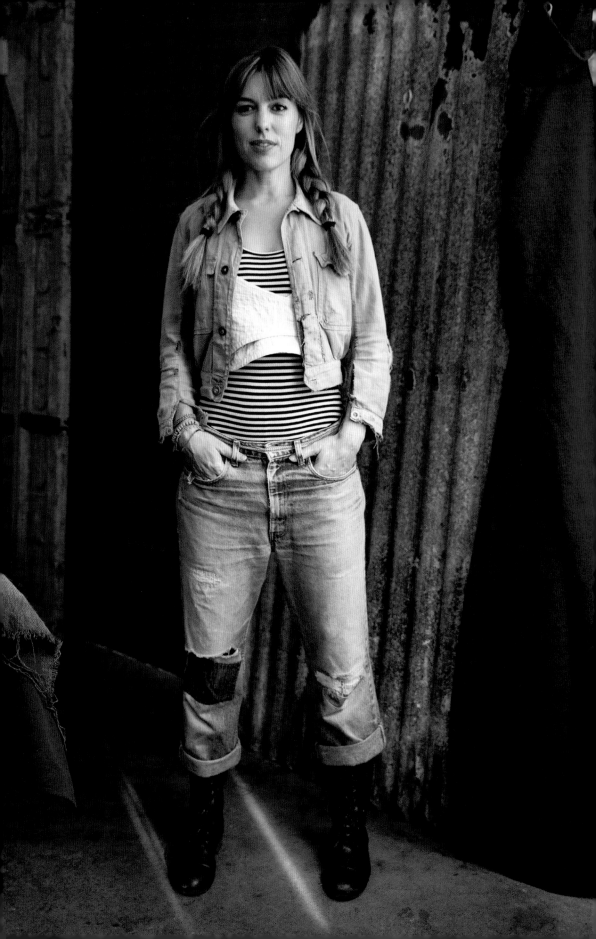

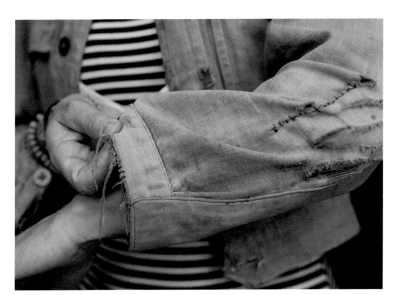

ROOS BRANCOVICH,
WORKWEAR BLUES

I've been suffering from "Work Wear Blues" ever since fate kindly landed me my first job with a denim guru. As her assistant I discovered denim's complexity and its history. A material rooted in the past, it carried me into my future as a designer. While countless technical terms became my professional vocabulary, I always found denim's poetry in the timeworn garments my passion and fascination led me to acquire.

Fifteen years in this industry and I'm still wearing the same rags I bought years ago. But as I say, "As long as it's blue with a story to sell me." In this picture I'm wearing a pair of old Levi's that I found in a small vintage shop in downtown Manhattan. There was a long period I wore these daily, so most of their patina is my doing. Repairs over repairs.

The French worker jacket is a true find and should be in a museum if you ask me. Beautifully faded and falling apart, it was repeatedly patched by the original owner's rough hands. Underneath I'm wearing a kid's corset held together by a spiderweb of delicate stitches. Caught in that fragile tangle is a butterfly patch, bought early one winter's morning from a market stand.

FREELANCE DESIGNER

/

AMSTERDAM

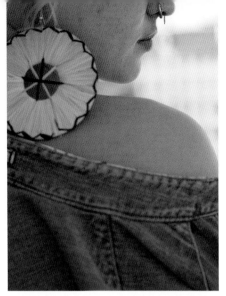

PAULA KUNKEL,
CUSTOMIZED ART

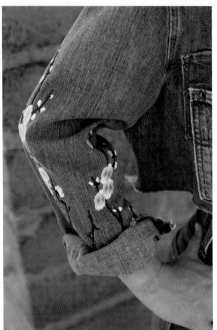

What I realized creating this outfit is that for me to truly connect with denim it has to have my personal handwriting on it, even if it's just a small signature. Denim is timeless, denim is classic, but I am not. As a self-proclaimed textile artist I have been working for Levi's Germany for more than a year now and have been lucky enough to meet numerous musicians, influencers, and fashion bloggers to "Paularize" their clothes. As an artist, denim has become the most beautiful canvas for me because it enabled me to express my thoughts freely. My denim mission has just barely started. Regarding my personal style, my heart beats for two-pieces! I got pretty excited when I picked this culotte from the Levi's Store because the wide crop of these jeans leave lots of speace for me to customize. After I discovered those gorgeous flower applications while viewing fabrics in the market, I started browsing my atelier for the matching second piece to this combo. I decided to take a shirt with already broken buttons, cut off the collars and bands and sew a pocket on the chest part. I really love this outfit because even though it's been made so easily, it has a bold effect and just screams "I feel good!"

FASHION ARTIST
/
BERLIN

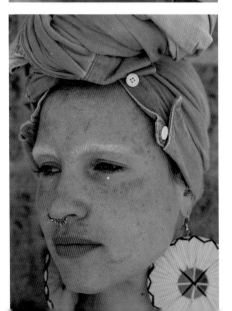

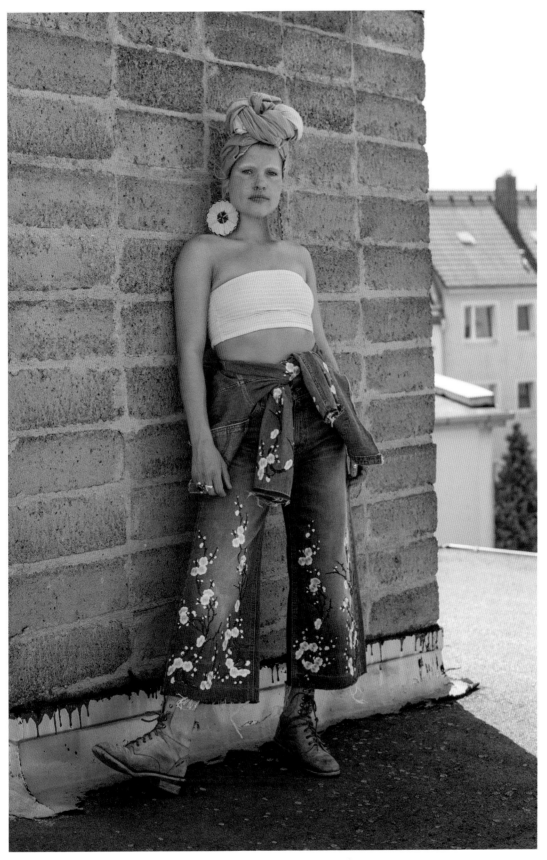

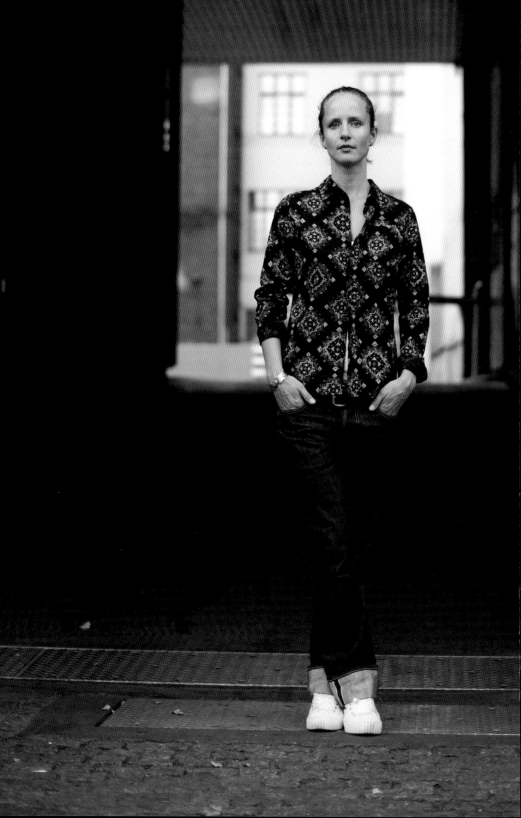

MARIA KLÄHN
ANDROGYNOUS ELEGANCE

To be honest, my love for all things denim and indigo only really began with Burg & Schild, the shop that I own. But I have always appreciated blue tones and the simplicity and straightforwardness of menswear. My favorites among the brands that we carry are the Japanese ones; I like how their clothes are somewhat androgynous and elegant in a way that lets the wearer take second place, while the clothes speak for themselves. A perfect example of this is the paisley shirt I'm wearing, which is made by Pure Blue Japan. All of their clothes are dyed with indigo and fade uniquely over time. I'm also wearing a pair of Edwin ED-71s, my favorite jeans and the first selvedge denim I ever bought. They've never been washed! My collection has since grown and some of my other favorites are by Pure Blue Japan, Iron Heart, and Rogue Territory, but the ED-71s are still number one. I have a big soft spot for jewelry, especially if there's any blue involved, so this turquoise bracelet I picked up from Iron Heart has become my constant companion.

OWNER, BURG & SCHILD
/
BERLIN

FRANCESCA PAVONI, APRON CHIC

I'm not a great expert of denim, but I wear it every day. Comfort is the most important thing for me, especially for my work (I'm a cinematographer), and being wrapped in it feels like being wrapped with a soft blanket. Even if I'm not a cook (or chef), I'm wearing my beloved denim apron by Blue Blanket that my father gave to me when he bought a few for his shop. I'm really attached to it because it's comfortable, light, and stylish but at the same time functional for cooking. Plus it's from my dad who always knows what's best for me. Believe it or not, my dishes aren't the same if I cook them without it! As in my everyday life, I'm also wearing high waist American Apparel jeans and a white Tee with one of the hundreds pair of shoes I have, a pair of awesome limited-edition Nike Air Max Zero.

FREELANCE DIRECTOR OF PHOTOGRAPH AND EDITOR, C 41 MAGAZINE
/
MILAN

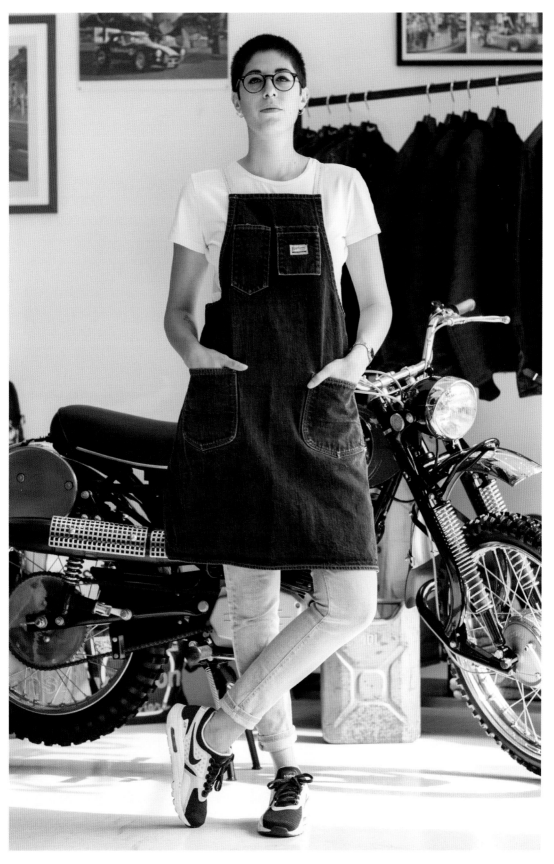

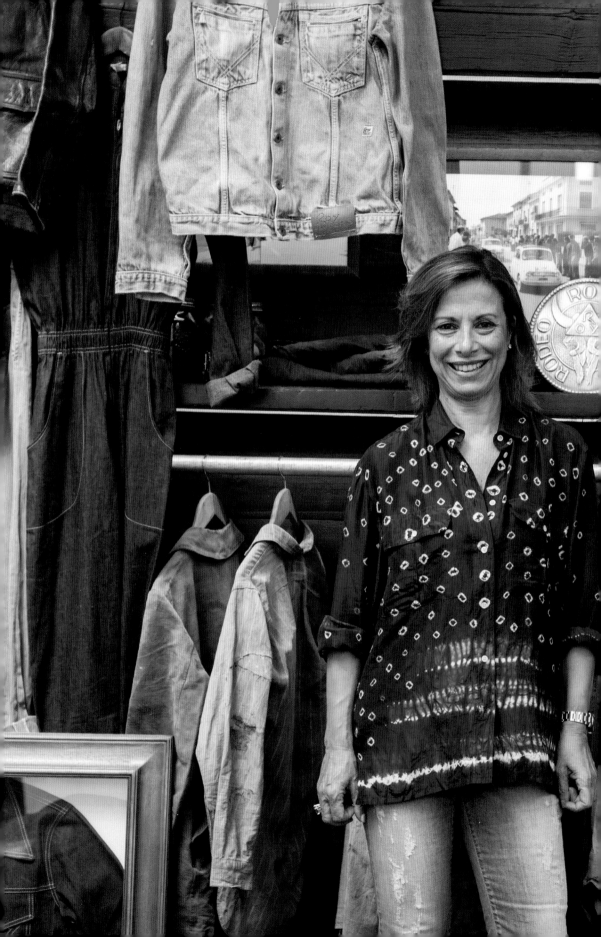

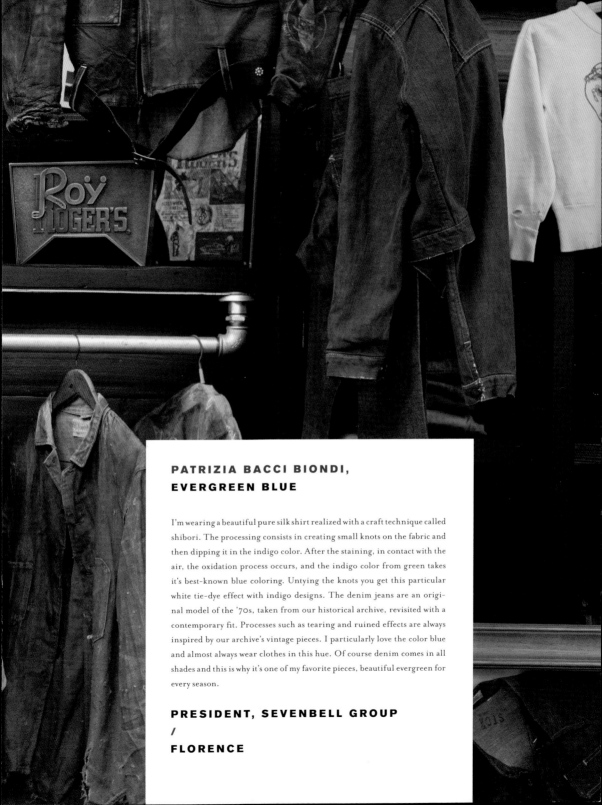

PATRIZIA BACCI BIONDI, EVERGREEN BLUE

I'm wearing a beautiful pure silk shirt realized with a craft technique called shibori. The processing consists in creating small knots on the fabric and then dipping it in the indigo color. After the staining, in contact with the air, the oxidation process occurs, and the indigo color from green takes it's best-known blue coloring. Untying the knots you get this particular white tie-dye effect with indigo designs. The denim jeans are an original model of the '70s, taken from our historical archive, revisited with a contemporary fit. Processes such as tearing and ruined effects are always inspired by our archive's vintage pieces. I particularly love the color blue and almost always wear clothes in this hue. Of course denim comes in all shades and this is why it's one of my favorite pieces, beautiful evergreen for every season.

PRESIDENT, SEVENBELL GROUP
/
FLORENCE

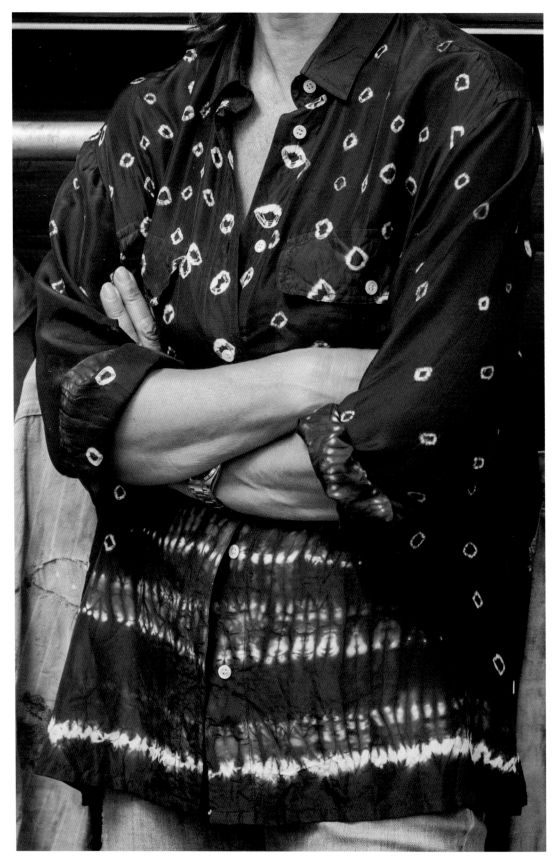

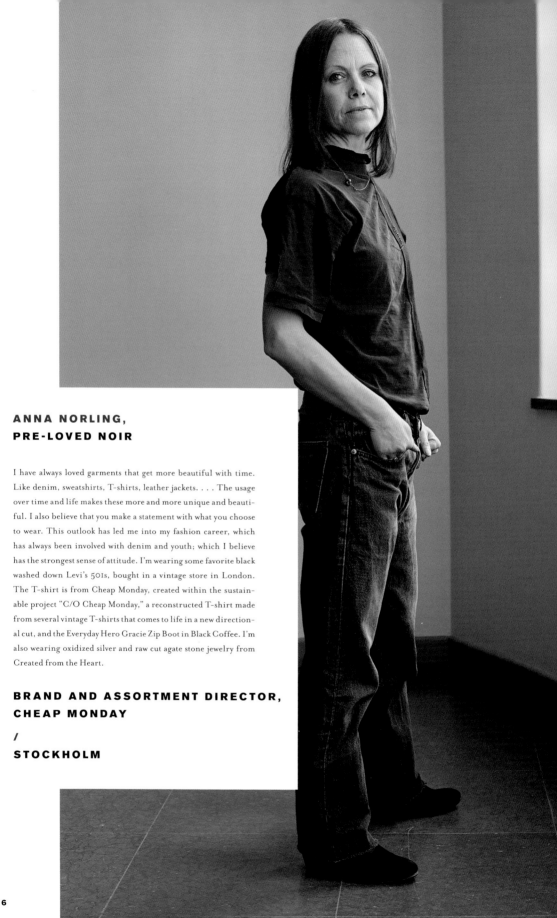

ANNA NORLING,
PRE-LOVED NOIR

I have always loved garments that get more beautiful with time.
Like denim, sweatshirts, T-shirts, leather jackets. . . . The usage
over time and life makes these more and more unique and beauti-
ful. I also believe that you make a statement with what you choose
to wear. This outlook has led me into my fashion career, which
has always been involved with denim and youth; which I believe
has the strongest sense of attitude. I'm wearing some favorite black
washed down Levi's 501s, bought in a vintage store in London.
The T-shirt is from Cheap Monday, created within the sustain-
able project "C/O Cheap Monday," a reconstructed T-shirt made
from several vintage T-shirts that comes to life in a new direction-
al cut, and the Everyday Hero Gracie Zip Boot in Black Coffee. I'm
also wearing oxidized silver and raw cut agate stone jewelry from
Created from the Heart.

BRAND AND ASSORTMENT DIRECTOR,
CHEAP MONDAY

/

STOCKHOLM

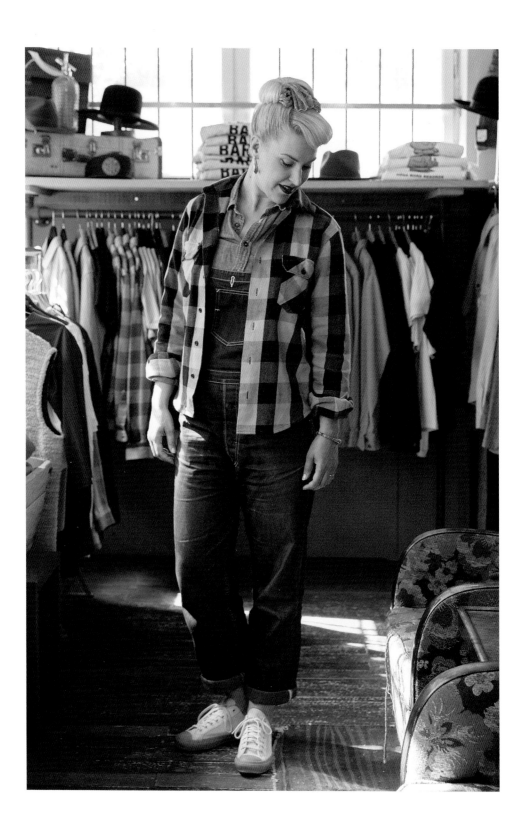

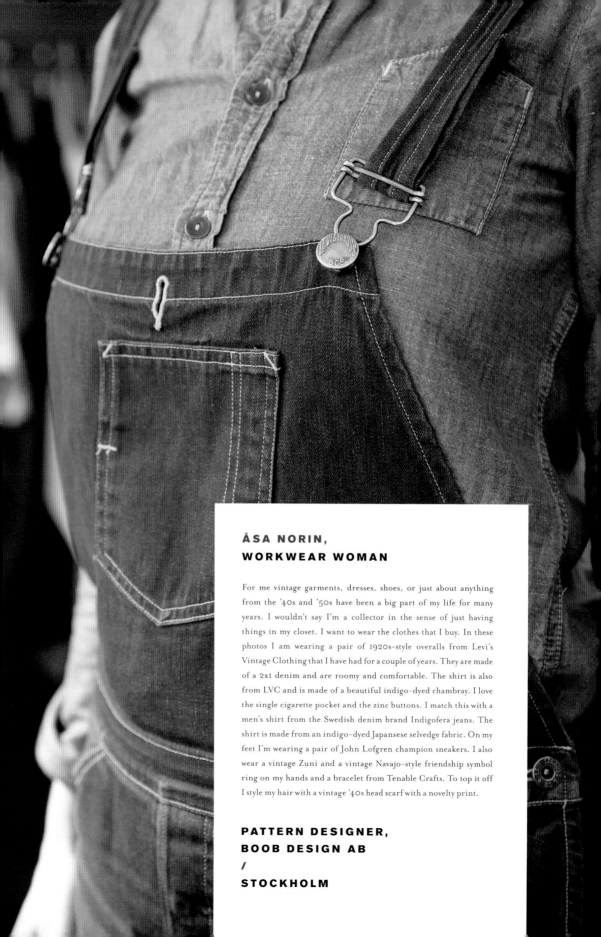

ÅSA NORIN,
WORKWEAR WOMAN

For me vintage garments, dresses, shoes, or just about anything from the '40s and '50s have been a big part of my life for many years. I wouldn't say I'm a collector in the sense of just having things in my closet. I want to wear the clothes that I buy. In these photos I am wearing a pair of 1920s-style overalls from Levi's Vintage Clothing that I have had for a couple of years. They are made of a 2x1 denim and are roomy and comfortable. The shirt is also from LVC and is made of a beautiful indigo-dyed chambray. I love the single cigarette pocket and the zinc buttons. I match this with a men's shirt from the Swedish denim brand Indigofera jeans. The shirt is made from an indigo-dyed Japansese selvedge fabric. On my feet I'm wearing a pair of John Lofgren champion sneakers. I also wear a vintage Zuni and a vintage Navajo-style friendship symbol ring on my hands and a bracelet from Tenable Crafts. To top it off I style my hair with a vintage '40s head scarf with a novelty print.

PATTERN DESIGNER,
BOOB DESIGN AB
/
STOCKHOLM

ASIA AND AUSTRALIA

JAPANESE DENIM
IS FAMOUS

the world over for its artisanal approach and respect of craft. But in the world of women's denim, is that lost in translation? Hell no, jeans are a serious business in Japan and women know far more than their warp from their weft. Tokyo is teaming with denim dudettes from the tomboy girls of Beams to the Kapital heads and slow-made maniacs of 45rpm. And don't even get me started on Kojima, Japan's denim mecca. This is the place where even seventy-year-old grandmothers have been known to spend serious yen on rare, artisanal indigo. Among the purists are the Harajuku kids who embrace directional silhouettes and crazy detailing, inspiring the West's future denim trends.

China is fast becoming an emerging fashion superpower and the world's biggest exporter of denim, so it's no surprise that the country has become home to a slew of incredible makers, dyers, and designers. Australian brands are a scene, in between Los Angeles's surf-psyche laid-back vibe—see Ksubi and Rolla's—and a more Euro-centric indie approach from brands such as Neuw Denim. Aussie denim style is creating brand buzz all over the globe. Thailand is an unlikely denim destination, but one that is home to fledgling denim brands, factories, designers, and some of the world's craziest vintage dealers. If you've ever braved a day in Bangkok's sweltering Chatuchak market, you'll know this is a hidden gem for street style and the very rarest denim. Head to the north of the country, to the villages of Chiang Mai, and you'll find women who are keeping Thailand's incredible indigo crafts alive.

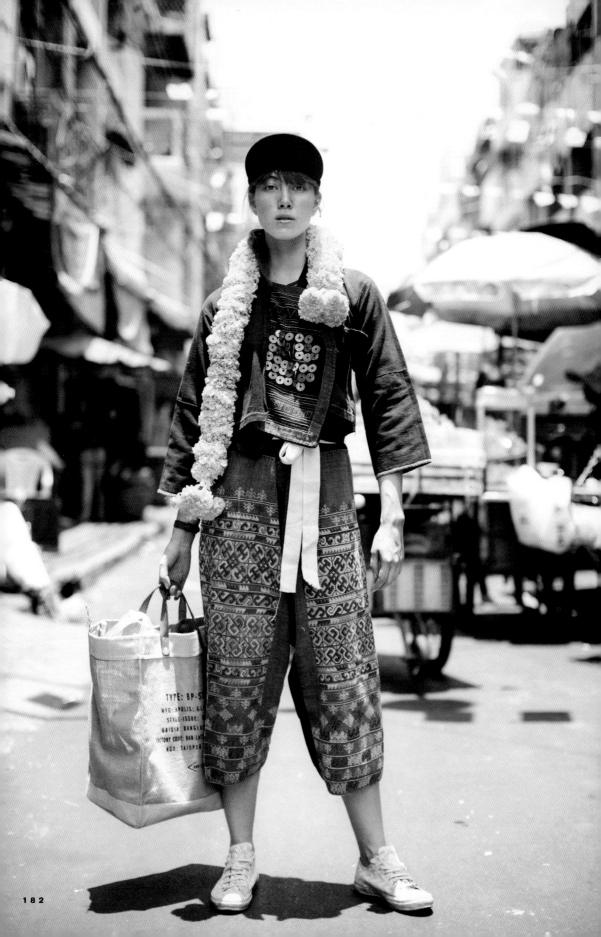

ROMANTIQUE

I am a nerdy collector of antique Southeast Asian textiles. It's in my blood, and this journey of mine has uncovered small clues about my heritage as a Thai-Chinese-British-Australian who is keen on history and a hopeless romantic in some respects. Fabrics have the incredible power to tell stories through color, pattern, fiber, and detail, so my outfit can be considered a story woven over a small lifetime some hundred—two hundred years ago. The jacket I'm wearing is of blue Hmong origin. I have been able to date it back some two hundred years thanks to the coins that are sewn into the breast as an elaborate detail (and they make an incredible sound when you wear it). The Hmong people are spread around hidden corners from the southern tip of China and into Southeast Asia. As a minority group, they have been displaced by war yet are so proud of their beautiful fabrics and heirloom rice varieties. They believe in the spirit world and in the interconnectedness of all living things, and, I have found many pieces that clearly show this through details like cocoon fringing, or randomly woven color thanks to whatever was growing at the time.

This was a personal gift given to me by one of the region's biggest collectors and her adoptive daughter, a Hmong lady named Si. I still receive the most delicious heirloom rice from her extended family who live on the land and practice the lifestyle of their great ancestors. The pants are also old enough to be considered antique. They are from Laos and are a lovely combination of handwoven silk, silk embroidery, and an organic fiber dyed in indigo. It feels like a fine banana fiber to me, but I can't be sure. I wear them like fishermen's pants, using some cotton twill taping to fasten them to my waist, but you should really fold them with enough skill that they won't fall off all day. My collection is special to me because it maps out my past and reminds me of a connection to the world that is more than just "having," but rather the beautiful state of "being."

PONYTAIL JOURNAL
/
BANGKOK

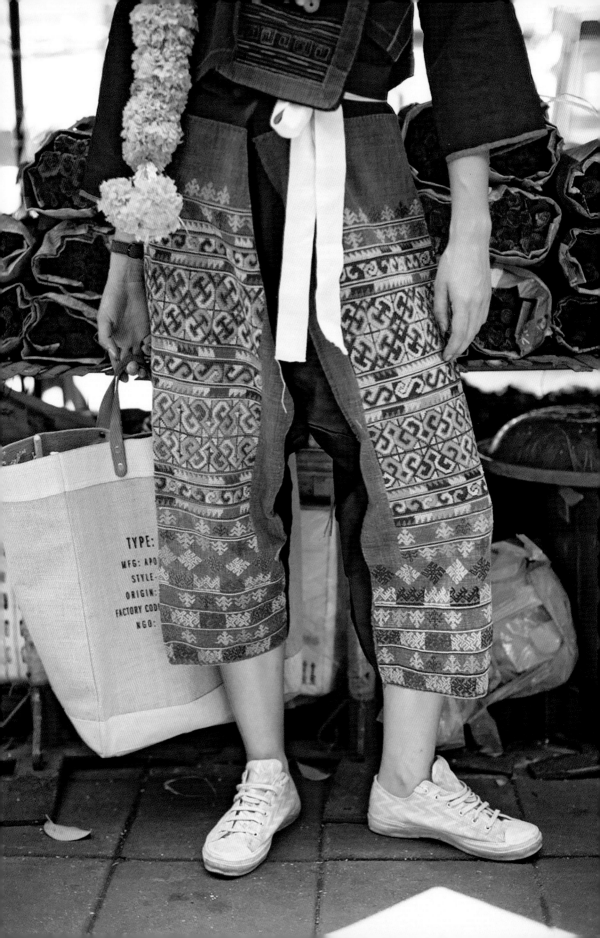

TYPE:
MFG: APO
STYLE:
ORIGIN:
FACTORY CODE
NGO:

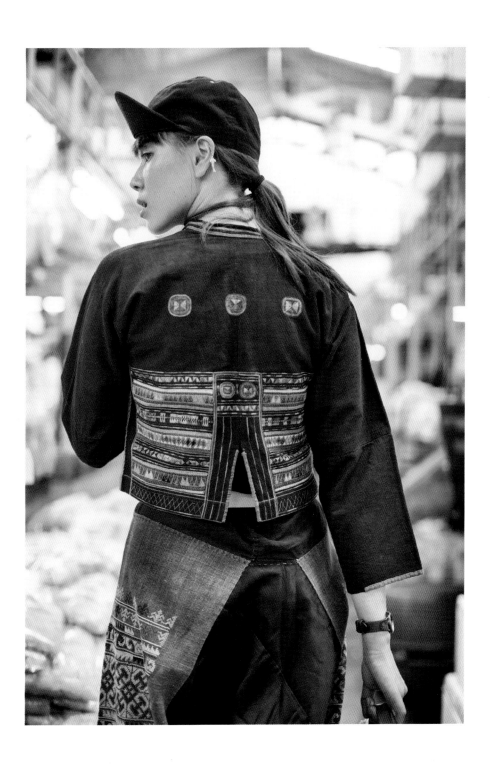

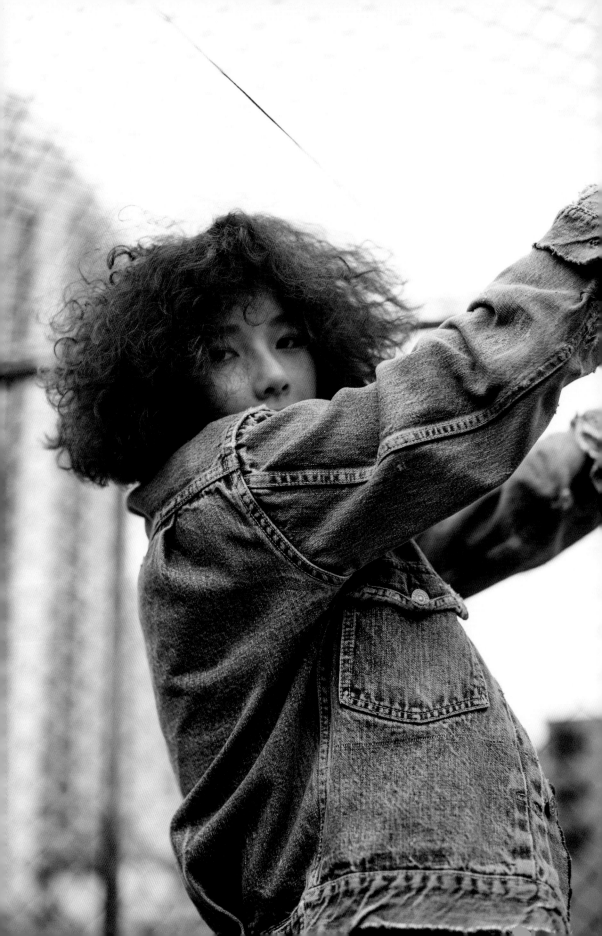

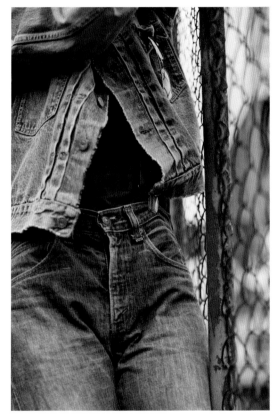
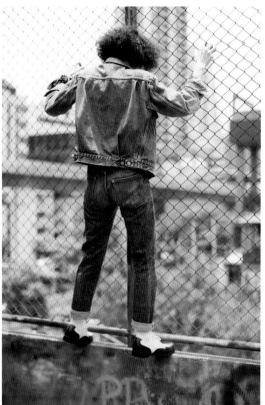

MASHANNOAD SUVANAMAS,

BANGKOK VINTAGE BABE

I get all my vintage clothes from my friend's store Bangklyn in Bangkok. I love to dress mostly in vintage but don't know enough about the eras and details to hunt for it myself so I always go to my friends and they teach me. I'm wearing a 1927 Bangklyn Indigo T-shirt, a 1950s 507 Levi's jacket, and 1970s Levi's 505 jeans with a pair of 1960s Onisuka two-tone shoes.

MODEL AND ACTRESS
/
BANGKOK

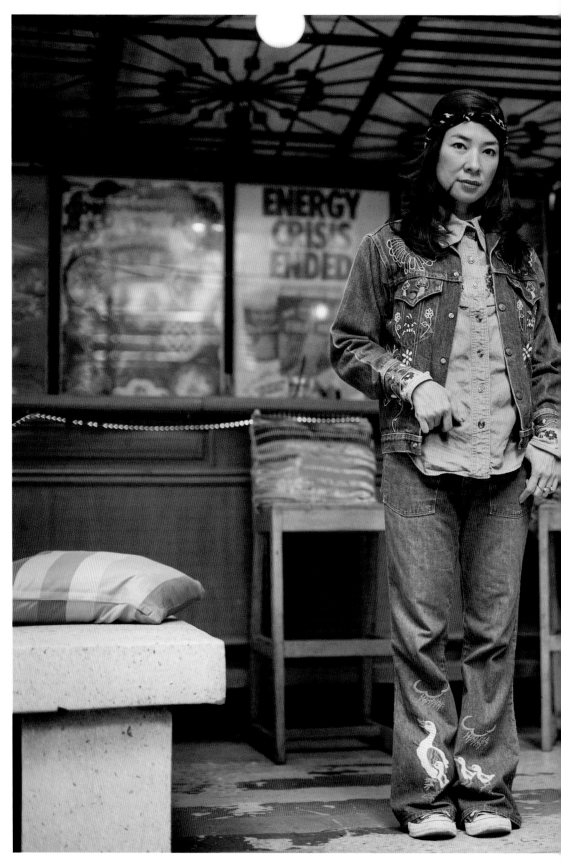

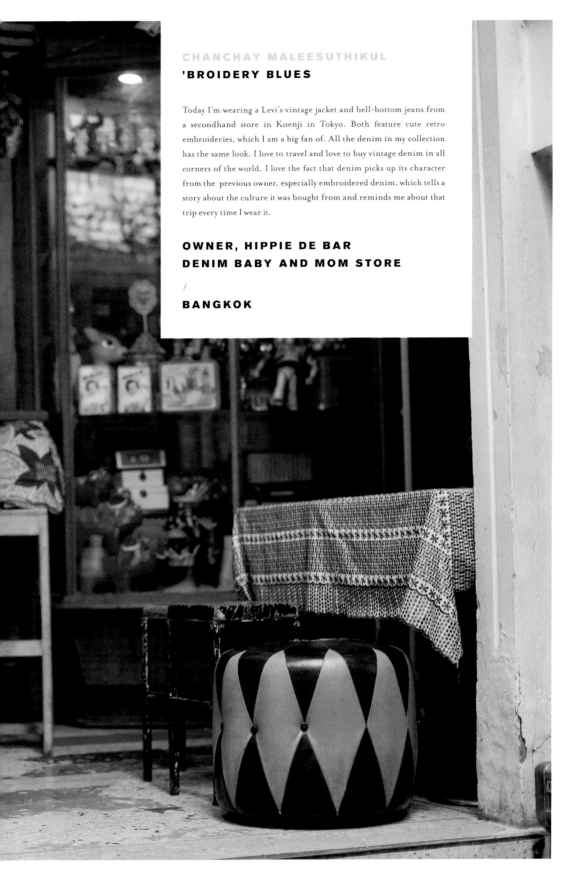

'BROIDERY BLUES

Today I'm wearing a Levi's vintage jacket and bell-bottom jeans from a secondhand store in Koenji in Tokyo. Both feature cute retro embroideries, which I am a big fan of. All the denim in my collection has the same look. I love to travel and love to buy vintage denim in all corners of the world. I love the fact that denim picks up its character from the previous owner, especially embroidered denim, which tells a story about the culture it was bought from and reminds me about that trip every time I wear it.

OWNER, HIPPIE DE BAR
DENIM BABY AND MOM STORE

/

BANGKOK

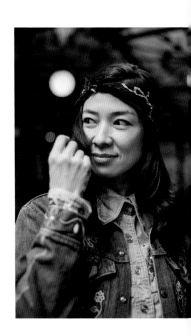

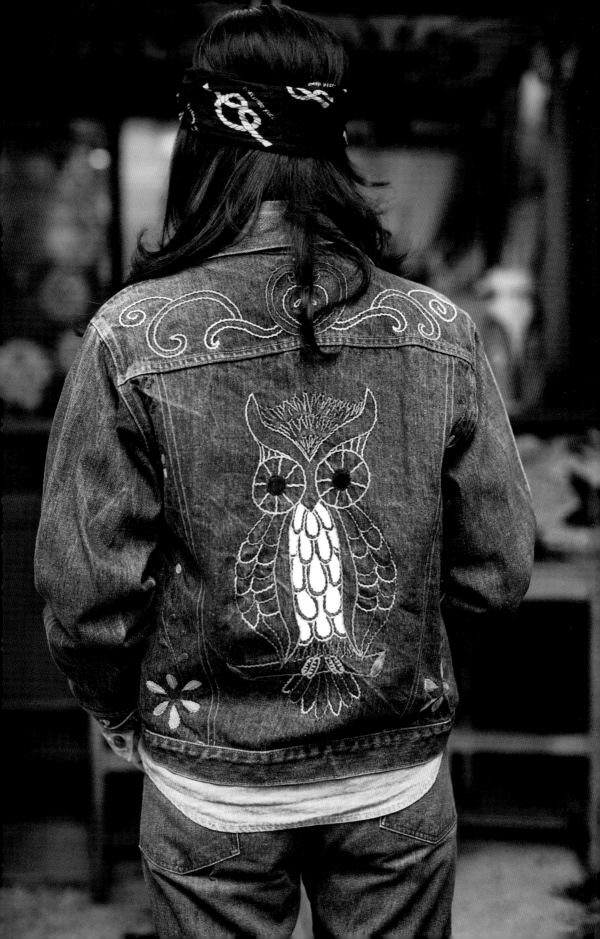

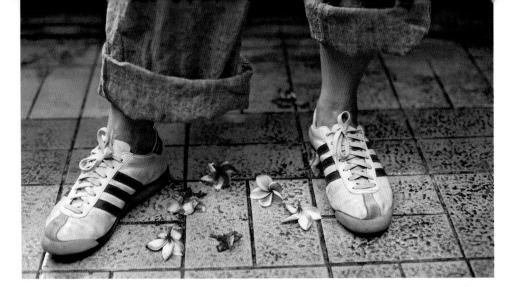

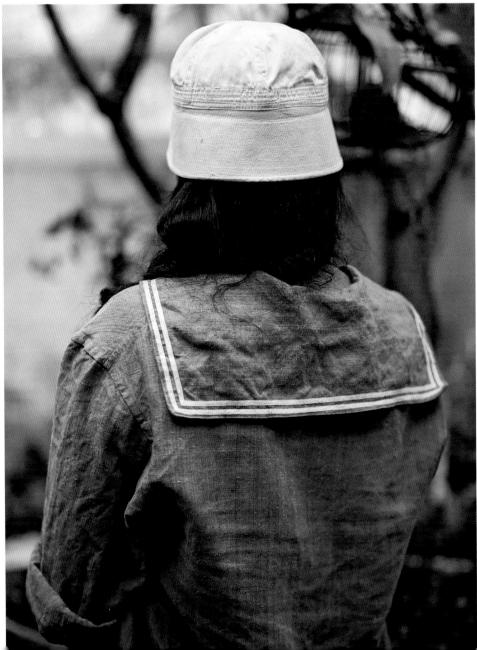

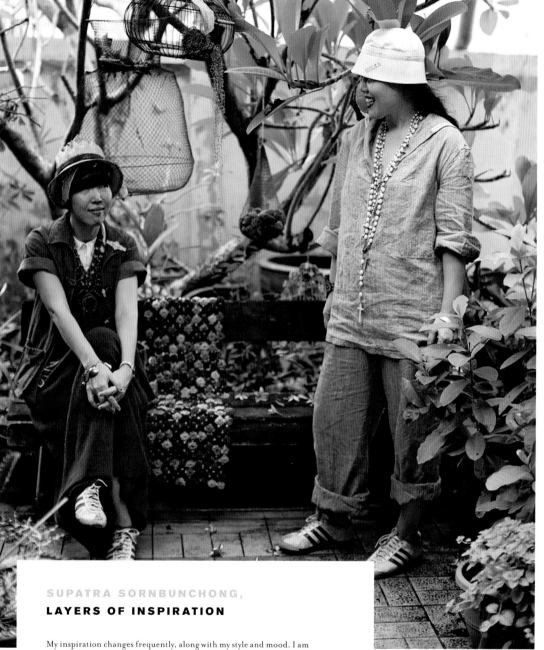

SUPATRA SORNBUNCHONG,
LAYERS OF INSPIRATION

My inspiration changes frequently, along with my style and mood. I am endlessly interested in work wear, uniforms, the Victorian and Edwardian periods, and vintage accessories. I prefer wearing men's fragrances to women's and always throw something together at the last minute, which keeps my outfits interesting.

A 1960s linen French sailor uniform is a key piece of my mood today; I just love the comfy casual feeling and the little bit of tomboy style going on. I got it on a trip to New York City a few years ago and was so happy that they came in a set (tops and pants) in very good condition. And I most likely overaccessorize with my favorite Santo Domingo necklace and rosary and traditional Zuni turquoise cuff bracelet.

CO-OWNER, IT TAKES TWO TO TANGO
/
BANGKOK

SUPALUK SORNBUNCHONG,

DOUBLE INDIGO

We're not identical twins and we're wildly different in all our own little ways. But what connects us so closely is what we adore; vintage clothing, handcrafts, folk art and travel. We march to the beat of our own drummers, but we have our natural and traditional Thai sense of style and inspirations that we picked up from our travels growing up. I'd say that I'm creative in odd ways. Unfortunately not skilled though! But I LOVE what I do. I dress for no one but myself.

I'm wearing a traditional Malaysian hat that's been customized with Thai indigo handwoven fabric. The jacket is from the '60s or '70s and is French with denim wooden toggle fastenings. My shoes are '80s vintage Adidas sneakers and I'm also wearing a Navajo necklace and a Mexican silver bracelet.

CO-OWNER, IT TAKES TWO TO TANGO

/

BANGKOK

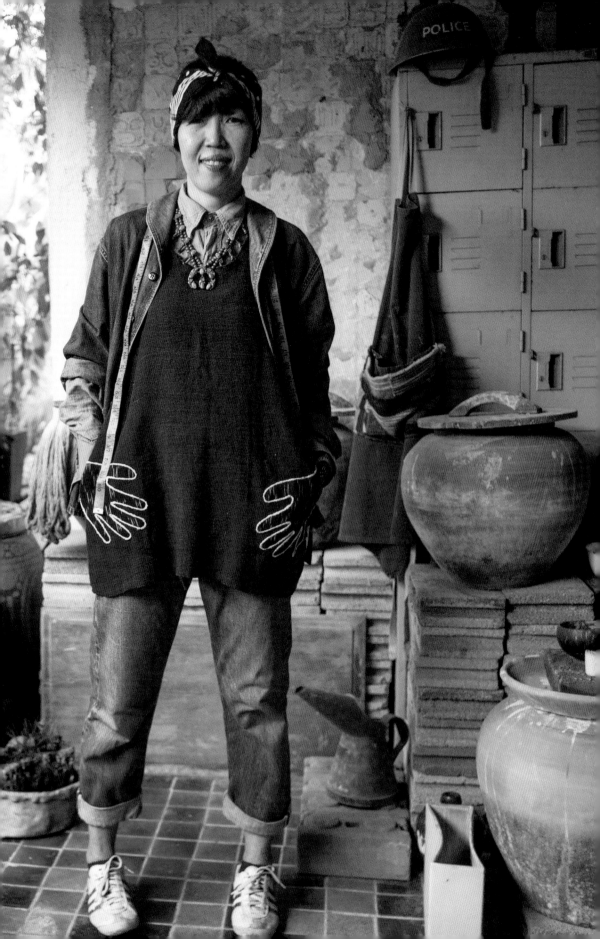

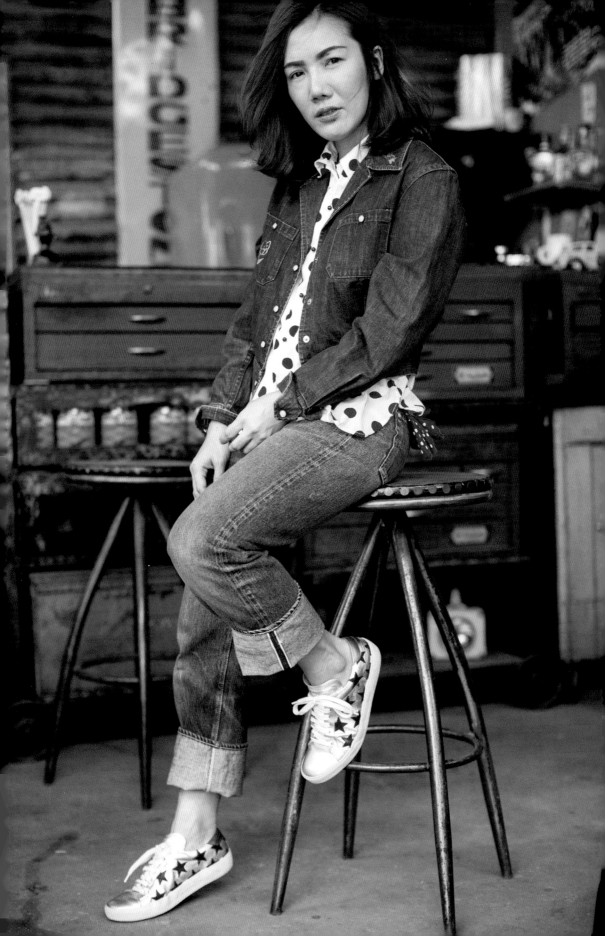

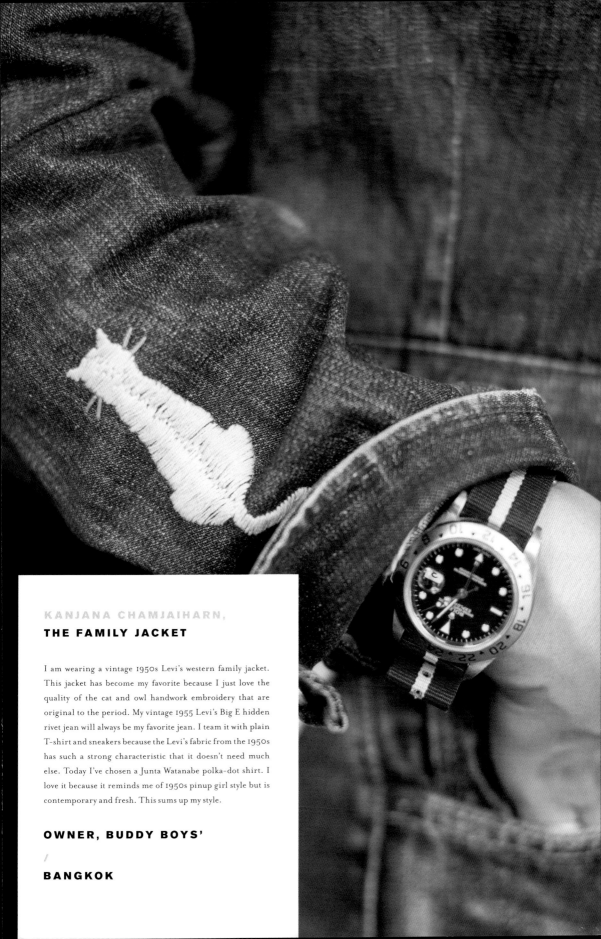

THE FAMILY JACKET

I am wearing a vintage 1950s Levi's western family jacket. This jacket has become my favorite because I just love the quality of the cat and owl handwork embroidery that are original to the period. My vintage 1955 Levi's Big E hidden rivet jean will always be my favorite jean. I team it with plain T-shirt and sneakers because the Levi's fabric from the 1950s has such a strong characteristic that it doesn't need much else. Today I've chosen a Junta Watanabe polka-dot shirt. I love it because it reminds me of 1950s pinup girl style but is contemporary and fresh. This sums up my style.

OWNER, BUDDY BOYS'

/

BANGKOK

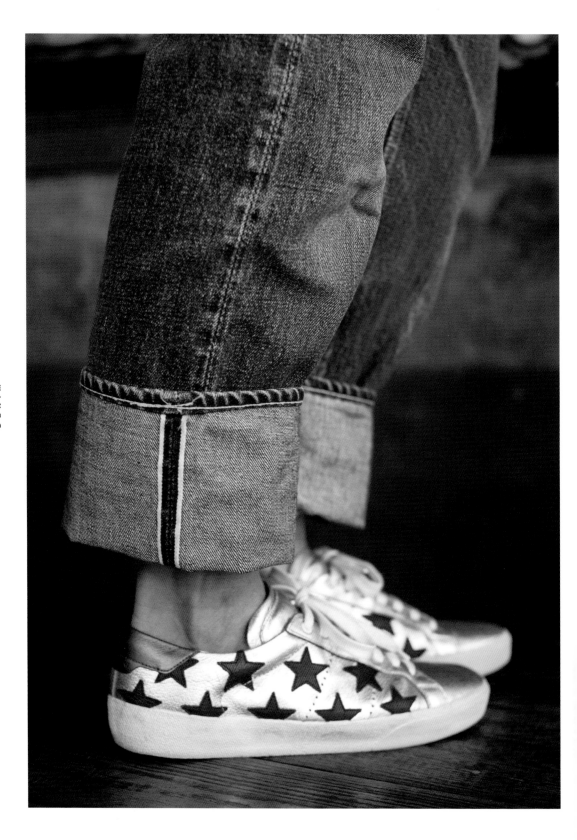

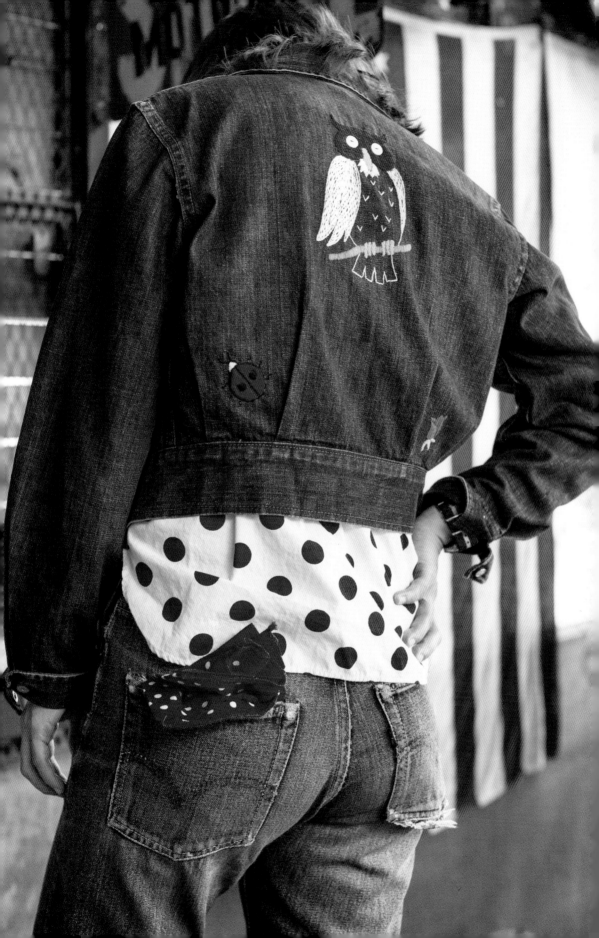

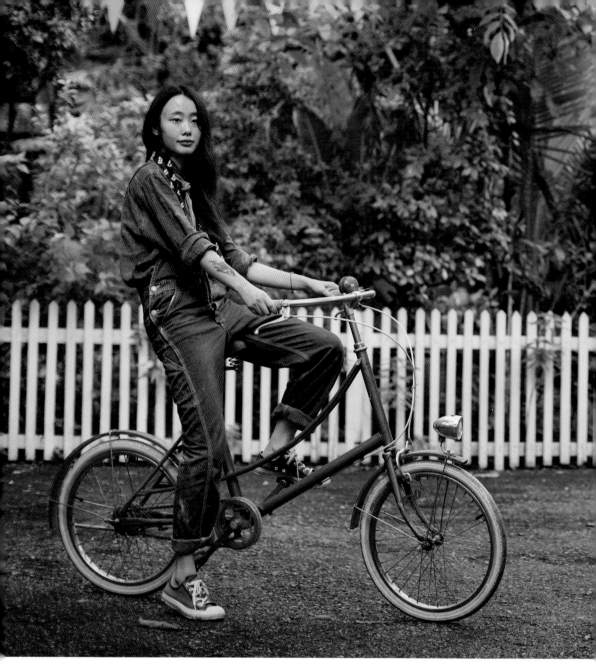

LILUN JIANG,

NATURAL INDIGO

I have been living in Chiang Mai for a few years and love this city. Natural dyed clothes are part of my daily life. I like to buy natural dyed garments made all over the world. I'm mainly into indigo stuff, of course; it could be a T-shirt, a dress, a scarf, pants, or just a piece of fabric. I then find fun in matching those old traditional clothes with new or vintage denim pieces; they complement each other perfectly most of the time. I use Instagram to show my daily outfit to friends, not advising people how to dress, but just showing different styling possibilities.

INDIGO DEALER

/

CHIANG MAI

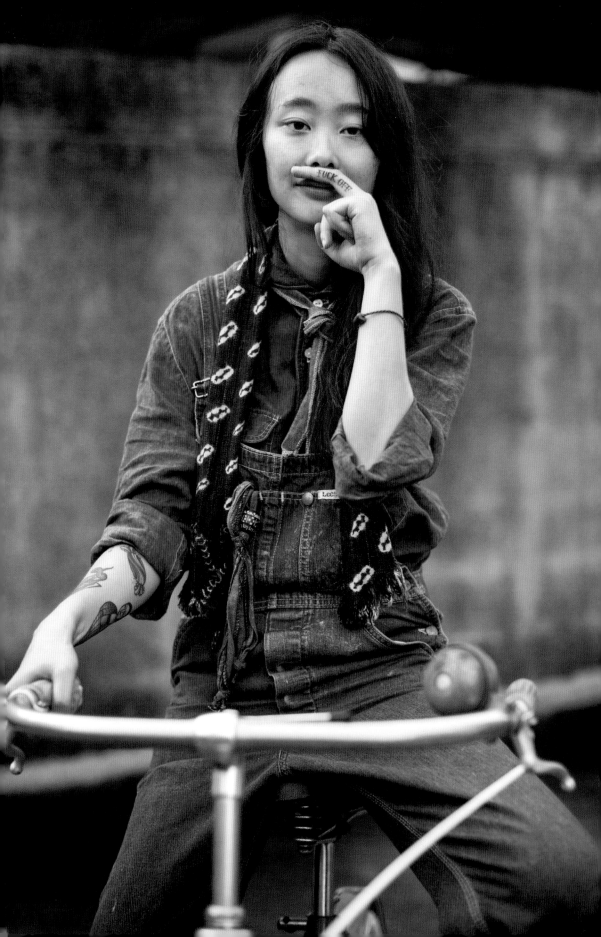

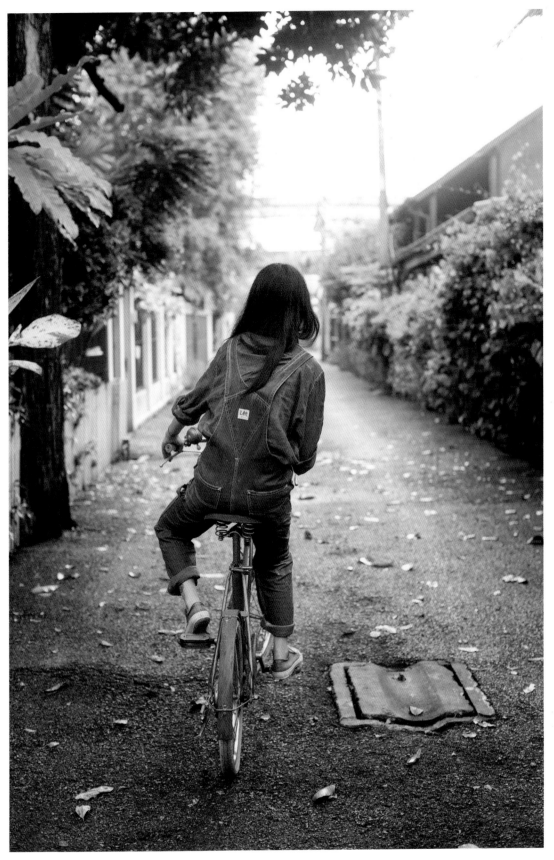

RAIDING THE ARCHIVES

In the photo I'm wearing Margiela boots, 1930s backzip work pants, a nineteenth-century Japanee noragi boro jacket, and oversize lightweight denim shirt from Neuw. The belt is an extra long suitcase strap from the first part of the twentieth century. I'm into denim and indigo garments because I find them aesthetically pleasing. The timeless, historical dimension of the classic blues is not really what appeals to me. I love clothes with character in fabrication, shape, and volume that reflect how I feel right now. My husband is an avid collector of all things indigo; I raid his archive on a regular basis. I really enjoy the process of reframing both old and new work wear pieces. By means of styling, recutting, and sewing I aim to make old, stiff, and slightly awkward pieces feel feminine, personal, and current.

FREELANCE DESIGNER

MELBOURNE

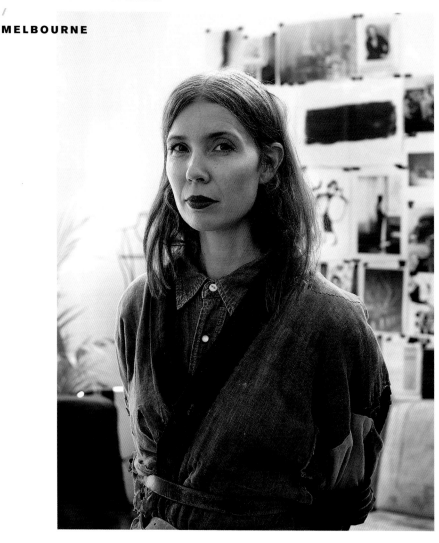

DENIM

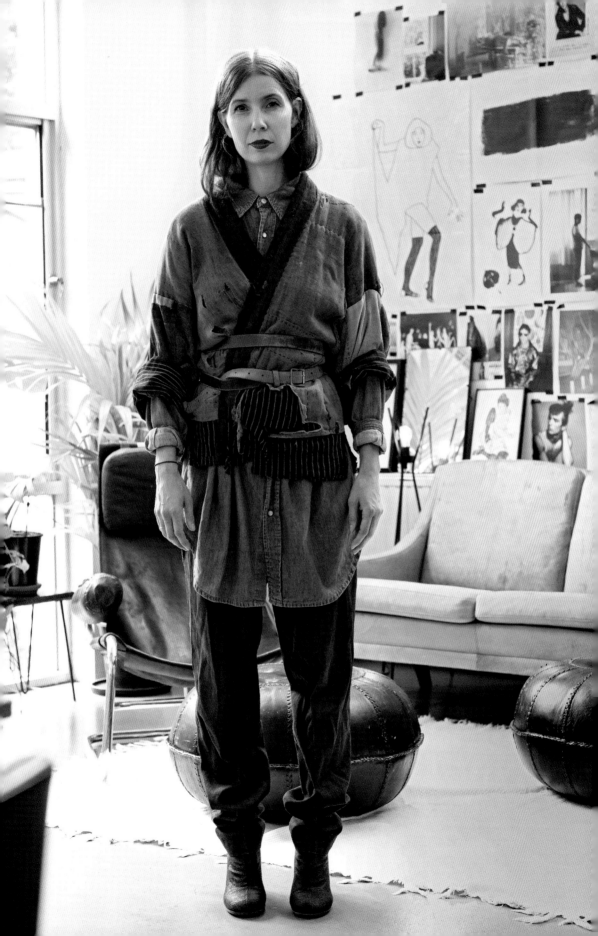

PAINTER JEAN

I'm wearing a pair of jeans that cost just $2 from the op shop. They're a cheap Melbourne-based denim label and they're completely covered in paint as I bought them to work in. They may not be the coolest brand, but they are good to trash and they've been my favorite pair of jeans for three years.

I'm not the orange tab Levi's loving denim dudette I once was, I live in denim but these days I don't really give a shit if it's a label, I just wear it.

OWNER, POP + SCOTT
/
MELBOURNE

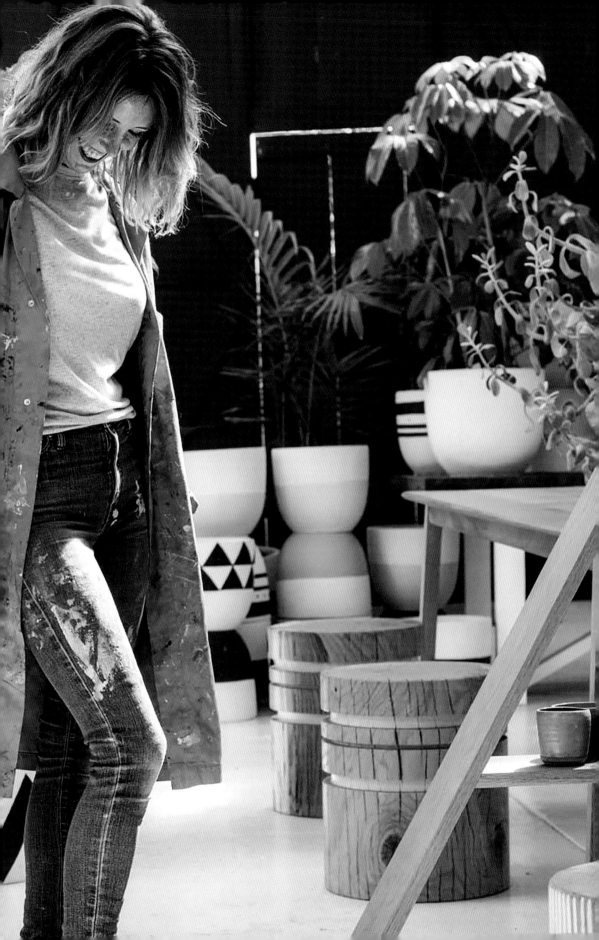

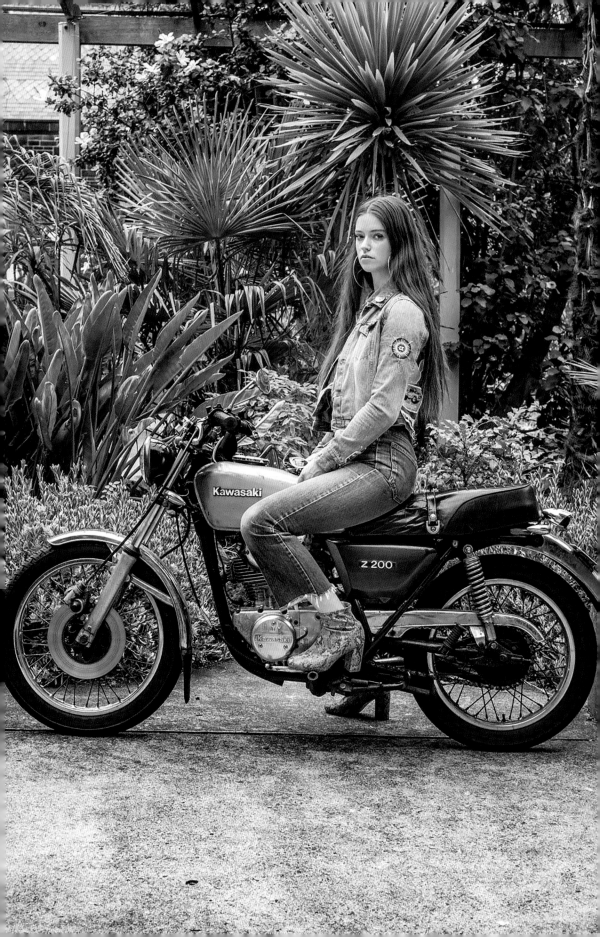

ROCK 'N' ROLLA

I'm wearing a rigid indigo Rolla's jacket I developed during my time with them. It's been embroidered with the lead singer's face from the Steve Miller Band and hand embellished with some of my favorite patches and classic band pins. The shirt is by Rolla's and the jeans are my favorite old vintage orange tab Levi's I picked up for three bucks down at a wacky country town shop. They made it all the way into my hands from their country of manufacture, Canada.

BOSS SHEILA, VOVO THE LABEL AND BASS GUITAR, BITCH DIESEL
/
MELBOURNE

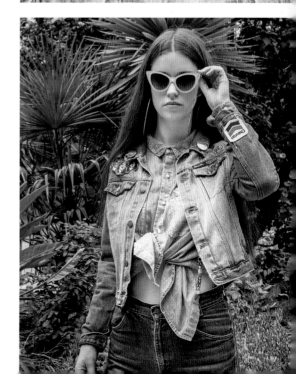

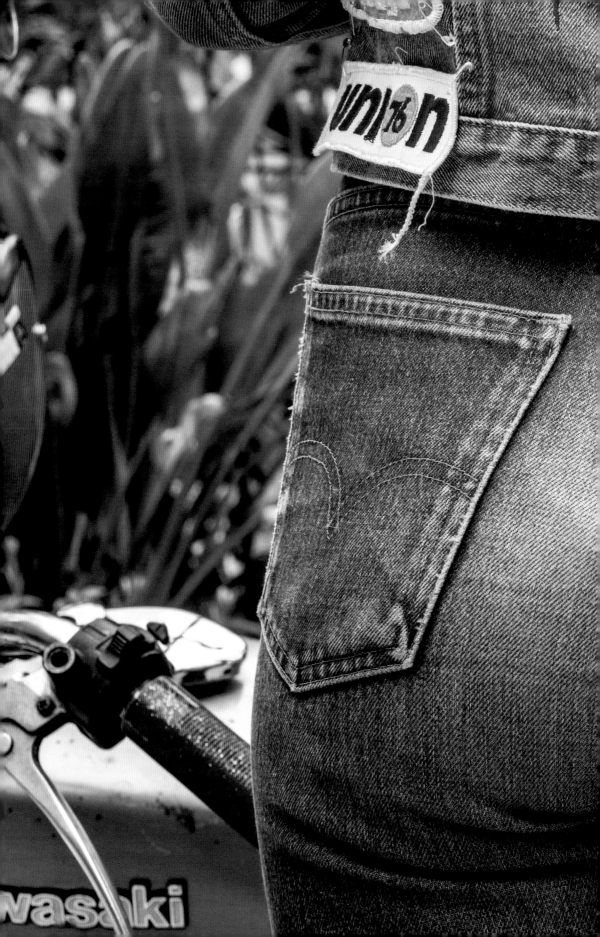

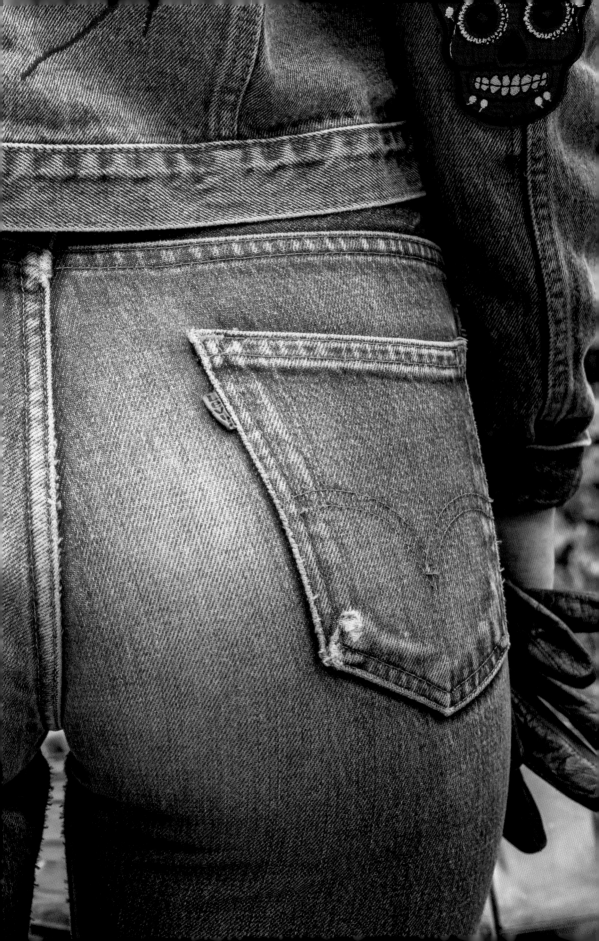

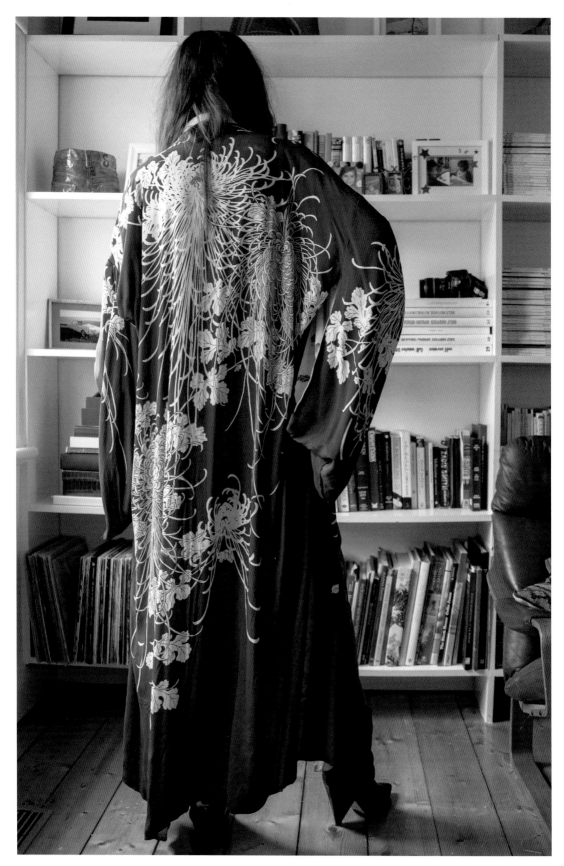

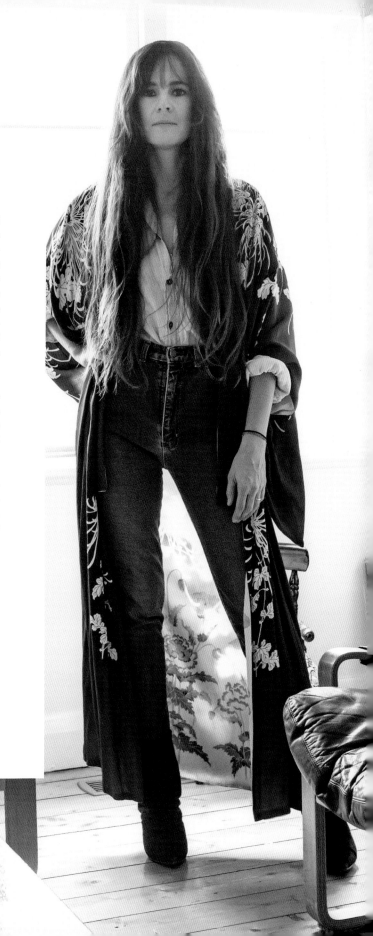

SARAH GILSENAN,
HI-LOW LADY

I am not a traditionalist when it comes to denim and I particularly identify with the '70s and '80s—when jeans took on a fun, fashion slant and were less about being a more functional or heritage item. These are a pair of '80s Faberge jeans—a now defunct Australian fashion jeans brand that was HUGE at the time. All the cool girls wore them when I was growing up and they all had this super sexy but really relaxed, effortless style—a very Australian look that I love. I actually love the cheap, open-end stretch denim; it just has such a great low-key look, wears in perfectly, and, in this case, is such a perfect blue.

The shirt is from the '40s and gets such a workout that it is now threadbare and just hanging on, with safety pins on some of the buttonholes. Every time I roll the sleeves it tears a little more. I think it will end up like a rag I wrap about me!

This and the Japanese kimono were both unearthed at my favorite denim stand at the Rose Bowl flea market in the United States many years ago. The kimono lives with my jeans and balances it all out. I like a bit of a softer element and have a vintage kimono collection that sits right alongside my denim—they complement each other and I tend to collect them at the same places. This one has doubled as a jacket, a dress, a robe, a blanket, a throw, and when I brought my baby home from the hospital I wore it around the clock. It was natural and soft against her skin, kept us both warm, and was the easiest piece of clothing to throw on during those early, foggy days.

HEAD WOMENSWEAR
DESIGNER, THREEBYONE
FOUNDER, ROLLA'S JEANS
/
MELBOURNE

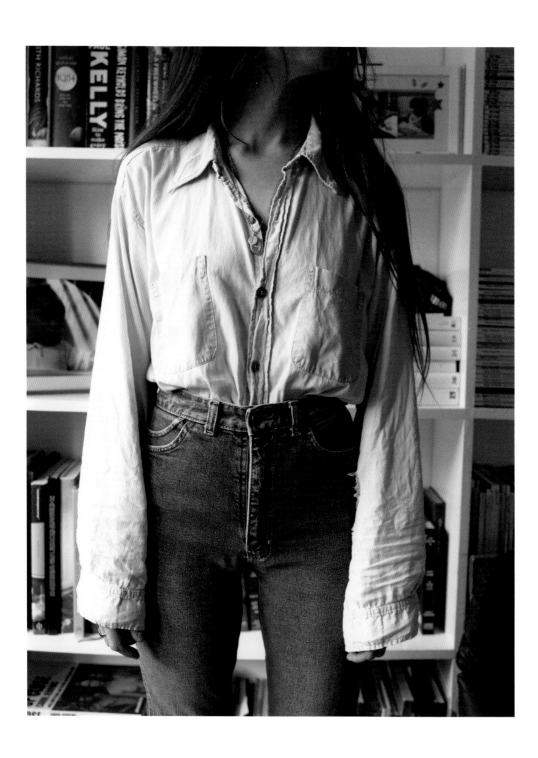

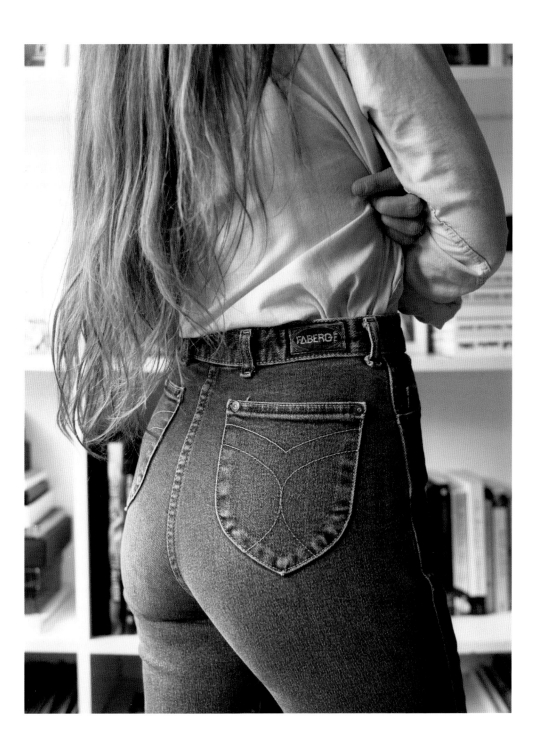

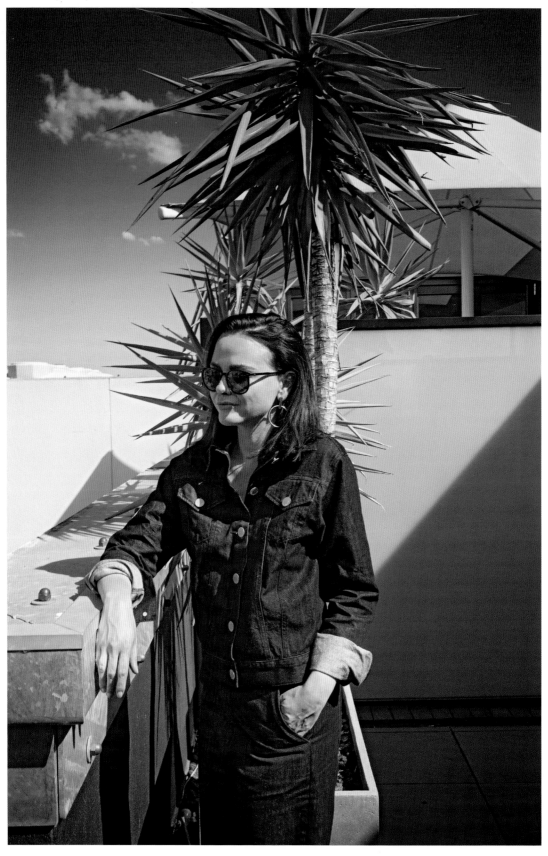

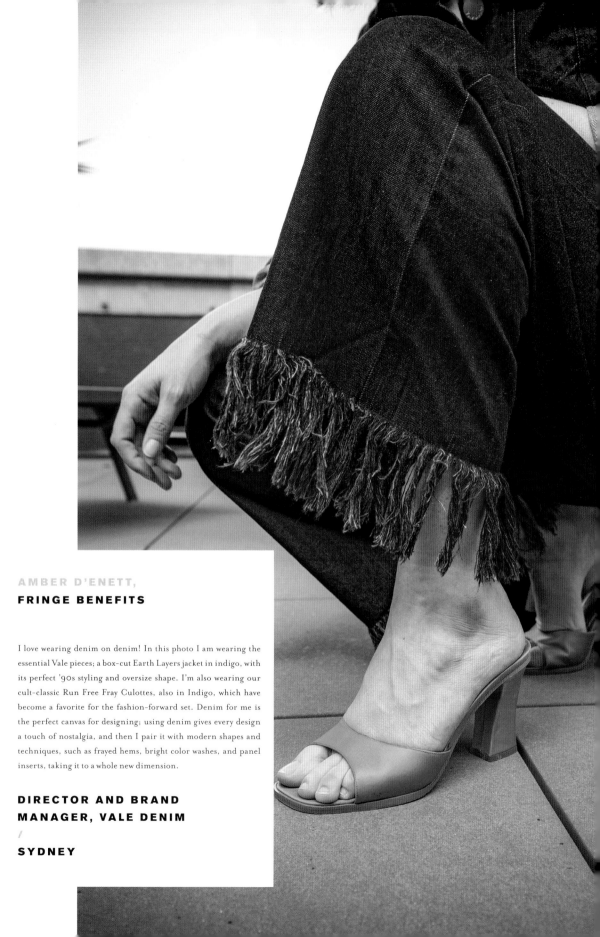

AMBER D'ENETT,

FRINGE BENEFITS

I love wearing denim on denim! In this photo I am wearing the essential Vale pieces; a box-cut Earth Layers jacket in indigo, with its perfect '90s styling and oversize shape. I'm also wearing our cult-classic Run Free Fray Culottes, also in Indigo, which have become a favorite for the fashion-forward set. Denim for me is the perfect canvas for designing; using denim gives every design a touch of nostalgia, and then I pair it with modern shapes and techniques, such as frayed hems, bright color washes, and panel inserts, taking it to a whole new dimension.

DIRECTOR AND BRAND MANAGER, VALE DENIM
/
SYDNEY

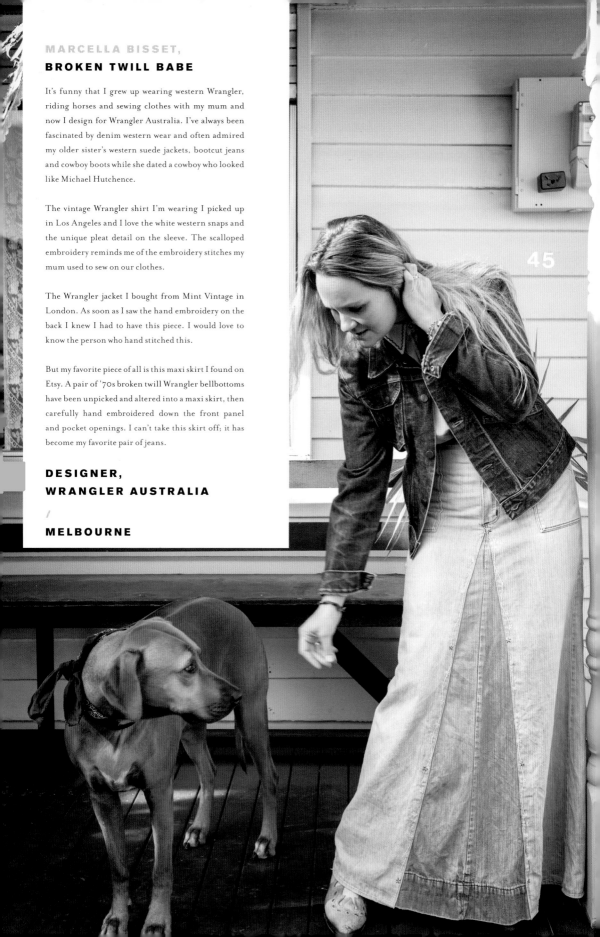

MARCELLA BISSET,
BROKEN TWILL BABE

It's funny that I grew up wearing western Wrangler, riding horses and sewing clothes with my mum and now I design for Wrangler Australia. I've always been fascinated by denim western wear and often admired my older sister's western suede jackets, bootcut jeans and cowboy boots while she dated a cowboy who looked like Michael Hutchence.

The vintage Wrangler shirt I'm wearing I picked up in Los Angeles and I love the white western snaps and the unique pleat detail on the sleeve. The scalloped embroidery reminds me of the embroidery stitches my mum used to sew on our clothes.

The Wrangler jacket I bought from Mint Vintage in London. As soon as I saw the hand embroidery on the back I knew I had to have this piece. I would love to know the person who hand stitched this.

But my favorite piece of all is this maxi skirt I found on Etsy. A pair of '70s broken twill Wrangler bellbottoms have been unpicked and altered into a maxi skirt, then carefully hand embroidered down the front panel and pocket openings. I can't take this skirt off; it has become my favorite pair of jeans.

DESIGNER,
WRANGLER AUSTRALIA
/
MELBOURNE

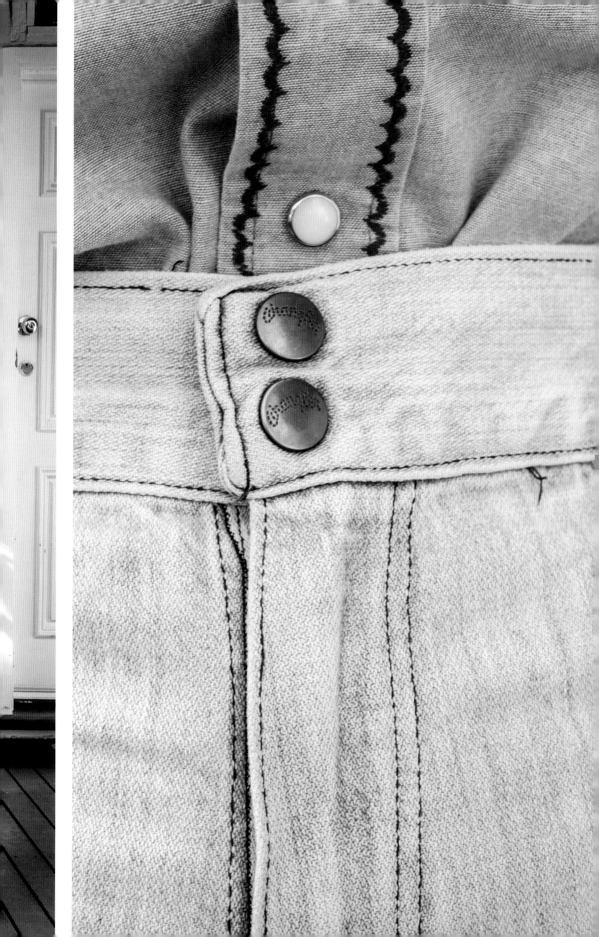

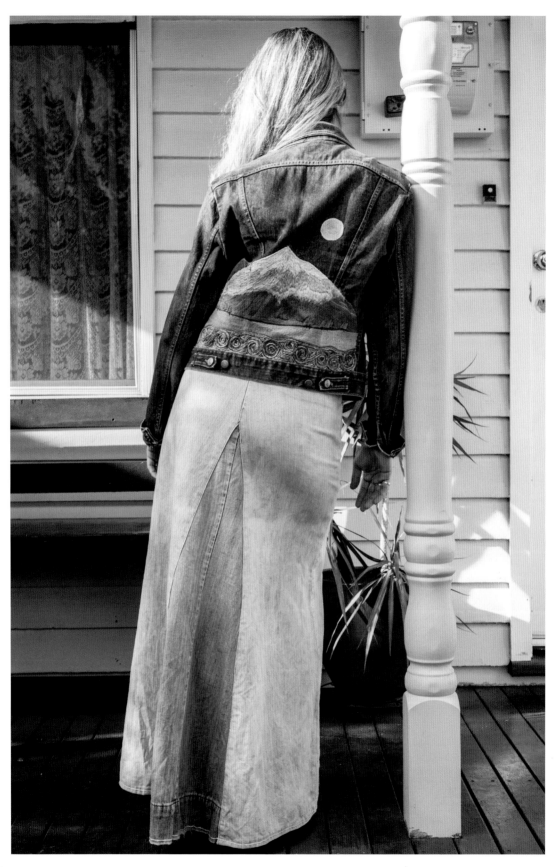

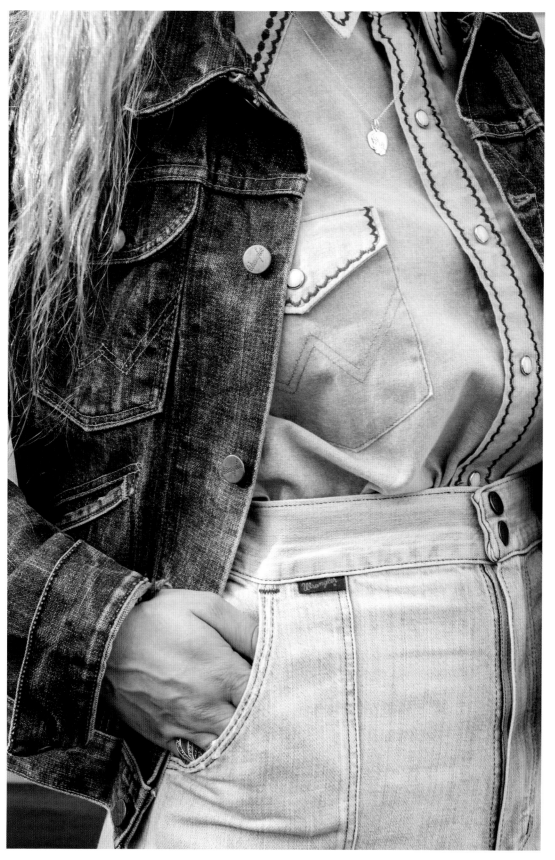

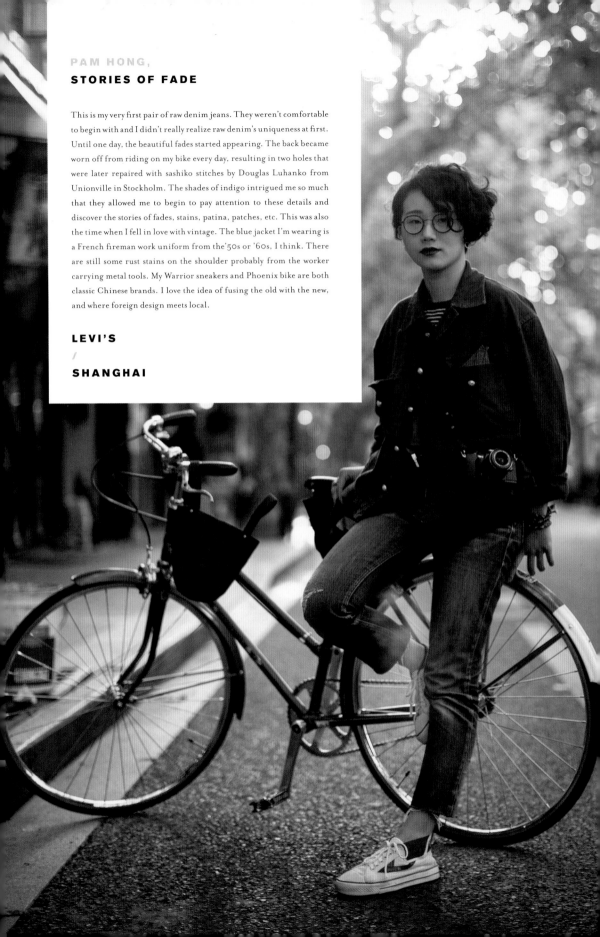

PAM HONG,
STORIES OF FADE

This is my very first pair of raw denim jeans. They weren't comfortable
to begin with and I didn't really realize raw denim's uniqueness at first.
Until one day, the beautiful fades started appearing. The back became
worn off from riding on my bike every day, resulting in two holes that
were later repaired with sashiko stitches by Douglas Luhanko from
Unionville in Stockholm. The shades of indigo intrigued me so much
that they allowed me to begin to pay attention to these details and
discover the stories of fades, stains, patina, patches, etc. This was also
the time when I fell in love with vintage. The blue jacket I'm wearing is
a French fireman work uniform from the '50s or '60s, I think. There
are still some rust stains on the shoulder probably from the worker
carrying metal tools. My Warrior sneakers and Phoenix bike are both
classic Chinese brands. I love the idea of fusing the old with the new,
and where foreign design meets local.

LEVI'S
/
SHANGHAI

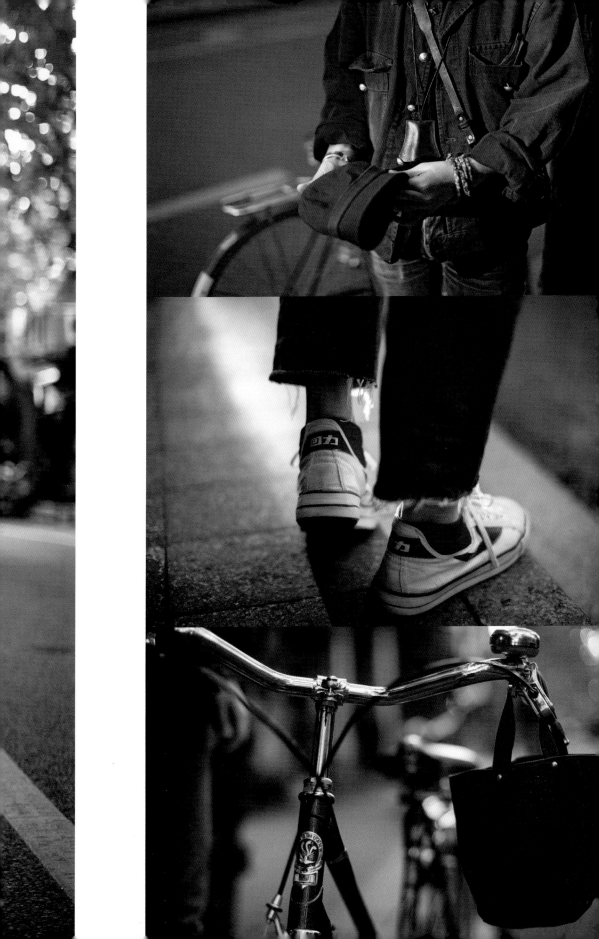

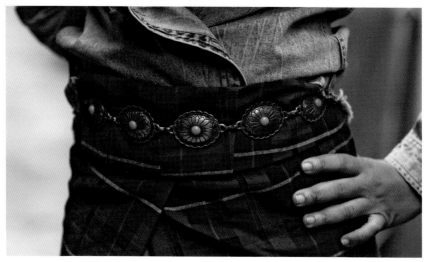

TOWY VAUGHNS,
GLOBAL MAGPIE

I have a passion for creativity, individuality, and quality, which creates longevity in fashion. Traveling and music from all over the world have had a huge impact on the way I dress.

I am wearing a gray raw denim blazer that I had tailored using leftover Chinese fabric. From my trips to Bangladesh, India, and Sri Lanka, I fell in love with the lungis (sarongs) the men were wearing. I then had the idea to hand sew my own version using a Japanese yarn dyed pure indigo plaid from Kurabo Denim Mills, giving it a structured fit with a vintage metal belt from New Orleans. My shirt is a wash development I did myself at a Chinese laundry. I really enjoy sewing my clothes using extra fabric I have acquired over the years...why waste?

DENIM DESIGNER AND WASH DEVELOPER, TOWYVAUGHNS CONSULTANCY STUDIO

/

SHANGHAI

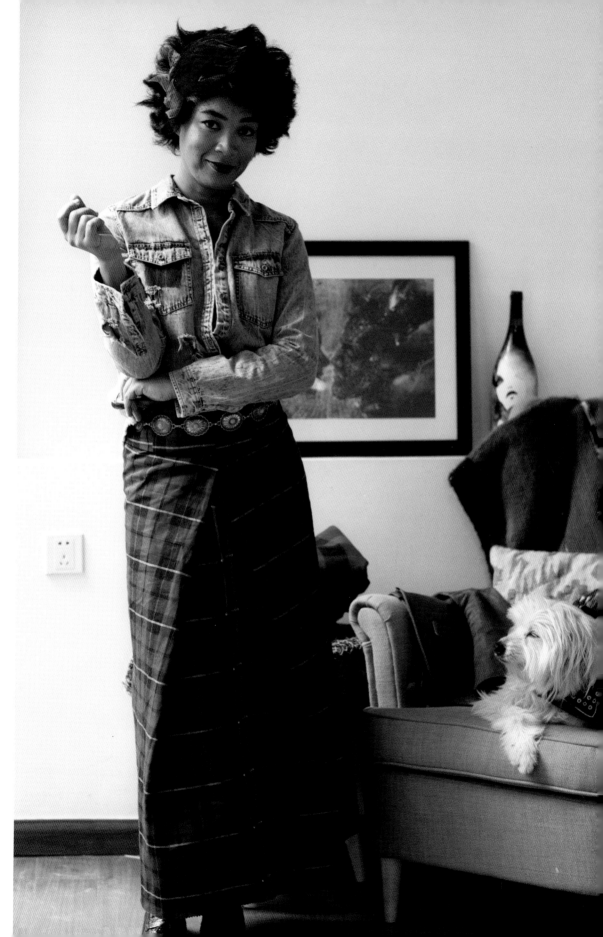

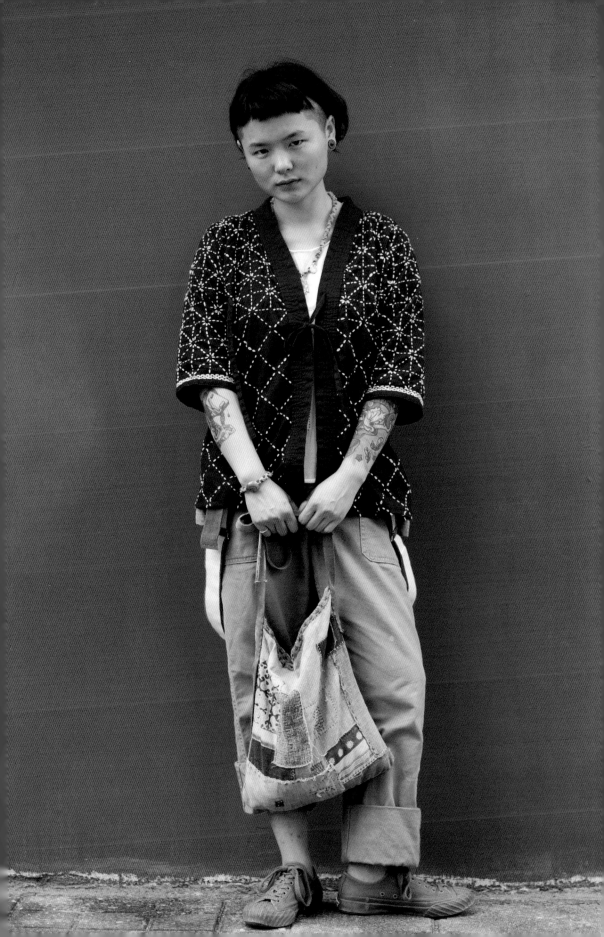

VIVI ZHANG,
VERY VERY VINTAGE

I'd always had a thing for the disappearing art of Chinese crafts. The obsession started to grow when four years ago I decided to go on a trip to Guizhou looking for the origins and learning the traditional dyeing techniques. From Kaili to the Dong tribe, everything that happened on the way amazed me and made me even more addicted to indigo dyeing. The magic about indigo is that it's alive. You have to take care of it very well to keep it reacting.

My boro bag is handmade, by me, and the patches on my T-shirt too using vintage fabrics I found on my trip to Guizhou. The vintage sashiko kimono is from Vietnam, and my trousers are from Kapital Japan in the earlier years. I'm currently running a coffee and baking studio in China, doing some indigo dyeing work in my free time and sewing a little too. I believe beautiful things have souls that take time to develop.

BARISTA AND TAILOR
/
SHANGHAI

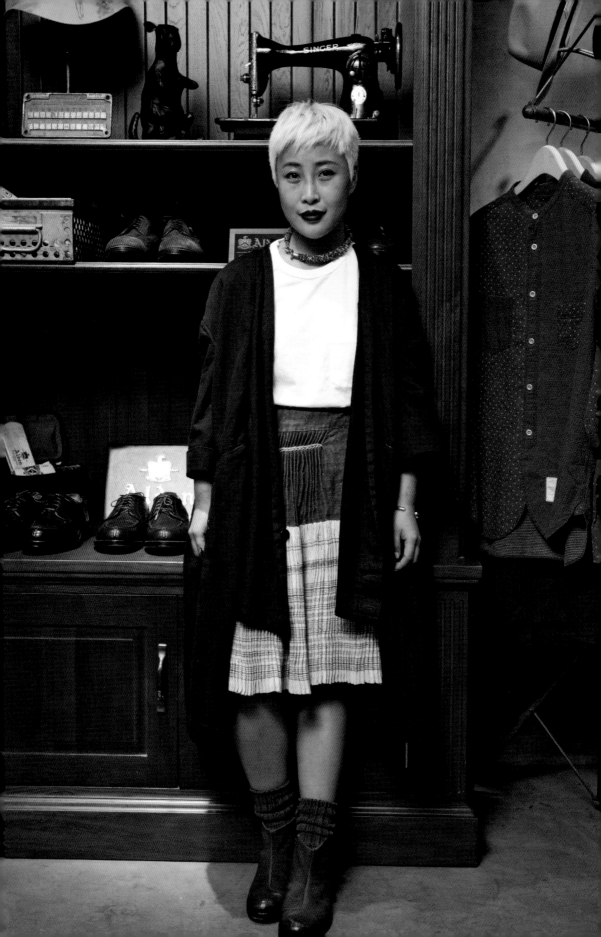

INDUSTRIAL FEMME

Menswear became my routine outfit maybe five years ago now, when I opened INDUSTRIAL & Co. stocking the heritage lines of many brands. The outfit I'm wearing combines stories from previous travels—there are beautiful stories behind each of these handcrafted pieces. My longstanding love of folk art is combined with handcrafted pieces and my own DIY projects. Currently I'm learning different handcrafting processes and how to work with natural dyes.

The coat that I'm wearing is transformed from the traditional Japanese KIMONO, indigo-dyed with a simple shape and national character. The dress is from my vintage collection, all handmade from the weaving, dyeing, sewing to stitching. A simple white Tee goes with any denim outfit perfectly. Paired with one or two accessories, it is enough.

COFOUNDER, INDUSTRIAL & CO.
/
SHANGHAI

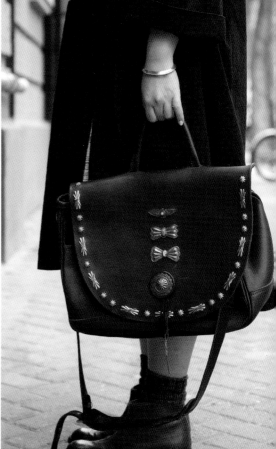

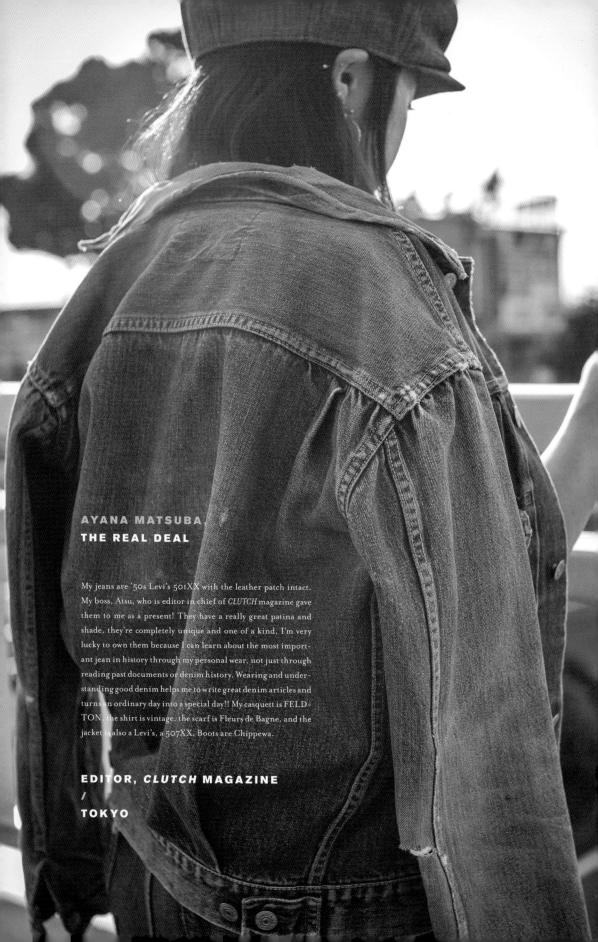

AYANA MATSUBA
THE REAL DEAL

My jeans are '50s Levi's 501XX with the leather patch intact.
My boss, Atsu, who is editor in chief of *CLUTCH* magazine gave
them to me as a present! They have a really great patina and
shade, they're completely unique and one of a kind, I'm very
lucky to own them because I can learn about the most import-
ant jean in history through my personal wear, not just through
reading past documents or denim history. Wearing and under-
standing good denim helps me to write great denim articles and
turns an ordinary day into a special day!! My casquett is FELD-
TON, the shirt is vintage, the scarf is Fleurs de Bagne, and the
jacket is also a Levi's, a 507XX. Boots are Chippewa.

EDITOR, *CLUTCH* MAGAZINE
/
TOKYO

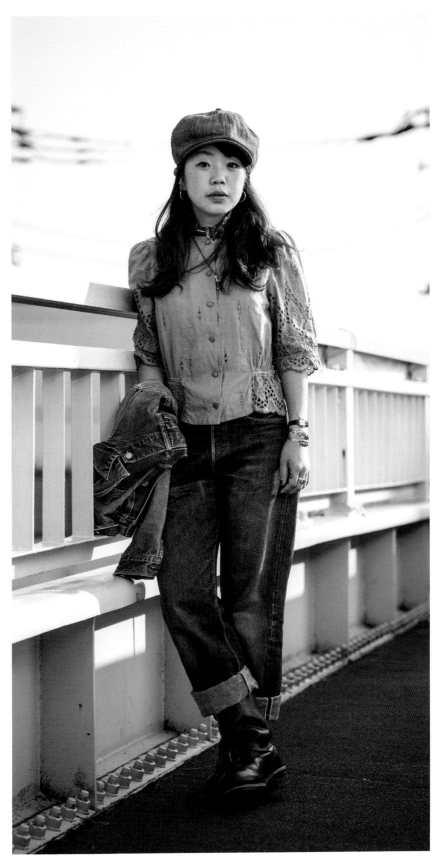

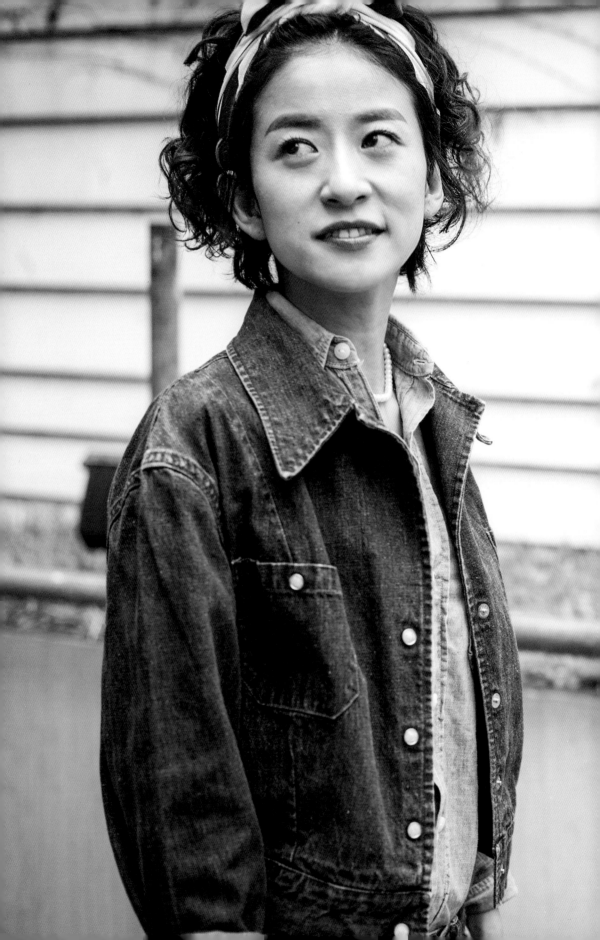

KIHO OGASAWARA,
CUSTOM TAILOR

I'm wearing Levi's 501 Big E. I bought these at Hello Hello Clothing, which used to be run by Freaks Store but sadly has shut down. This pair of jeans must have been a custom remake, I'm guessing because the waist was too small . . .so they added this fabric on the sides of the jeans. I actually wasn't fond of the fabric because it was a camouflage print, so I changed it out by cutting an old neck tie of mine and adding the pink piping around it. My jeans are paired with a chambray shirt that was a rare find because of its small size—perfect for me! My jacket is a Levi's Denim Family western jacket, which was a present from my boss. It's one of my absolute favorites that I plan to wear forever. My head scarf is vintage Chanel.

P.R. ASSOCIATE, FREAK'S STORE
/
TOKYO

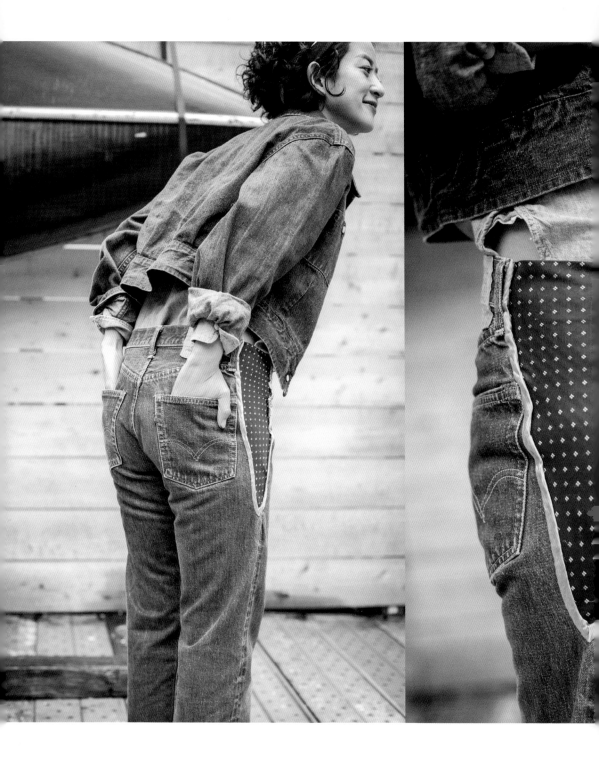

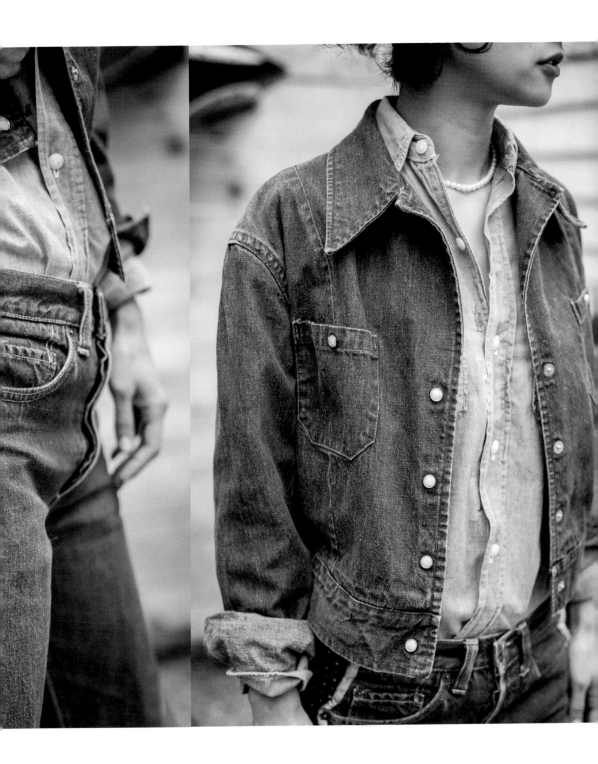

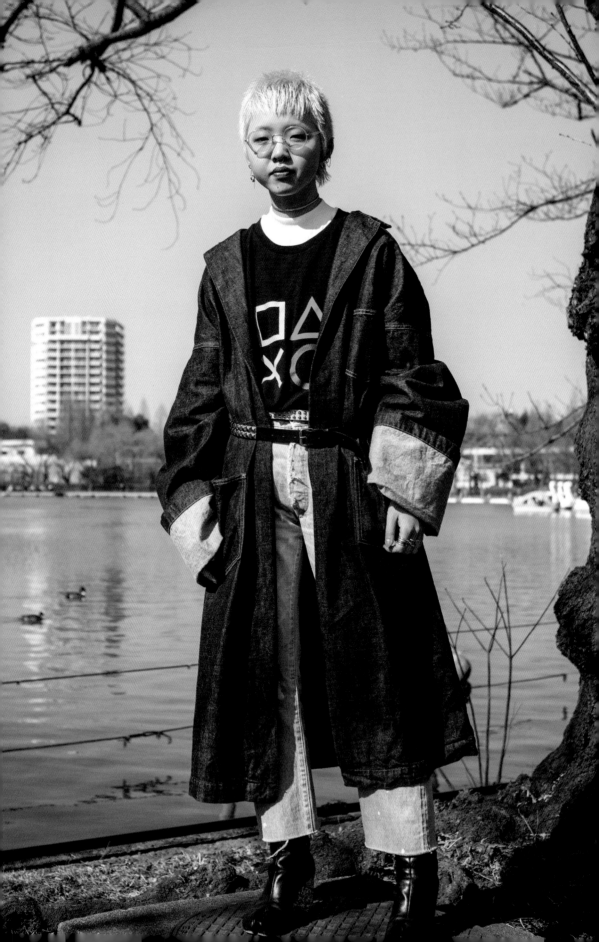

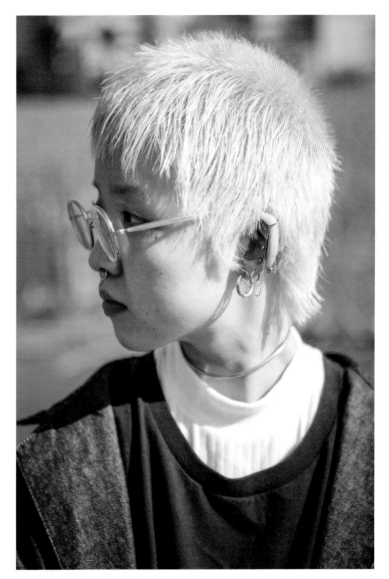

YUZUKI KAMADA,
MADE IN JAPAN

I wear Japanese brands a lot because I just love the quality and workmanship. I tend to choose those brands without knowing they're made in Japan until afterward. Maybe it's from my time working at Kapital, I saw how much energy and skill is put into making just one pair of jeans . . . also I love to see how my jeans change color and age just like me. They turn into something truly rare and one of a kind. My jacket is from Ganryu by Comme des Garçons, the T-shirt is Playstation official goods, my jeans are of course Kapital, and I'm wearing Ashibukuro boots.

FREELANCE MODEL,
ILLUSTRATOR, AND DESIGNER
/
TOKYO

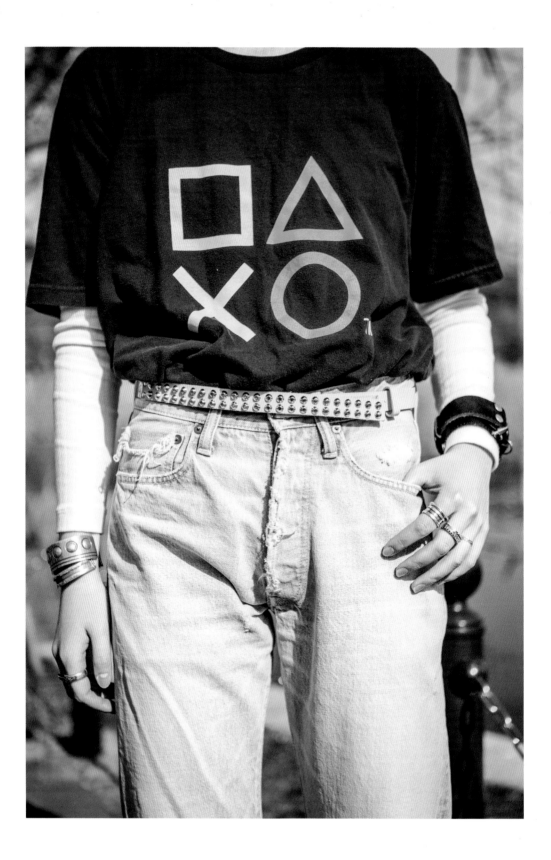

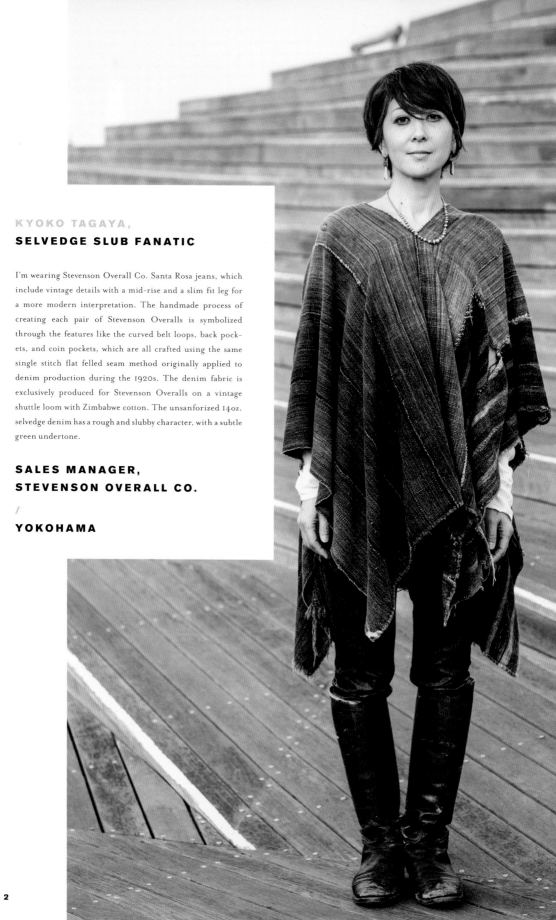

KYOKO TAGAYA,
SELVEDGE SLUB FANATIC

I'm wearing Stevenson Overall Co. Santa Rosa jeans, which include vintage details with a mid-rise and a slim fit leg for a more modern interpretation. The handmade process of creating each pair of Stevenson Overalls is symbolized through the features like the curved belt loops, back pockets, and coin pockets, which are all crafted using the same single stitch flat felled seam method originally applied to denim production during the 1920s. The denim fabric is exclusively produced for Stevenson Overalls on a vintage shuttle loom with Zimbabwe cotton. The unsanforized 14oz. selvedge denim has a rough and slubby character, with a subtle green undertone.

SALES MANAGER,
STEVENSON OVERALL CO.

/

YOKOHAMA

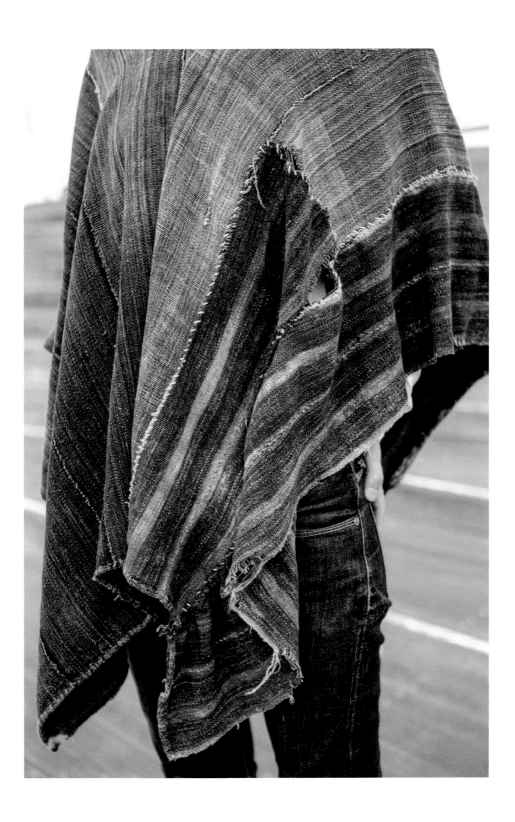

YUKIKO KAI,
DENHAM DUDETTE

My Jeans are DENHAM Boyfriend JDS. This pair is from the Made in Japan Denim Series 1st edition 2011SS and to me you can tell the difference, as the craftmanship is totally unique. When you see the fabric's contrasting colors, marks, and stressing throughout that gives it that true vintage look you realize Japan has beautifully combined their technology with aesthetics. The knees and pockets have a repaired effect and there is patchwork and hand stitching along the sides, darting on the backside of the knees as well as 20 cm above the hem, which also has serubichi. It takes six months from the day the fabric is first cut until the day the jeans are completed. My shirt is DENHAM 5 ounce. My jacket is MAME KUROGUCHI. It's carefully made to look like the item has some history to it using torn yarn. They use traditional Japanese technology to give it those handmade details. The more I wear this jacket, the more I love it. My bracelet and buckle boots are TOGA. My ring is my own personal design.

MODEL
TOKYO

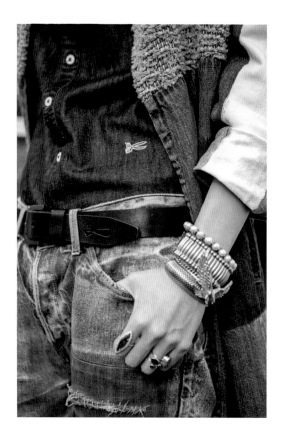

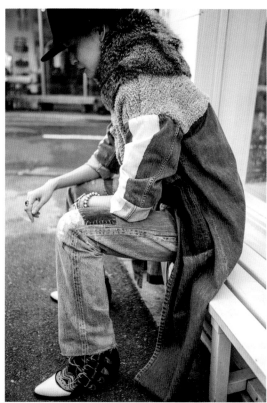

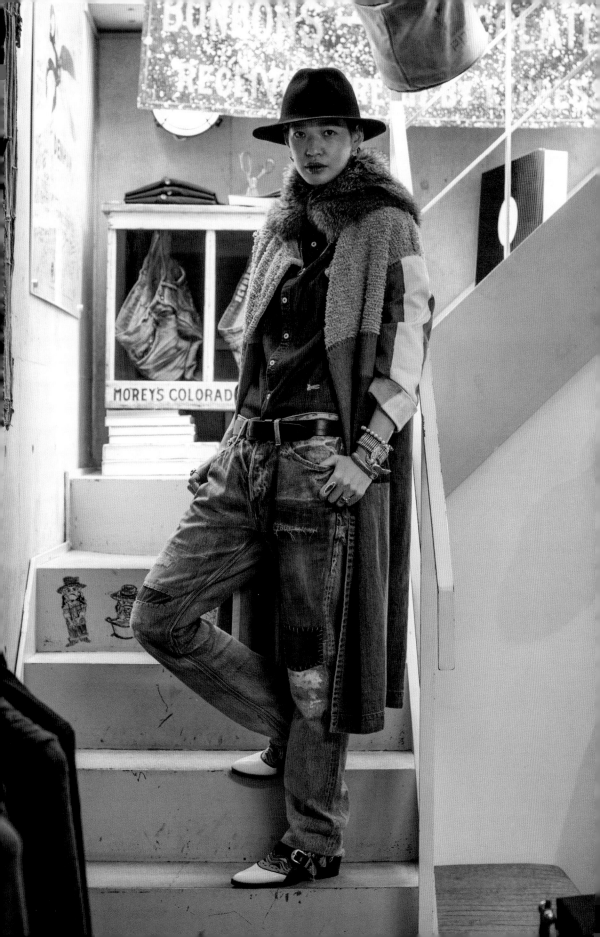

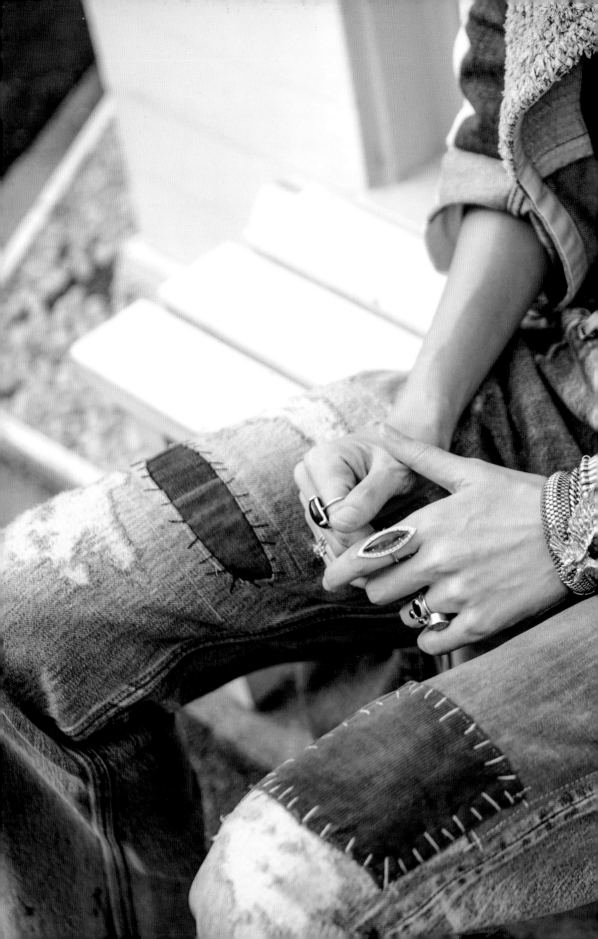

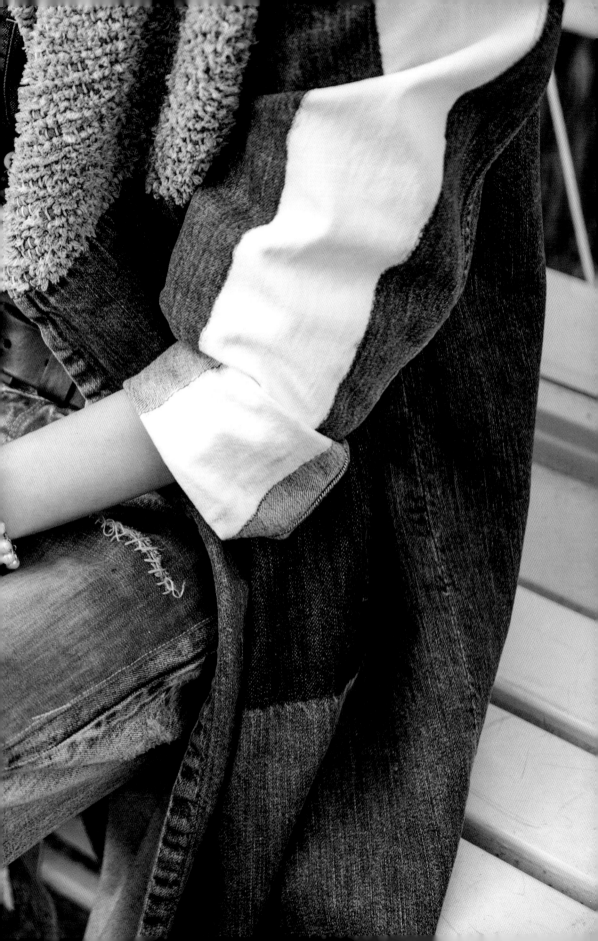

PHOTOGRAPHERS

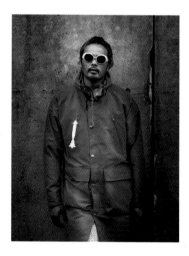

ERIC KVATEK
NEW YORK AND BANGKOK

JON MORTIMER
BERLIN

SHIMA
TOKYO

Eric Kvatek was born in Virginia, raised in Ohio, and studied drawing at the University of New Mexico. He spent the 1990s restoring muscle cars and motorcycles, and sold vintage leather and denim. In 1998 he became a full-time fashion photographer in New York City. Kvatek is best known for his twelve-year-long photo journey with the Japanese denim brand Kapital. His personal documentary projects include the aftermath of the tsunami in Japan and an outlaw biker gang's effort to supply aid and relief to the survivors.

Jon Mortimer is a fashion and portrait photographer based in Berlin and London. He started off assisting the likes of Annie Leibovitz and Tim Bret-Day and now shoots regularly for *Jocks & Nerds* magazine and *GQ France* among others. Mortimer has a lifelong love of denim and works with denim brands across Europe. www.jonmortimer.com

SHIMA is a photographer based in Tokyo, who works in Japan, New York, Los Angeles, Chicago, and Hong Kong. He was an International Photography Masters Cup nominee and winner of the 2016/2017 Advertising APA Award. His photos range from editorial, portrait, commercial, landscape, architectural, and travel. Exhibitions showcasing his works can be seen throughout Japan.

SHOT: *Mildred "Mickey" Bolin, Kara Nicholas, Kelly Connor, Lauren Rodriquez, Rosario Dawson, Abrima Erwiah, Linda Rodin, Hsiang Chin Moe, Florence Kane, Jane Herman Bishop, Sara Brown-Rubinstein, Rachel Comey, Lauren Yates, Mashannoad Suvanamas, Chanchay Maleesuthikul, Supatra Sornbunchong, Supaluk Sornbunchong, Kanjana Chamjaiharn, Lilun Jiang*

SHOT: *Paula Kunkel, Maria Klähn*

SHOT: *Ayana Matsuba, Kiho Ogasawara, Yuzuki Kamada, Kyoko Tagaya, Yukiko Kai*

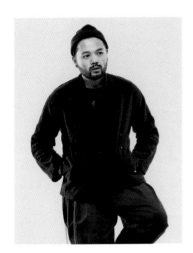

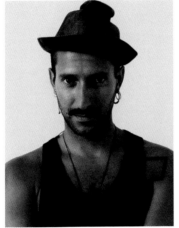

JAMES JIANG
SHANGHAI

ANTONIO GIACOMETTI QUITO
MILAN

RYAN LOPEZ
LOS ANGELES

Being a Shanghainese and Shanghai-lover, James Jiang started his career shooting street snaps and developed the passion for portraying people in different views. He currently focuses on the fashion industry and has worked for *Vogue*, *Grazia*, and *Hypebeast*.

Antonio Giacometti Quito grew up between Ecuador and Europe. He is a nomadic trend researcher who travels around the globe with his camera. Coincidence is his main inspiration. Photography has became a fundamental resource in his professional life and the best way to share his latest discoveries. He is a cofounder and player of the Dynamo Dora Rugby Torino team.

Born on a farm and raised by wolves, Ryan Lopez is first and foremost an adventurer and a lover of new experience. He receives inspiration from the people he comes in contact with and the places he has had the privilege to visit. His mode of expression comes through photography. Classically trained in art, advertising, and photography, he translates every moment of his life into a visual exploration. Lopez is currently based in Joshua Tree, California, but is constantly traveling for work.

SHOT: *Pam Hong, Towy Vaughns, Vivi Zhang, Sissi Ching*

SHOT: *Francesca Pavoni, Patrizia Bacci Biondi*

SHOT: *Nina Kaplan, Jayne Min, Nana Miura, Kathleen Schaaf, Florence Tang, Liz Baca, Madeline Harmon, Erin Barajas, Vivian Wang, Jamie Wong, Langley Fox, Carrie Eddmenson, Emily Current, Meritt Elliott*

ALBERT COMPER
MELBOURNE AND SYDNEY

KELLY FOBER
AMSTERDAM

STEPHANIE SIÂN SMITH
LONDON

Albert Comper is a photographer based in Melbourne, Australia. Inspired by both the ordinary and extraordinary, he collaborates with clients across both commercial and cultural sectors, with a particular focus on projects for fashion and retail markets. Driven by passion, he practices a holistic and concept focused approach; with an aim to create visually powerful, and exceptionally executed work which is both forward thinking, and unique in order to stand out against a sea of competitors.

The Antwerp-based photographer Kelly Fober was born and raised in the Netherlands and carries her "Brabantse gezelligheid" with her as one of her most important assets. Her ever-positive attitude and open-minded vision are a perfect marriage for working with people. Most of her work is in the music, fashion/streetwear, and sneaker industries. From her love for spontaneous portraits she creates editorials with a raw and natural mood.

Stephanie Siân Smith specializes in people, fashion, and lifestyle shoots, where she captures the energy and spontaneity of her subject in an authentic manner. She strives to "see" the person within her images, making a point of searching for flaws, where accidents become beautiful. Through her visual reaction to people comes a certain strength and beauty that draws you in. Whether she is working on a large-scale ad project, a guerrilla-style fashion shoot or an intimate portrait session, Smith is always able to strip away the artificial, get close to people and capture something real and magical.

SHOT: *Sofia Lundqvist, Poppy Lane, Phoebe Taylor, Sarah Gilsenan, Amber D'Enett, MarcelLos Angeles Bisset*

SHOT: *Lizzie Kroeze, Elza Wandler, Mariette Hoitink, C. Cruden, Alexandra Melgaard Lewty, Roos Brancovich*

SHOT: *Amy Roberton, Kelly Dawson, Katharine Hamnett, Jo Sindle, Faustine Stienmetz, Malin Ekengren, Linda Rieswick, Donna Ida Thornton, Kelly Harrington, Caroline Issa, Amy Bannerman, Chloe Lonsdale, Ame Pearce, Helen Large*

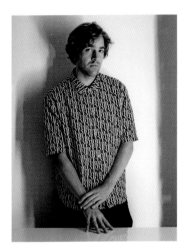

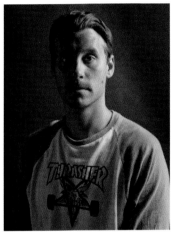

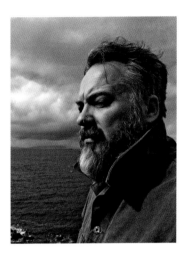

ULYSSES ORTEGA
SAN FRANCISCO

KARL-FREDRIK MARKLUND
STOCKHOLM

DANNY NORTH
FRANCE

Ulysses Ortega is a fashion and portrait photographer based out of San Francisco, California. His work has been featured in a number of publications, including *VICE*, Bloomberg, and Plus 81. Ortega has traveled to Japan, Hong Kong, Mexico, and Sweden to photograph a number of endeavors, all unified by a fascination with origins.

Karl-Fredrik Marklund is a photographer based out of Stockholm, Sweden. He started his career in Los Angeles where he studied photography and moved on to working in the industry as an assistant to several renowned photographers. Recently he moved back to Europe where he now lives and practices photography full time as a fashion and portrait photographer.

Proudly raised in the north of England and now based in London, Danny North has received commisions from clients such as MasterCard, Apple, Monster Energy, Clarks, Interscope, Atlantic and Capitol Records for his dynamic portraiture and lifestyle photography. His personal project "As I Found Her," a story of belonging, has been selected by the National Portrait Gallery to be exhibited as part of the Taylor Wessing Portrait Prize 2017.

SHOT: *Rain Delisle, Melissa Vu, Jessica Geesey, Lynn Downey, Samantha Lee, Cindy Spade*

SHOT: *Anna Norling, Asa Norin*

SHOT: *Katy Rutherford*

 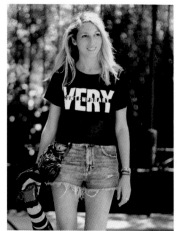

OLIVIER RIMBON FOELLER
PARIS

VALENTINA FRUGIUELE
PARIS

Olivier Rimbon Foeller is a Paris-based independent photographer who works in all areas related to interior and exterior architecture. His passion for encounters and faces also regularly leads him to lend his humanist eye for portraits or events in which he captures the human emotion. This has led him to work with Paris-based brand Lago 54 and to shoot backstage for haute couture brand Dice Kayek.

Valentina Frugiuele is a fashion and street photographer. Born in Italy, she moved to Paris in 2006 and worked there for ten years before returning to Italy. Her collaborations include *Vogue Arabia*, *Vogue Japan*, *L'officiel Italia*, *InStyle*, *Grazia*, *Glamour*, and brands such as Sisley, Diesel Black Gold, Clinique, Desigual, Patrizia Pepe, and Marco de Vincenzo. www.valentinafrugiuele.com

SHOT: *Ming Yin*

SHOT: *Jane Karolina LeCann*

THANK YOU DUDETTES

A big, heartfelt thank you to the following amazing women for their help and support:

Jenny Shima, Susie Draffan, Sofia Bennasar, Amanda Gilbert, Shannon Davenport, Claire Foster, Joy Yoon, Kelly Miller, Shanu Wapita, Helen Sac, Sadia Rafique, Claire Walsh, and Marianne Leverton.

And a thank you to all the dudettes who appear in the book, with a special shout out to Ayana Matsuba, Kelly Connor, Pam Hong, Ming Yin, Lauren Yates, Kelly Dawson, Mariette Hoitink, Elza Wandler, Katy Rutherford, Kelly Harrington, Kara Nicholas, Florence Tang, Erin Barajas, Vivian Wang and Nina Kaplan for their extra help and advice.

And of course thank you to all the photographers, with special thanks to the ever-awesome Stephanie Siân Smith

THANK YOU DUDES

In loving memory of the wonderful Rick Lightstone. And, for your continued help and support, I'd like to thank:

Samuel Trotman, Jonathan Cheung, Greg Foley, Alvaro Rojas, George Wilson, Donwan Harrell, Brian Awitan, Mats Andersson, Troy Strebe, Scott Anderson, Toni Worthington, Andy Paltos, Mohsin Sajid and Neil Leverton.

And to all the photographers, with special thanks to: Eric Kvatek, Ryan Lopez, Tayaka Shima, Antonio Giacometti, Ulysses Ortega and Albert Comper.

First published in the United States of America in 2018 by
Rizzoli International Publications, Inc.
300 Park Avenue South
New York, NY 10010
www.rizzoliusa.com

Yves Saint Laurent quote page 6: *New York Magazine* (November 28, 1983), p. 53.

Design: Sarah Chiarot
Rizzoli editor: Ellen Nidy

2018 2019 2020 2021 2022 / 10 9 8 7 6 5 4 3 2 1

Library of Congress Control Number: 2016962833
ISBN-13: 978-0-8478-6230-6

Printed and bound in China

Distributed to the U.S. trade by Random House